GEORGIA O'KEEFFE

AND THE

EROS OF PLACE

Georgia

O'Keeffe

and the
Eros of Place

BRAM DIJKSTRA

PRINCETON

UNIVERSITY

PRESS

Copyright © 1998 by Bram Dijkstra
Published by Princeton University Press, 41 William Street,
Princeton, New Jersey 08540
In the United Kingdom: Princeton University Press,
Chichester, West Sussex

All Rights Reserved

Library of Congress Cataloging-in-Publication Data
Dijkstra, Bram.
Georgia O'Keeffe and the eros of place / Bram Dijkstra.
p. cm.
Includes bibliographical references and index.
ISBN 0-691-01562-7 (cl : alk. paper)
1. O'Keeffe, Georgia, 1887–1986—Criticism and
interpretation. I. Title.
ND237.05D55 1998
759.13—dc21 98-3751

This book has been composed in Berkeley

Princeton University Press books are
printed on acid-free paper and meet the guidelines
for permanence and durability of the Committee
on Production Guidelines for Book Longevity
of the Council on Library Resources

http://pup.princeton.edu

Printed in the United States of America

1 3 5 7 9 10 8 6 4 2

ONCE AGAIN
FOR SANDRA
OF COURSE

CONTENTS

PREFACE

In 1934 the Literary Guild published *America and Alfred Stieglitz*, a set of tributes suggesting a basic link between the photographer and the background that helped form him. *Georgia O'Keeffe and the Eros of Place* sets out to explore the implications of a similar conjunction in the work of O'Keeffe. Those familiar with the book on Stieglitz will recognize some of my chapter titles as analogues to some of the titles of sections in that book. These parallels are deliberate, for what belonged to Stieglitz of America also belonged to her.

Perhaps more so, because, as what follows will show, O'Keeffe was far more consistently than Stieglitz the product of her local background; but O'Keeffe's America is harder to recognize in today's world, because much of it has been buried by his side of the story in the history of art.

As I hope to show, this premature burial has skewed our view of American art in a way that has fundamental ramifications for our conception of culture in general. Therefore this book is perhaps as much about the fate of certain ideas in America as it is about O'Keeffe. For because there is no artist more American than O'Keeffe, a book about her American intellectual background is also a book about her.

This book has its origin in my first, written almost thirty years ago: *The Hieroglyphics of a New Speech: Cubism, Stieglitz, and the Early Poetry of William Carlos Williams*, and also published by Princeton. In that book O'Keeffe was only a secondary presence. Here she comes first. What follows explains why.

O'Keeffe herself had a hand in it. Some years after my book on Stieglitz appeared, she contacted me and we had several lengthy discussions about the period I had delineated in it. From those discussions I learned a lot about her, about me, and about issues of gender.

In 1991 Doris Bry and Nicholas Callaway asked me to write something about O'Keeffe for their book *Georgia O'Keeffe: The New York Years*. This became a long essay containing some of the same material included in this book. But I realized then that America would have to

be given a much more prominent place in the story of O'Keeffe than was possible within the framework of that essay. This book is the result: the story of an unfairly maligned and overromanticized fragment of America that brought us O'Keeffe.

GEORGIA O'KEEFFE

AND THE

EROS OF PLACE

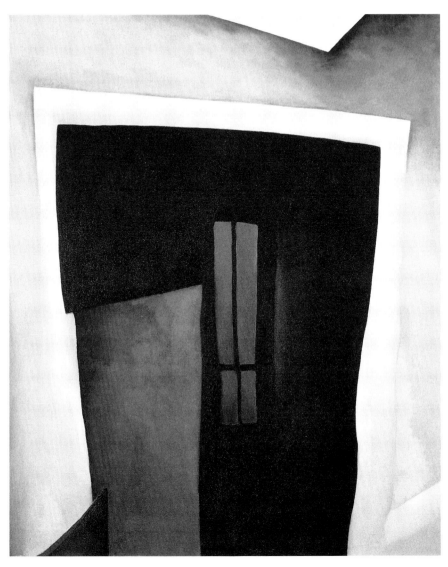

1. Georgia O'Keeffe, *Fifty-ninth Street Studio*, 1919. Private Collection.
© 1998 The Georgia O'Keeffe Foundation / Artists Rights Society (ARS), New York.

I

The Fifty-ninth Street Studio

When Georgia O'Keeffe arrived in New York in 1918, she settled into the studio of Alfred Stieglitz's niece, Elizabeth, on the top floor of a Fifty-ninth Street brownstone. Many years later, she fondly remembered the place as emblematic of the creative fervor her new environment had sparked in her. "The studio was bright with a north skylight and two south windows," she recalled. "Elizabeth had painted the walls a pale lemon yellow. The floor was orange—not a very good place for painting but it was exciting. It made me feel good and I liked it. The room back of the studio had a rather narrow window opening into a small court so it was not very light."*

The studio on Fifty-ninth Street was the chrysalis of O'Keeffe's mature sensibility as an artist. Where we live inevitably shapes what we do—unless we cannot register the visual rhythms of the life around us, or the textures of the surfaces our fingertips touch. O'Keeffe did not suffer from such sensory deprivation. As her remarks indicate, she was well aware that her New York studio provided the lines of touch and the textures of sight for her complex state of mind. The eros of place was an organic part of her sensibility—a creative necessity. She understood that the colors and textures of the world we live in are body to our sense of self. The objects we grow up with become the furniture of the innermost rooms of our imagination. They shape our material being. She had come to understand, well before she found herself as an artist, that "the local is the only universal" and that there can be "no ideas but in things," as William Carlos Williams was beginning to realize just around this time.

* These, and all subsequent statements by O'Keeffe not otherwise credited, are taken from the artist's unpaginated autobiographical comments accompanying the plates of *Georgia O'Keeffe* (New York, 1976).

The Fifty-ninth Street studio therefore became the material analogue to O'Keeffe's inner sense of being at this time. Living there helped her reshape her art—the outer shell of her aesthetic sensibility—within a remarkably short period of time. No doubt she sensed that she was living through one of those rare interstices between what is past and what is still to come that have the power to shape the entire trajectory of our subsequent existence.

Being an artist, she recorded what she saw of herself in the lines of her environment. Her painting *Fifty-ninth Street Studio* (fig. 1) therefore became as accurate a document of her understanding of the America that had shaped her as any image can possibly be. It concretizes a world hovering between common sense and the understated eccentricities of a life moving ever deeper into itself: a world in which concepts of inter-connectedness can do no more than attach themselves to the edges of a crystalline self-awareness forged in the labyrinthine back rooms of the American social imagination.

Consequently, strange as such an association may seem at first when we scrutinize a life as solidly grounded as O'Keeffe's, there is also some-thing of Edgar Allan Poe in this painting: "The windows were long, narrow, and pointed, and at so vast a distance from the black oaken floor as to be altogether inaccessible from within. Feeble gleams of en-crimsoned light made their way through the trellised panes and served to render distinct the more prominent objects around" (233–34).* But O'Keeffe's room of the soul is not as febrile as that of Roderick Usher—instead it has the warm concavities, angles, and curves of Poe's places of happy seclusion with their "silver gray" walls, their "short irregular curves," and their warm but dark hues of "predominant crimson"—places, outlined in detail in his "Philosophy of Furniture," where one's mind could hover peacefully between exterior realities and the inner comforts of the imagination.

O'Keeffe, because she understood the shaping power of one's mate-rial environment, would have known (had she, as is unlikely, ever read his work) what this dark androgyne of the American imagination meant with his insistence upon "the sentience of all vegetable things" ("Usher," 239). Like Poe she saw the deepest reaches of the soul echoed in the forms of the material world, "the perfect keeping of the premises with

* This and all subsequent quotations from Poe are taken from *The Complete Tales and Poems*, The Modern Library (New York, 1938).

the accredited character of the people" in it (232). In Poe's "Colloqui of Monos and Una" the artificially gendered halves of a naturally polymorphous human creativity are woefully sundered by the "wreck and chaos of the usual senses" (449) and cowed "into a diseased commotion, moral and physical" (445). They were, as we shall see in what follows, to be reunited in O'Keeffe's acute awareness of the sensuous materiality of the Fifty-ninth Street studio, where the self she had been seeking to express had suddenly become articulate, when, in the language of Poe's "Colloqui of Monos and Una," she came to realize how in her experience "the idea of entity was becoming merged in that of *place*. The narrow space surrounding what had been the body, was now going to be the body itself" (450).

Our reality is given form by the tactile matter of experience. Given the consistency with which, throughout her later life, O'Keeffe returned to her memories of the Fifty-ninth Street studio, the painting that defined her being there can fairly be regarded as an accurate reflection of her sense of self at this point in time. The studio of her mind, it becomes clear, though allied with Poe's room of the imagination in its celebration of the sensuous beauty of nature, was also dramatically different from his still puritan sensibility. She did not hesitate to accept the eros of place as a guide. She did not believe, as Poe insisted to the last, and to his utter destruction, that beauty was destroyed by the sexual energies of the gendered body, to be recaptured only in the transcendence of eros by the synthetic capacity of the poet's androgynous imagination. O'Keeffe recognized that the creative energies of the body were always in dialogue with their immediate surroundings, that the erotic was a bridge *between* the extremes of gender separation and otherness that had driven Poe to distraction. In her introduction to the Metropolitan's exhibition of Alfred Stieglitz's photographs of her she recalled this aspect of her experience vividly: "There was very little furniture in the studio, and I slept right under the skylight. I spent a good many days painting in this room, and it was so hot that I usually sat around painting with nothing on."

As we shall see, O'Keeffe's eyes had been focused by her American background. In her work the shapes of nature finally regained their wholeness, their polymorphously erotic multiplicity. Rather than serve as the hesitant manifestation of a largely discordant temporary alliance between darkness and light, they became in O'Keeffe's work the very soul of self-identity. Beginning with *Fifty-ninth Street Studio*, her

paintings almost invariably celebrate the beauties of sense experience, localized and validated in the forms, colors, and textures of the material world. More than words can ever hope to, O'Keeffe's paintings illuminate and celebrate the eerie beauty of the silences that fold themselves into nature's ability to overcome the closely guarded distances between our selfhood and what is Other.

Fifty-ninth Street Studio, therefore, does not attempt to aestheticize the politics of "individualism" by simply celebrating private darknesses or by seeking to romanticize the dry ice of personal dissociation. Instead it transforms the private lines of sight deflected inward by the virtually impermeable surfaces of American social ritual into the raw materials of art. The painting celebrates what many of us would see as the daunting surrealism of the space between the otherness of the material world and the solipsistic isolation we are forced to endure in response to the social requirements of selfhood.

In O'Keeffe's painting, however, form as such becomes the object of desire—becomes what is both other and self. The world she makes us see moves in upon itself in celebration of the luminous volumes, infinitely variable lines, warm, layered colors, and sensuous textures of organic space. It is a superbly self-confident celebration of the material world as coextensive with selfhood, as the repository of the visual modalities of a personal expression unhedged by convention and the predictable formal arrangements with which habit contrives to dull our senses. Though intensely personal, O'Keeffe's painting in this manner transcends the realm of solipsism, and instead invites us to explore the common forms and shared emotional resources that underlie all private experience. It manages to establish a visual space located somewhere between selfhood and otherness, and creates a common ground that exists both within and beyond the conventional space of our being. It simultaneously contains and transgresses the social enclosures established by our normal limits of belief, and it challenges our traditional concepts of isolation as much as our fears concerning the supposed evils of otherness. And in its absolute indefiniteness about what is inside or outside, encompassing or recessive in the space we call self, it also transcends our most ingrained clichés about gender to celebrate instead the polymorphous eroticism of the body in nature.

These are extravagant claims and therefore risk being dismissed as subjectively overstating the emotional appeal of what is, after all, not a philosophical disquisition, but a remarkable painting. Still, as I intend

to show in what follows, O'Keeffe's depiction of the Fifty-ninth Street studio documents an extraordinary event in American art. It is the felicitous product of an unusual confluence of circumstances, a creative nexus into which O'Keeffe, at thirty-two, gathered most of what she had learned about the link between the pleasures of the senses and the matter that constitutes being. Thus the painting concretizes one of those rare conjunctions of knowledge, self-possession, and sense experience in a person that, when successfully captured in a work of art, can reveal to all of us a world of creative possibility far beyond the constraints convention imposes on our perceptions.

In that sense the painting not only represents a turning point in the artist's career but also shows itself to be a significant marker of continuities in the American cultural environment. Thus it is one of those rare works of art that succeed in blending the private and the public spheres of experience, and therefore become emblematic of certain creative possibilities embedded in the history, shared knowledge, and sense experience of an entire nation.

The potential embedded in O'Keeffe's *Fifty-ninth Street Studio* was that of an art freed from the prejudices of gender—an art that would instead find its motivation in a celebration of the creative energies generated by any sense experience grounded in reality. This fundamentally humanist concept was the motivating force behind virtually all of O'Keeffe's work from this point on.

The artist herself always understood that her *Fifty-ninth Street Studio* was different from anything she had done before. More than fifty years later she still fondly recalled her reckless and defiant mood at the time she painted it. "When I knew I was going to stay in New York, I sent for things I had left in Texas. They came in a barrel and among them were all my old drawings and paintings. I put them in with the wastepaper trash to throw away and that night when Stieglitz and I came home after dark the paintings and drawings were blowing all over the street. We left them there and went in."

O'Keeffe's memory of this event—a dramatic gesture expressing both a determined dissociation from what she had come to recognize as the insufficiencies of her past work, and a remarkable confidence in her newfound ability to express herself—even as filtered through the moderating perspective that comes from many years of reflective distance, clearly remained one of satisfaction. She voiced no after-the-fact regrets that so much of her earlier work had been destroyed. The atmosphere

of brash experimentation characteristic of the New York art world at this time had taught her the uses of decisive action. The festive visual environment of the Fifty-ninth Street studio had provided her creative imagination with a new grammar of form. For the moment, the city had become her inspiration and the source of her future as an artist, imprinting itself upon her senses and infiltrating her art, and helping her develop an entirely new, decidedly architectural concept of the visual management of volume and line. Long before she chose to pay overt homage to its influence in her cityscapes of the mid- and late twenties, New York City had thus come to play a significant role in O'Keeffe's attempts to establish analogues between her states of mind and the visual rhythms of organic being.

But we cannot throw our formative environment into a garbage can the way we can dispose of what we consider to be our failed attempts at art. The startling modulations of the *Fifty-ninth Street Studio* were linked at least as directly to the formative influence of O'Keeffe's early midwestern background as to her sense of the pulse of life in New York City. The *Fifty-ninth Street Studio* and much of O'Keeffe's subsequent work is quintessentially American precisely because it is the product of a remarkable confluence of stylistic and sociocultural energies. Much of the discussion of O'Keeffe's style to date has more or less taken for granted that her art was shaped by the impulses of European modernism. But though these inevitably played a role in her formation, O'Keeffe's very American confidence in material reality as source and expressive vehicle for every human emotion was ultimately far more important.

Indeed, there is in O'Keeffe's work none of the cynical, and frankly rather sophomoric, mock-sophisticated ironic intellectual distancing that was characteristic of the European avant-garde of the 1910s and early 1920s. Instead O'Keeffe tenaciously pursued an unpretentious quest to express in her art the essence of her American self. She did not hesitate to take from the Europeans what she thought she could use, but what she took helped her develop an expressive calligraphy of the emotions—she was not interested in games of intellectual one-upmanship.

The antics of Duchamp and the dadaists—an avant-gardism designed to satisfy the generational rebellion of the elitist sons of the new international middle class—meant nothing to her. She believed, like William Carlos Williams and many other American artists of the period,

that, as Marsden Hartley was to remark in *Adventures in the Arts* (1921), "art is an essentially local affair," and that the better it is able to absorb international influences, "the truer it will be to the place in which it is produced" (62). She understood, and was not afraid to experiment with, what the cubists and Duchamp were doing, but, though fiercely articulate and perfectly capable of being devastating in her judgments of others whenever she chose to be, she usually remained on the sidelines in the culture wars. The modernists' appropriation of ostentation as an art form did not appeal to her, particularly when her love affair with the material world was at its most passionate and sensuous. Quietly analytical, she was also brusquely intolerant of fuzzy thinking, verbal obfuscation, and posturing. No wonder she remained, throughout her life, suspicious of the written word. Against her better judgment she hoped that the world would let her paintings speak for her: "Where I was born and where and how I have lived is unimportant. It is what I have done with where I have been that should be of interest."

Even so, O'Keeffe's work has, in recent years, all too often had to take a backseat to fantasies of how she lived produced by the celebrity voyeurs of our contemporary media; these, instead of paying attention to what the artist did with where she lived, have instead tried to uncover virtually her every step, or perceived misstep. In the process they have turned O'Keeffe into an icon of her art—a preternatural creature, shamanistic, exalted, and removed from everyday experience. Her work has, in consequence, often been treated as if it were representative of a would-be "universal feminine" state of being, virtually unrelated to the historical preoccupations of her fellow artists. In what follows I hope to be able to indicate that much of the enduring significance of O'Keeffe's work lies, instead, in her ability to respond to and synthesize the creative currents of "the local," of the specifically "American" mix of tendencies in the art and culture of the earlier years of this century. O'Keeffe's mind-set was dialectical, but she grew up in an era that came to be dominated by extreme dualistic thinking. Some "feminin-ist" enthusiasts among the artist's contemporary followers insist on celebrating the presumed gender-specificity of her work. They only help to perpetuate the prejudicial effects of quasi-scientific speculations about an ever increasing evolutionary male-female sexual dimorphism originally fueled by the gender politics of turn-of-the-century culture, speculations O'Keeffe, as we shall see, despised.

II

The American Background

To delineate the trajectory of exploration followed by O'Keeffe as she developed her own style is also to describe the specifically American social and historical particularities of the environment that helped shape the work of many other early modernist artists in this country. Even so, O'Keeffe was always eager to maintain her distance from movements and tended to undercut any suggestions of external influences on her work. But even that attitude itself was very much in line with her characteristically American confidence in the self-creative dynamic of personality.

Actually the individuality of her work is in large part due to her perceptive assimilation of the expressive visual language of a wide range of other American artists. Thus she was able to synthesize many significant influences into a coherent personal style. That style, in turn, inevitably became the expression of an unmistakably American sensibility—a sensibility that was, during the early years of this century, perhaps most "American" in its humane celebration of certain qualities we still tend to see as expressive of "the feminine sensibility" within the context of the tendentious ideologies of gender difference that continue to dominate our culture.

It may seem foolish to attempt to tie a delineation of what might be truly "American" in art to a discussion of outdated conceptions of what is "masculine" and "feminine" in human behavior. But history is the public record of our misconceptions, and many of these have to do with gender. The United States came into existence, and has continued to develop, as a remarkably heterogeneous gathering of particularly narrowly focused, and initially rootless, immigrants whose primary concern was the protection of their families, the cultivation of the soil, and the search for working capital. Within this context most men scorned the niceties of art. Unlike Europe, this country, in its early years, did not

have a comfortable aristocracy with enough free time to find amusement in the indulgent supervision of the nation's artistic output.

In consequence the realm of culture in the United States became, with the development of a leisure class in the nineteenth century, largely the province of women in search of enlightenment and entertainment—a pattern of development effectively delineated by Ann Douglas in her book *The Feminization of American Culture* (1977). This development, however, was closely related to the "moral" needs of the Anglo-American commercial bourgeoisie, which saw its self-proclaimed privileged position in the eyes of God threatened by the strenuous, frequently spiritually compromising demands connected with getting ahead in the world. Women—who might have become dangerous competitors in business if they had not been sidetracked effectively—were relegated to being the "soul keepers," the "angels in the house" of the bourgeois family. Their infinite patience, absolute willingness to be stepped upon and to sacrifice themselves for the good of man, would guarantee God's approval and hence the ultimate resurrection of the married couple's shared soul, no matter how severely the husband had been forced to sully himself as part of the daily grind.

Darwin and the theory of evolution came along at just the right time to provide an aura of scientific legitimacy to the earlier nineteenth century's domestic division of labor into the separate spheres of "masculine" productive aggression and "feminine" passive capacity to suffer and be still. The Almighty had clearly designed the world as a testing ground for the ever more precise and efficient evolution of this miraculous division of labor—this functional dimorphism—in the male and female spheres of being.* In the United States in particular, men busy making money had little time or inclination to concern themselves with the arts, and they were therefore, well into the 1870s, happy to let their wives manage the care and feeding of those peculiar gender-intermediary creatures of culture, the writers and the painters of pictures who had braved the inclement weather for art in the New World.

Though in Europe a similar pattern of middle-class dissociation from the world of cultural creation had taken place, the effects of this pattern were far less noticeable there than in the United States, for the typical

* I have treated these developments in considerable detail in *Idols of Perversity* (New York, 1986).

European art patron was a male aristocrat, not really concerned with the vulgarities of making money, or otherwise a well-heeled son of the upper bourgeoisie in search of a toehold among the aristocracy. Art remained largely the playground of the idle—and, many of the more puritanical members of the bourgeoisie believed, rather decadently underproductive—rich. Moral salvation was rarely a major concern among these representatives of an outmoded social system. Subjects of long-standing interest to their aristocratic audience had therefore remained the bread and butter of the most successful European painters, from military scenes and dramatically subservient female nudes to ostensibly high-flown, though preferably quite sexually suggestive cautionary tales taken from history and mythology. Dandyism, a self-conscious delight in one's own worldly sophistication and the moral imperfections of attractive women, had become the norm among these painters. The European ruling class found these men entertaining. When theories of evolutionary inequality among social groups became all the rage as the nineteenth century began to wind to a close, these dandified artists therefore had no trouble at all seeing themselves as part of an evolutionary elite.

But American men in positions of power would have regarded artists who behaved like that as parasites, as confidence men who played upon the emotional weakness and moral fastidiousness of their wives. And the women, in turn, would have deemed immoral any such behavior on the part of the artists under their protection. As a result, much more than in Europe, artists in the United States had to adjust their concerns to the values that women, and these women's moral wardens, the clergy, brought to them.

Many of the American artists of the later nineteenth century who remained connected with their native environment therefore found themselves painting in a manner that expressed what the twentieth century was to come to see as "female concerns." Toward the close of the century, however, the art scene became more and more varied. Some continued to pursue romantic tributes to the grandeur of nature as an expression of God's magisterial vision, such as those we associate with the landscapes of Frederic Edwin Church and Albert Bierstadt. By the 1880s, however, many others, no doubt influenced by the collections of French Salon art being amassed by stateside millionaires, were being swept up in the vogue for French academic art. They began to work and

study in Paris and exhibited regularly at the Salons. Many of the older painters, meanwhile, remained content with the mass production of moral anecdotes about the antics of street urchins, dogs, and children of assorted ages, work of the kind that had been popular in the 1860s and 1870s.

The "feminine" American influence persisted as well, guided by a conservatively humane (in a pre-Darwinian sense) and often strongly religious philosophy that sought to affirm humanity's unity with nature under God's guidance. Painters under its influence tended to concentrate on landscapes of a subdued, quietly contemplative kind. In their paintings the luminous glow of light came to echo a wide range of emotions; warm colors suffused with pinks and grays came to reflect their constituency's interior contentments as well as the gnawing existential fears of souls kept on the margins of life. The American landscape in its boundless variety became, in their work, a mirror to the longing, and the terrors, of the stern varieties of religious experience still promulgated among American women by the gatekeepers of God's will. But more and more the painters as well as the women who were their principal patrons grew skeptical of religious salvation and more attuned to nature's ability to reflect the nuances of their personal feelings.

This mix of influences produced tonalism, a gracefully undemonstrative, subtly intellectual style of painting that ultimately succeeded in escaping the clergy's harsh judgments concerning humanity's (and particularly women's) subservience to the punishing censure of God's will, by first investigating and subsequently celebrating the bonds connecting the mind, the body, and nature. Ultimately, between 1890 and 1910, it was to become the most widely acclaimed "native" form of landscape painting in American art—just when America's new prominence in world affairs and the industrial robber barons' newfound superwealth demanded that the arts be rescued from their banishment to the silent waters of the woman-soul and be reattached to far more muscular forms of conspicuous consumption.

As Ann Douglas points out, it was just around this time, therefore, that "many men, and women, were becoming deeply concerned about the 'feminization' of American culture." Soon "movements were afoot in the field of education to control the still-proliferating and preponderant ratio of women to men among grade-school teachers, even to reverse the tide of co-education at the university level. Violent collegiate sports,

outdoor camping, hunting, and fishing grew rapidly in favor. Social Darwinism with its exaltation of the right of the strong to trample the weak dominated political practice and sociological theory" (327).

But change takes longer in the arts. It is hard, if not downright impossible, to teach old painters new tricks. Yet the acquisition of art, particularly painting and architecture, was the most "European"—and indeed, most "aristocratic"—way to wield one's big stick in the high-stakes game of conspicuous consumption needed to reflect the robber barons' new wealth. American power brokers of the late nineteenth century in search of a high public profile began by buying up whatever certified European masterpieces they could find. In the first stages of the gilded-age millionaires' rush to art, therefore, they took to raiding the yearly exhibitions of the Paris Salon, and carrying off its major sensations by the dozens. Some turned their homes into blushing repositories of the French academic artists' predilection for acres of pink and waxy female flesh (though they were also careful to acquire numerous tippling cardinals, sturdy, hardworking peasants, and scenes of domestic crises, to emphasize the fundamental moral rectitude of their cultural endeavors).

Not surprisingly, the influx of American cash into the pockets of certain French artists brought on an intensification of the usual bickering about hierarchical issues among establishment figures, even to the extent of splitting the Salon, in an act of elementary parthenogenesis, into two barely distinguishable, but even so inalterably opposed, rival exhibitions—a rivalry that of course also served to double hanging opportunities (and the potential for sales to American business tycoons). Even so, as the American art critic George William Sheldon reported in 1890 in his *Ideals of Life in France; or How the Great Painters Portray Woman in French Art*, a veritable storm swept over the Parisian cultural scene when that very year the country's women artists "protested vigorously against the management of the *Salon*, which had refused more than a hundred of their pictures 'for want of space.'" A fierce "Kinder/Küche" debate erupted, which appears to have been settled largely in favor of the argument that modern women should tend to their pots and pans and leave it to the men to concern themselves with the higher moral issues of artistic expression.

The overwhelming majority of French art critics, by this time, habitually derided the work of the ever growing number of women painters exhibiting at the Salons, and at the Society of Women Artists—many of

whom were American. Sheldon reported in his book that the French had almost unanimously declared the ability to paint in an original manner to be beyond the limited abilities of women. What is particularly interesting, however, is that, no doubt acutely aware of the large feminine constituency among his readers, he also pointed out quite sensibly that the works shown at the Society of Women Artists "do not reflect the influence of their masters in a greater degree than do those of the sterner sex, and there was nothing in the subjects chosen or in the manner of treating them which indicated to the average visitor that the exhibition of 1890 was produced by women and not by men" (29).

But the reasoned, pro-feminine focus of Sheldon's appraisal, which had been a characteristic feature of the earlier American critics' treatment of art produced by women, only confirmed his "conservative" role in the American art world of the 1890s. Until then the American artists (and hence also the critics) had still found themselves relegated to an "outsider" position, their place in the culture essentially on a par with that of the women who supported their output. Now artists and critics alike began, as the market for art in the United States became more lucrative in the closing years of the nineteenth century, to scramble in virtually every direction in their attempts to disassociate themselves from the taint of "feminine influence."

But this was made more difficult by the fact that the Americans' primary successes in the realm of artistic expression had come from the field of landscape painting, which, in Europe, was still widely regarded as primarily a stomping ground for second-stringers, at least until the widespread popularity of impressionism made it into a particularly lucrative field for even the most masculine intellects among the artists. Most Americans, therefore, had long taken the inferiority of their own art for granted, particularly given its predominantly "feminine" ambience. "Art is too often looked upon only as a plaything, unworthy of profound thought," S. R. Koehler emphasized in the preface of his *American Art* (1886), deftly skirting the gender issue in deference to his female readers, while at the same time belittling them in his choice of words.

Hoping to catch the attention of the new mental musclemen of social Darwinism, Koehler assured the males among his readers that it was his intention "to restore to [American art] that intellectual position to which it is entitled," even though, as he emphasized in his conclusion, he expected to continue to hear complaints that the native artists "yet

do not rise above a gentle height." Such failure of artistic nerve, however, was due entirely to the environment in which they had had to work. Mental muscle could come only from an influx of cultural masculinity: "We have not provided those opportunities which they might reasonably have expected from a nation sincerely desirous of art expression. . . ; therefore the shortcomings of our art are chargeable to the people as a whole, rather than to the artists as a class" (58).

Almost a decade earlier, in 1877, S.G.W. Benjamin, in the preface to his perambulation of *Contemporary Art in Europe*, had already called upon Americans to recognize that their "manifest destiny" indicated "that the energies called forth by a great struggle for national existence" were about to produce "a full harvest of intellectual activity." America was ready to throw off the shackles of its cultural childhood and enter into its "era of mental development." He had ended his book by calling upon American artists to get rid of their low self-esteem: "The notion that our native methods and native ideas and culture can never equal those of the Old World should be frowned upon as not only unpatriotic, but unreasonable . . ." (160). Economic nationalism was starting to rattle its sabre. American culture must grow to manhood by shaking off the feminine embrace.

Two years later, Sheldon, in his book *American Painters* (1879), emphasized that American artists had already "wrought for themselves, especially in the domain of landscape art, a very distinct and honorable position" (10). Lately he had noted among them a diminution of "self-conceit and the indolence proceeding therefrom," and a new tendency toward "manly persistence in toil" (184). In the 1890s such equations of quality and "virility" in American art were to proliferate dramatically—particularly when critics wished to emphasize its philosophical or "intellectual" content. Since American landscape art was internationally recognized as having developed a distinct character of its own, it thus became the principal focus of the masculinists' cultural rescue operation.

An interesting dynamic, directly linked to the ever greater international visibility of American painters, had forced many critics to rethink what they should be looking for in a "mature" native style of painting. The Paris Universal Exposition of 1889 became, in this respect, a watershed. The conservative critic Theodore Child (who gracefully dedicated his book *Art and Criticism* [1892] "to the cultivated women of North America") had still proudly reported that "the American Fine Art sec-

tion was one of the strongest and most interesting of all the foreign departments" (79). But he also emphasized that "in the United States section a broad distinction was made between the American artists resident in Europe and those resident in America." The works of each group "were hung in separate rooms, as if to challenge comparison. It must be said that the comparison was disastrous to the American artists resident in America, or classed as such" (134).

Sheldon, however, in his *Ideals of Life in France*, reported that "the almost universal criticism on the American pictures exhibited at the Paris Exposition of 1889 was that they did not indicate the existence of an American School of Painting. 'Important though these pictures were,' said a writer in the *Revue des Deux Mondes*, 'and more in number than those of any other foreign nation, it was in the American gallery above all that the spectator would consider himself in the French Gallery. . . ; the young Americans are so French that we can scarcely distinguish them from ourselves.' And similar views have been expressed by a hundred other writers." But, emphasized Sheldon, "all the American painters mentioned . . . are those who are called in Paris the 'Paris Americans,' to the exclusion of the 'American Americans,' whose works were exhibited in a separate room at the Exposition of 1889" (139–43).

As Albert Boime has pointed out, most of the French critics' praise for the Parisian contingent was clearly "a calculated attempt to reduce the importance of the Americans as a national group vis-à-vis the French" ("The Chocolate Venus," 77). The rising tide of American individualism could not brook such a dismissal of its cultural production. A "distinctly American" form of expression needed to be found. A small contingent of the painters in the U.S. exhibit (most among them relegated to the separate room of "American Americans") had exhibited work in the still developing tonalist manner—artists such as George Inness, Alexander Helwig Wyant, Charles Harold Davis, Hugh Bolton Jones, Arthur Matthews, Robert Swain Gifford, Arthur Parton, William Anderson Coffin, and Arthur Wesley Dow. The latter's contemplative *At Evening* (fig. 2) and Davis's equally moody and virtually identically titled *Evening* (fig. 3) both blend Barbizon influences with a luminist predilection for the afterglow of the setting sun; they show the remarkably delicate, brooding, and philosophically inflected qualities of this style, which was, in its astonished reverence for the unrelenting, harshly demanding purity of nature, distinctly American.

2. Arthur Wesley Dow, *At Evening*, 1888. Courtesy of Ipswich Public Schools, Ipswich, Massachusetts.

3. Charles Harold Davis, *Evening*, 1886.

In the new patriotic rush to find a truly original "nativist" art, the critical establishment now took a closer look at this art, snubbed by the French and the more European-oriented American critics alike, and soon came to recognize its special merits. In the process the critics conveniently overlooked the style's roots in the "feminine" sensibility of the older American art public. Thus if "the importation into the United States of the best works of the best modern painters" had initially led "to a dissatisfaction with much that we ourselves had produced," as Sheldon pointed out in *Recent Ideals of American Art* (1890), a companion volume to his *Ideals of Life in France*, the industrialists' newly acquired aesthetic patriotism now helped them accept the art of the tonalists, with its intelligent blend of European technical expertise and its quietly "feminine" American aesthetic sensibility. These well-heeled aesthetes' critical appreciation of the movement was undoubtedly honed further by the fact that they had to pay a 33 percent import duty on their Salon purchases.

As a result Sheldon was able to announce that "to-day the American artist who can draw and paint soundly has a chance of selling his work at good prices. Perhaps twenty citizens of New York city alone are forming collections exclusively of American paintings; and not one of them puts much store on mere 'elegance and eloquence' [a thinly veiled dig at the "feminine and clerical" preferences of the older American art public]. The landscapes of men like Inness, Wyant, Tryon, Murphy, Davis, and Bolton Jones, find purchasers as soon as they are put on the market. . . . The demand for good work is sustained and increasing, while the canvases of the sentimentalists were never before worth so little. The private collector makes his purchases, not 'to encourage American art,' as was often urged as a duty twenty-five years ago, but to please his taste and to invest his money" (2).

III

Tonalism versus Technocracy

Among the most cherished myths of the international art-historical establishment (including its "postmodernist" branch) is that of the cultural martyrdom of the pioneers of modernism. Every year another book recounts the sad travails of the impressionists against the brutal forces of a reactionary critical establishment. The effect of this has been to provide the many aficionados of impressionist art among the general public with a vague, ideologically convenient image of these mostly well-to-do middle-class artists as misunderstood geniuses who led lives of struggle and bitter poverty straight out of Murger (and particularly Puccini's *La Bohème*). The example of van Gogh—a genuine "outsider"—in this respect always comes in handy. Like every movement in art that represents something of a departure from whatever happens to be the currently entrenched norm, the impressionists encountered vocal and sometimes acerbic opposition—mostly during the few years around the first impressionist exhibition of 1874. But, in fact, their work, almost from the first, sold far better than that of most mainstream artists not included in the inner circle of the art establishment of the 1870s and 1880s.

We like to anoint our cultural heroes with suffering. It makes us feel marvelous to be so much more perceptive than the philistines of past ages. The historians of impressionism, who tend to record at length every disdainful remark made against the movement, are, in contrast, far less likely to quote the remarks the impressionists' main Parisian dealer, Durand-Ruel, made when he arrived in New York in 1886, with a generous selection of their work. George William Sheldon paraphrased the French dealer's remarks as follows: Today the impressionists' "pictures had reached fabulous prices, and amateurs bought, for

more than their weight in gold, paintings that they would hardly deign to look at a few years ago; while, to meet the incessant demand, search had been made far and wide for every vestige of their skill" (*Recent Ideals of American Art*, 102).

In December 1892 the popular monthly magazine *Scribner's* reproduced Manet's *Bar at the Folies-Bergère* and one of Degas's paintings of ballet dancers in an article entitled "French Art—Realistic Painting," by William C. Brownell, along with works by Lhermitte and such perennial Salon favorites as Paul Baudry and Jean Béraud. Brownell, noting that plein air work was all the fashion, identified Manet as "certainly one of the most noteworthy painters that France or any other country has ever produced," and proceeded to give a pointed little history of the style we still like to see as martyred by a philistine community: "For a time French landscape was pitched in a minor key. Suddenly Claude Monet appeared. Impressionism, as it is now understood, and as Manet had not succeeded in popularizing it, won instant recognition."

Brownell thereupon launched into a remarkably astute and very positive analysis of Monet's method of painting. His remarks seem more like those of a late-twentieth-century historical revisionist than what we might expect from a popular late-nineteenth-century American writer on art. If there was a problem with impressionism, he pointed out, it was not so much "its technical conventionality" as the fact that it lacked "a seriousness commensurate to its claims." After all, "a theory of technic is not a philosophy, however systematic it may be. It is a mechanical, not an intellectual point of view. It is not a way of looking at things, but of rendering them." Still, Brownell concluded, "for the present, no doubt, Monet is the last word in painting. To belittle him is not only whimsical, but ridiculous. He has plainly worked a revolution in his art." No one attempting to represent nature "will be able to dispense with Monet's aid" (604–27).

This is not the sort of commentary one produces to describe a beleaguered avant-garde. But the romance of modernist martyrdom, along with what it suggests about the additional travails of the first group of early-twentieth-century American modernists, has encouraged critics to sketch a late-nineteenth-century art scene so brutally reactionary that it was not until the years after 1900 that American impressionism could even establish a toehold among its benighted constituency. The realities of history put a very different light on what actually took place.

The 1886 Durand-Ruel sales exhibition in New York, Sheldon had noted after paraphrasing the Parisian dealer's comments regarding the popularity of impressionist art, "caused great interest on the part of both artists and amateurs; and many of the canvases—particularly the luminous landscapes of Claude Monet—found a way into the private collections. Today, three years afterward, the fame of Monet is well established, and his pictures are displayed in the galleries of the most fashionable dealers."

If we consider this receptive environment, the American preference, during the 1890s, for the muted, contemplative colors of tonalism over the festively colored bonbons of the impressionists can no longer be dismissed as a lack of cultural sophistication, or as indicative of a widespread reactionary sentiment. The Americans' preference for tonalism has much more to do with their eagerness to support an art that would, finally, be fully representative of an indigenous artistic sensibility and, for once, *not* be a slavish imitation of whatever happened to be most fashionable and marketable in France. Critics who responded negatively to American explorations of impressionist techniques during the 1890s almost invariably emphasized the *imitative* nature of such ventures—they rarely gave any indication, despite what we like to assume, that they were appalled by such work as "socially unacceptable" or as particularly "daring."

Tonalism, at its best, was one of the most subtle and complex—and, perhaps because of that, still one of the least appreciated—major movements in turn-of-the-century American art. It differed from other forms of landscape painting primarily in its emphasis on a philosophical contemplation of the emotional analogues between the moods of nature—its atmospheric conditions—and the spiritual condition of humanity. The tonalists' evident technical expertise, combined with the distinctly American focus of their subject matter, connected with the new patriotic fervor of the American fin de siècle's indigenous robber barons, even if these painters' values were, on the whole, drastically opposed to the rapacious industrialism of their patrons. The robber barons liked to flaunt their nostalgia for the America they helped destroy. Buying the work of the tonalists was to them like bringing back part of the land—a sentiment similar to that of the real-estate moguls of today's California, who, after having made their money from bulldozing the landscape and building tract houses and strip malls in formerly arcadian locations,

have eagerly bought up works by early-twentieth-century painters documenting the natural beauty of the canyons and hills of a state no longer quite as "Golden" as it once was.

By championing the work of the tonalists, who recorded the passing of a rural world that had seemed guided by an Emersonian oversoul, the robber barons could quiet their still voices of regret and demonstrate their sensitivity to the call of the land. For tonalist art had developed out of the principles of the American transcendentalists of the 1840s. These had, as Orestes Brownson stressed, refused to rely on reason alone to explain the meaning of being: "Reflection can add nothing but itself to the materials furnished by the senses, and reasoning can deduce from those materials only what is contained in them. The spiritual is not contained in them, and therefore cannot be deduced from them." Science, unaided by the emotions, could never uncover truth. Reason must operate *in conjunction* with our inner apprehension of the affective significance of matter.

Such a realization was, Brownson recognized, profoundly antiauthoritarian: "Christianity by this is adapted to the masses, and fitted to become an universal religion. Its evidence is simplified, and the necessity of relying on an authorized teacher superseded." The transcendentalists therefore "claim for man the power, not of discovering, but of knowing by intuition the spiritual world." However, this did *not* mean "that feeling is to be placed above reason, dreaming above reflection, and instinctive intimation above scientific exposition"; it merely meant that reason and feeling should work together, interact, be as one (244–46).

Transcendentalism thus was an attempt to bridge the ever widening chasm between science and the spiritual—and, by implication, also the ever greater distance between what were rapidly becoming identified as the "separate" spheres of the sexes. Reason and science had more and more come to stand for masculinity, and intuition and the "lawless fancy" of nature for the feminine.* Transcendentalism was thus also— though largely on an unconscious level—at least in part an attempt to find a way to redress the imbalance the growth of industrialism was helping establish between man's authoritative scientific (and economic) "reason" and woman's passive moral (and domestic) "intuition." *Both*

* See my *Idols of Perversity*, chapter 2, and passim.

men and women must continue to be governed equally by reason and intuition, the transcendentalists argued—men and women thus also must continue to have equal moral and intellectual responsibilities.

As the nineteenth century wore on, the transcendentalist emphasis on intuition as evidence of humanity's contact with God's will began to fade, to be replaced more and more prominently by a focus on the individual person's intuitive apperception of analogues between the natural world and human emotions. The transcendentalists' emphasis on the spiritual as evidence of the existence of a personal God came gradually to be supplanted by a pantheistic sense that God existed primarily in the objects and the atmospheric conditions of the natural world as the source of humanity's sense of moral and spiritual awe—as a "restraint" upon humanity's potential for excess: nature "herself" came to dwell "inside" each person. When placed against the ever-burgeoning later-nineteenth-century fetish for the equation of nature and womanhood, this search for guidance from nature represented a "conservative" response, based on the transcendentalists' search for the integration of emotion and intellect, to the new exclusionist Darwinist world of "manly" science and reason. Thus this continuing focus on a blend of reason and intuition became a moral-"spiritual" counterforce, grounded largely in materialism, to the claims of science that "man," in order to evolve ever further, must "overcome" nature—and hence divorce himself ever further from the world of the emotions, intuition, and primitive "feminine" drives.

In contradiction to the claims of the evolutionists' scientific idealism, this antidualistic, essentially human-centered version of transcendentalism held (with or without reference to divine inspiration) that one's apperception of the beauties of the material world served as an otherwise inarticulable personal intuition of the necessary link between human understanding and the intrinsic internal coherence of nature. Thus nature proved to be the source of the individual person's ability to develop humane moral insight. In his "Song of the Answerer," Walt Whitman made that point succinctly when he chanted: "The greatness of sons is the exuding of the greatness of mothers and fathers, / The words of true poems are the tuft [i.e., the warp and woof] and final applause of science." True poems (the materials of the moral imagination) were also "divine instinct, breadth of vision, the law of reason, health—," and therefore "They balance ranks, colors, races, creeds, and the sexes" (123–24).

The "transcendental materialism" of the second half of the nineteenth century was thus—in a pragmatic sociohistorical sense—at least in part this transitional culture's attempt to justify the continuing central importance of women—and hence the "feminine sensibility"—in the American social organization of the period. The blend of intuition and reason represented a continuing belief in the "equal rights" of "male" and "female" qualities to participate in the construction of a personal sense of being in the world. This later aspect of the transcendental materialist tendency in American thought had been anticipated in the thinking of Edgar Allan Poe.

Poe was convinced that indelible parallels existed between the structure of a person's inner life and the material configuration of the natural environment in which that life is lived. In "The Colloqui of Monos and Una," his prescient poetic diatribe against his own period's incipient industrial assault upon the androgynous coherence of the human soul (Monos and Una are, clearly, the masculine and feminine components of "One"), Poe described the world the robber barons were to construct half a century later: "huge smoking cities arose, innumerable. Green leaves shrank before the hot breath of furnaces. The fair face of Nature was deformed as with the ravages of some loathsome disease." A "diseased commotion, moral and physical" had descended upon humanity, creating a world governed only by the "rectangular obscenities" of science. These developments had caused the tragic separation of Monos and Una, the splitting of the androgynous soul into its gendered components. Poe saw this "utilitarian" world as "infected with system," and incapable of apprehending the central truths of being which "could only be reached by that *analogy* which speaks in proof-tones to the imagination alone, and to the unaided reason bears no weight" (444–51).

The art of the American tonalists was grounded in a similar sense of lamentation for the harmonies of a world whose time was past. They, too, believed that in the lines and volumes of the natural world, in the moods of nature, the artist could find profound analogues to every human state of mind. They strove therefore to make their paintings into harmonious, unified expressions—into what Alfred Stieglitz thirty years later would call "equivalents"—of what they thought to be nature's fundamental role in organizing the organic coherence of the person's perceptual capacities. They sought to make their paintings express what it meant to be "one" with nature. Their paintings were road maps

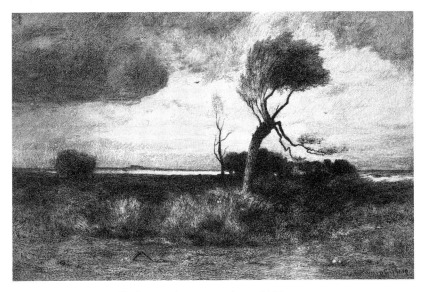

4. Robert Swain Gifford, *Near the Coast*, etching, 1885.

for the soul's return to the preindustrial harmonies of Monos and Una. Only a return to nature's ways, as Poe had argued, only a return to humanity's fundamental recognition of the unity and coherence of all being within the context of material reality would be able to reunite the separated halves of humanity, the soul-partners Monos and Una.

Thus, because at first the industrialists of the late nineteenth century did not have much interest in American art, the "feminine element"— Una's side—of American culture continued to flourish in a quiet, "conservative" coalition of clergy, women, and artists who had continued to preside over the transitional phase of American culture, and who had clearly come to share Poe's sense of longing for an older, preindustrial society of gender harmony. The tonalist sensibility in American art, a longing for spiritual wholeness seemingly no longer relevant in the modern world, was characterized by an elegiac style of painting in search of what Wanda Corn has felicitously termed "the color of mood."

Painters in this movement tended to concentrate on landscapes that seemed representative of a natural world, becalmed, but as if ravaged by the unseen yet lingering fury of a passing storm, as in Robert Swain Gifford's remarkable *Near the Coast* of 1885 (fig. 4). Harvey Otis Young painted the dangers of settlers about to be caught in the stormy darknesses of unexplored territory in his *Colorado Encampment* (fig. 5), while William Trost Richards, in his *February* of 1887 (fig. 6), seemed deter-

5. Harvey Otis Young, *Colorado Encampment*, ca. 1885.

6. William Trost Richards, *February*, 1887.

mined to add winter to the opening lines of Poe's "Fall of the House of Usher": "During the whole of a dull, dark, and soundless day in the autumn of the year, when the clouds hung oppressively low in the heavens, I had been passing alone, on horseback, through a singularly dreary tract of country, and at length found myself, as the shades of evening drew on, within view of the melancholy House of Usher" (231).

Others, like the young Arthur Wesley Dow, as in his contribution to the display of works by "American Americans" at the Paris World's Fair of 1889, *At Evening* (fig. 2), still sought to paint the harmonious inner balance of the human community as it nestled in nature. But this was

7. William Anderson Coffin, *First Dawn*, ca. 1897.

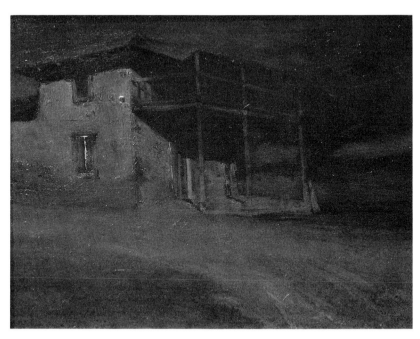

8. Charles Rollo Peters, *Monterey Customs House*, 1904.

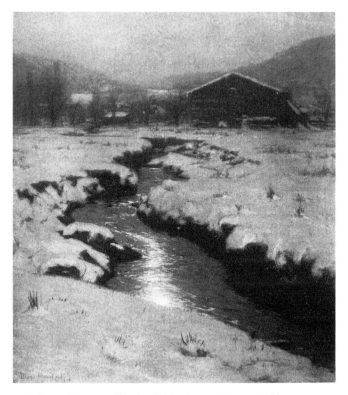

9. Birge Harrison, *Woodstock Meadows in Winter*, 1909.

a community fading into the darkling, brooding uncertainties of a world in isolation and decline on the edge of the modern city. William Anderson Coffin, in paintings such as *First Dawn* of 1897 (fig. 7) still found an eerie, blue-gray glow warming the isolated houses of a new suburban world. His "conservative" emphasis on sharp outline was to blend seamlessly into the "modernist" inspiration of "precisionist" painters such as Charles Sheeler, several decades later. Charles Rollo Peters, as in his *Monterey Customs House* of 1904 (fig. 8), specialized in painting the widening distances between his viewers and the dim light of community still beckoning from a single warm window opened to the night air in windswept adobes huddled against darkness.

The tonalists often brooded over this world of edges—leaving each individual viewer to define the emotions we feel as nature blankets us in cold isolation, as Birge Harrison does in his *Woodstock Meadows in Winter* (fig. 9), a work that brings the insecurities of Peters's West to

rural New York State and seems to announce to the viewer that henceforth we must forever stand alone at evening, isolated and chilled in our separation from human society, warmed only by the distant light of a fading moon.

These paintings describe that point of being in one's experience of nature when one loses or gains, as Poe described it in his "Colloqui of Monos and Una," one's "idea of contact" with the world, and when "all of what man has termed sense [is] merged in the sole consciousness of entity, and in the one abiding sentiment of duration," until finally even "the idea of entity [becomes] merged in that of place," and "consciousness of *being*" grows "hourly more indistinct, and that of mere *locality* . . . , in great measure, usurp[s] its position" (450). The tonalists, then, tried to delineate exactly what O'Keeffe was able to capture in her painting of the Fifty-ninth Street studio: that creative exhilaration of the senses Poe saw as the gateway to the material reunification of Monos and Una, the sundered halves of humanity's pregendered wholeness, when intellect and body are in harmony, when "the idea of entity" becomes "merged in that of *place*."

In the work of the tonalists, the optimism of Emerson's speculations about the progressive blending of nature and human culture into an empire of mind had met the pessimism of Poe's fears about the "rectangular obscenities" of the burgeoning industrial world. Theirs was therefore basically a still nongendered visual language depicting the harmonious equivalence between one's state of mind and one's sense of the material world—of the body. The tonalists clearly intuited the waning of an earlier America's dreams of a nongendered culture, and in their twilight world between night and day, the celebratory natural world of the transcendentalists and the Emersonian Oversoul was caught in the nightfall of forgetting. Harmonies that Poe saw falling apart into the artificially gendered distances between Monos and Una, orchestrated by the rapacious needs of the bourgeoisie, were reduced in their work to the light falling, from a distance, over the ghostly soul of a nature expelled from human consciousness.

Tonalism, then, was still rooted primarily in a middle ground of late-nineteenth-century American culture between the humane, contemplative sensibilities of the strong women who had "feminized" the New World, and the territory covered by the numerous idiosyncratic pantheistic naturist philosophies that grew like wildflowers among the men who had tried to cope with their existential isolation within the vast,

silent stretches of nature along the nation's ever expanding frontier. But the tonalists' characteristically "American" mind/body analogues were no longer of interest to most of the "men of action" who were beginning to dominate the American scene toward the turn of the century. These men were far more interested in designing a world in which the stern supermasculinity of a highly evolved Aryan intellect would finally triumph over the effeminate emotionalism of nature. Ambitions of this sort had already been reconfigured into scientific imperatives of fundamental biological gender difference, just around the time the tonalists were able to gain their greatest measure of popular visibility.

As the frontier was closing, this ever intensifying philosophy of gender difference was beginning to overtake the more complex, intellectually fluid cultural environment of earlier years. The tonalists had still—largely unconsciously—celebrated what they were losing: the "female" side of their being, what Poe had seen as the "pure contemplative spirit" that "could have led us gently back to Beauty, to Nature, and to Life" (446). Their links to the philosophical idiosyncrasies of the American midcentury, in turn, made their work recognizably different from (though certainly philosophically related to) the many other elegiac, "tonal" styles of painting indebted to Barbizon and popular throughout European culture at about the same time. But even then the differences between the American style and the various European analogues were clearly recognizable to most observers. The idiosyncratic nature of American tonalism made the critics and the robber barons newly in search of a "native" art of international caliber eager to recognize its thoroughly "American" qualities.

The somewhat "effeminate" emotional "subjectivity" of the style, however, continued to pose something of a problem. The ideologues of gender had, by the 1890s, conclusively categorized "mind," the realm of the intellect and of creativity, as exclusively masculine, while "body," the realm of the emotions, of physical being, of sensuality, materialism, reproduction, and seduction, had become the stomping ground of feminine "reproductive" being. To become fully worthy of the robber barons' economic attention, the "Americanist" muscle of tonalist art therefore clearly needed further toning.

IV

Adding Muscle to
American Art

The task of theorizing tonalism into a style with enough mental muscle to be worthy of the supermasculine money makers who became its champions fell to the generation of critics who had succeeded Sheldon, Koehler, and Benjamin. Their descriptive language helped retool this quiet art into a visual food fit for the eyes of men. Among them Charles H. Caffin had, with the opening of the new century, become one of the most prominent, and most widely read. Caffin, one of Alfred Stieglitz's favorite critics, and soon to become a perennial habitué of the pages of *Camera Work*, delineated the matter starkly while discussing the works of Homer Dodge Martin in his book *American Masters of Painting* (1902).

Though this artist had been a jovial fellow during his lifetime (he had died in 1897), "the bigness of Martin," Caffin remarked, "was principally that of a big intellect." Clearly his work was particularly suited to the new era of evolutionary masculinity, for "to be big with seriousness in season, and big with sportiveness betimes, is the quality of an extra large-souled man. Of a man, indeed; for the quality is essentially a masculine one, and rare even among men, particularly in art, so large a portion of which is feminine in significance." That latter aspect, Caffin continued, "is the latent reason of so much indifference toward pictures in this country by persons otherwise cultivated. Our past history, as well as the immediate present, has demanded qualities essentially masculine, and so many people instinctively suspect the superabundance of the feminine in painting." This was because, in the past, "the class of people" who were interested in American painters "committed itself unreservedly to that kind of picture, which is least of all the product of intellect, or likely to make any demands upon the intelligence."

As a result today's men of affairs, Caffin pointed out, unfortunately still "find incomprehensible the suggestion that a man may be found who puts into a picture as much mind and force of mind as another man puts into the upbuilding of a great business; that the qualities of mind expended in each case may be similar in degree, and not altogether different in kind; power to forecast the issue, and to labour strenuously for it, with a capacity for organization, for selecting, rejecting, and coordinating; a gift of distinguishing between essentials and non-essentials, and of converting sources of weakness into strength, so that the issue becomes in each case a monument to the intellect of its creator" (118–20).

Caffin was clearly trying to convince his readers that Americans could be "real men" even if they were painters. A new "masculinity" was about to sweep away the dry rot of the feminine sensibility that had infected most of the American art of the past. "Force of mind," "power," "organization," "strength": all these were key words in the identification of the new evolutionary elite. Tonalism, Caffin wanted the well-heeled industrial investors among his readers to know, was made for them, not for the wishy-washy souls of a previous age. Where female sentimentality had once reigned, a manly Americanism was about to triumph: "For do we pay enough heed to the essential differences that nature presents in different localities?"

Caffin had great faith in the burgeoning scientific consensus among his contemporaries that had begun to link the development of superior evolutionary masculinity with the psychosocial effects of a "Nordic" climate: "The great landscape painters," he declared categorically, "all belong to northern countries, who have lived, comparatively speaking, within the same degrees of latitude; and yet the landscapes of Holland, France, Scotland, England, Norway, and America can never be mistaken for one another. Apart from local conditions of man's handiwork, each varies in the local quality of its atmosphere—its degree of clarity or humidity, of briskness or caressingness."

A masculine climate clearly bred a masculine art: "Our landscape painters, like most other true students of nature, have found, each for himself, their own necessary and inevitable language of expression. Necessary because it originated in their own peculiar need, and inevitable because it grew out of the particular character of the portion of nature that they studied. And in most cases it is some phase of the

American landscape that has engaged the American painter, which accounts in no slight degree for the individuality of his work" (155–56).

For Caffin, the highest goal of art was to capture mind at its most creative. He was enough of a transitional figure to have disdain for the crudely materialist preoccupations of his contemporaries; the spirit of modernity was, "in fact, the very antithesis of brawn and muscle, of hard and wholesome thinking, of the *bourgeoisie* and Philistinism." Even so, it needed to be "analytical, for it is part of, or compelled by, the contemporary scientific movement" (38). Thus tonalism clearly represented the intellect of the evolutionary elite, not the fuzzy thought of the masses.

Mind rather than sentiment—individuality rather than community, a celebration of the masculine rather than a capitulation to the feminine—was to be the focus of all superior art. Caffin, prefiguring the arguments of F. T. Marinetti, attacked the decadent version of "modernity" characteristic of symbolist art as seriously contaminated by feminine traits. Unlike the "sweet and wholesome," yet brawny, art of Whistler, their art, he insisted, is "intolerant of restraint, except such as it chooses for itself; is callous when not personally interested, and finds its interest in subtleties; its faith is self-found and felt to be honored by the discovery; in scope not so much broad and embracing as diffused and discriminating; for depth it substitutes a carefulness about many things, and for sincerity a nice tactfulness. It is polished, dainty in taste and manners, seeking the essence of life in its most varified [rarified?] appeal to the senses, even sometimes in abnormal depravity" (38). Instead, a new intellectual individualism expressive of the subtleties of mind, yet keyed to the universal mechanisms of scientific understanding, was to be the future of art.

In his 1907 book, *The Story of American Painting*, Caffin again identified the earlier focus of American culture as a retrogressive capitulation to feminine concerns: "Belief in humanity is the practical religion of to-day, and it works for man's physical, material, and intellectual uplifting. But, as a motive for art, its influence is almost purely materialistic and sensuous. It is only when this new religion shall become impregnated with a correspondingly practical belief in the facts of spirit, that the possibilities of a great art in modern times will arise" (12). Caffin's imagery left no doubt that the sensuous materialism characteristic of American art was a "feminine" cultural tendency, as yet not made "whole" by having been "impregnated" by the "masculine spirituality"

to be found in great European art, and, more recently, in what he saw as the intellectual art of the tonalists.

An unstated subtext of Caffin's book was the suggestion, common among the social philosophers of his time, that American women were to blame for "a society sprawling on materialism and wallowing in ostentatious display." Given this discouraging environment American artists had, in the past, shown themselves "a little fibreless and lacking in marrow. To be candid, a similar lack of positive moderation may be charged against our annual exhibitions of native work. For there is all the difference in the world between a strong man, adjusting his output of strength to the work in hand, while holding a portion in reserve, and another whose moderation seems to be the result of not having an abundance of either force or conviction" (340).

Caffin's remarks about the "strong man's" capacity for moderation are linked directly to the turn-of-the-century scientists' obsession with the preservation of every man's "vital essence." Sexual continence, creative excellence, and intellectual superiority were directly linked, it was thought, to the male's ability to retain the "generative fluids" produced by his reproductive organs. This "vital essence," the source of all human evolution, was habitually squandered by the weak-minded (and hence, "effeminate"), but if "held in reserve" by those possessed of the proper manly moderation, it would bring out the best in any male. The issue was a vital concern, as much among turn-of-the-century art critics as among the general populace. In his *Ideals of Life in France*, for instance, even the conservative, "pro-feminine" George William Sheldon made prominent mention of "Dr. Brown-Séquard's recent discovery of the source of perpetual youth" (47). This world-famous physiologist's magic solution was a "vitalizing" potion concocted from the ground-up testes of dogs and guinea pigs.*

Few of Caffin's contemporary readers, therefore, could have misunderstood why the critic put so much emphasis on the American artist's need to develop *his* ability to be "continent," and to keep of *his* vital energies "a portion in reserve." The false gentility fostered by the feminine ambience of American culture, Caffin insisted, made it as difficult for most artists to stimulate their manhood as to cultivate their mental

* For a detailed account of Charles-Edouard Brown-Séquard's experiments and the turn of the century's obsession with "vital essence," see my book *Evil Sisters: The Threat of Female Sexuality and the Cult of Manhood* (New York, 1996), 190 ff.

continence. In the United States, he pointed out, culture was still dominated by a public "overwhelmingly composed of young girls." "Dilettanteism" was therefore rife in all the arts. "The actual plague spot of this disease centres around the relation of the sexes in literature and the use of the nude in art, but its morbid effects spread through the whole body of fiction and painting, inducing a flacid [sic] condition of self-consciousness and insincerity" (340–43). True mental fortitude, Caffin implied, could come only from the American public's willingness to give up its puritanical attempts to hide from temptation. Notions directly related to Freud's concept of sublimation were already widespread at this time, and Caffin was convinced that American culture could overcome its "young girl" mentality only if the public allowed itself to confront nudity and eroticism in art with manly fortitude. Censoring these issues would serve only to keep the arts in America in an artificial state of adolescent naïveté. The confusing complexity of the arguments surrounding the issue of what constituted "manly" sexuality is well-illustrated by the fact that a few years after Caffin published his determinedly progressive opinion concerning the constructive uses of the erotic *imagination*, F. T. Marinetti, the futurist, would, in turn, denounce the symbolists' obsession with "the naked female body" as "enfeebling" (68) and would cry, "We're sick of erotic adventures, of lechery, sentimentality, and nostalgia!" (56).

But both men were convinced that the male's supply of vital essence, properly sublimated, was the key to creativity. In the late tonalist-impressionist work of John Henry Twachtman, Caffin saw "that quality of idealism that may be said to represent the most modern note in painting." Twachtman had been able to transcend "the facts of nature" and, putting "aside the consideration of them," he "has extracted from them their essential abstract significance, so that he interprets that highest kind of sentiment, which is not a product of the individual and personal, but a whisper from the universal." The ideas of the transcendentalists clearly still echo in these remarks and therefore, paradoxically, also explain Caffin's eagerness to demonstrate the "intellectual masculinity" of the tonalists. Mere "intuition" sublimated—"abstracted"—into "the highest kind of sentiment" would become a manifestation of spiritual intelligence as the highest trait of evolutionary masculinity. Caffin's aesthetic thus reflected an American intellectual idealism that clearly occupied a position between American transcendentalism and the extreme forms of mechanistic masculinist philoso-

phizing that would characterize figures such as Marinetti. It is this quasi-religious celebration of the intellect as a source of "spiritual transcendence" that was to create a continuity between the "masculinist" aesthetics of such otherwise very differently focused personalities as Charles Caffin and Alfred Stieglitz, during the 1910s, and Clement Greenberg, with his mechanistic 1940s dogmatism about the virtues of "nonobjective" painting. Caffin even anticipated the terminology of post–World War II aesthetics: "To anyone who esteems of highest value the abstract expression in a picture, some of John H. Twachtman's landscapes are of superlative interest." But Greenberg would have smirked at the transcendentalist residues in Caffin's claim that Twachtman's work "represents the effort of the artist to free himself from the material, by giving expression to the spirit that abides in matter" (281–82). Greenberg was to see the virtue of abstraction as residing in its capacity to reflect the structures of the intellect unaided by "intuition."

But for Caffin, who was, no doubt, influenced by the evolutionist aesthetic of Henri Bergson, it was up to the real men among American painters to transcend the vulgar effeminacy of their obsession with mere nature in a conflation of science and true spirituality (which had conveniently come to be classified as part of "mind"—not of intuition—within the context of the evolutionists' new system of fundamental biological divergences between the sexes). Thus by giving voice to "the spirit," the artist would be able to transcend the vulgarities of the natural world (the realm of "the feminine"). In this manner Caffin had managed to "masculinize" creativity and strip it of the "pregendered," androgynous ideal that still informed Poe's imagery of the harmonious soul-unity of Monos and Una. By doing so he succeeded in "masculinizing" the work of the tonalists he admired, even though their art was clearly in direct opposition to what Poe had called the "harsh mathematical reason of the schools" (446), the new mechanistic philosophies that celebrated science and industrialism as the finest expression of the masculine intellect.

Indeed, the issue of the "intellectual" content of art was on everyone's mind as O'Keeffe was growing up. In the years around 1900, for instance, the work of the impressionists, whether European or "native," was often criticized, not because it was considered too "experimental," but because it was too "vulgar," too materialistic, too concerned with what Caffin had called "the facts of nature." Its popular manifestations, critics maintained, spoke primarily to the material well-being of

wealthy bourgeois women, for these were, after all, the style's main champions. An anonymous "New York Letter" in the May 1900 issue of *Brush and Pencil*, at this time the leading American art magazine, used a snide allusion to the "vital essence" theory to comment ironically on the current exhibition of the foremost group of American impressionists known as "The Ten." Their "whole performance," the writer commented, was "marked by a poverty of intellectual expression, little gray matter having been expended on any composition there" (82). This cannot be dismissed as the ignorant commentary of a hidebound academician, for this critic had no difficulty in identifying a group of Monet's studies of the Rouen cathedral, being sold by the American Art Association at the same time, as "wonderful affairs in the matter of light" that "make everything about them seem dull, lifeless, and commonplace" (83).

Impressionism was a "foreign import," and though most critics of the turn of the century recognized its importance, it continued to represent the rule of Europe to a public eager to discover "native" roots. In an essay exposing the "Alien Element in American Art," published in the October 1900 issue of *Brush and Pencil*, Ellis Clarke expressed the American art nationalists' disappointment with the U.S. art exhibit at the Paris Exposition: "Despite the extent and excellence of the exhibit, there remains the somewhat depressing fact that its works in the main are not national, do not exemplify the American spirit or reflect American life." Clarke found the representation of 1900 "better, as a whole, than that of 1889, but it is no less un-American, no less untrue to national ideals and national temperament."

Clarke's confidence in the United States' future as a world power made him particularly testy about the shortcomings of the Frenchified Americans at the Paris exposition: "A national art is not the mere vague vaporing of country-tied enthusiasm. Be it in figure painting or in landscape, it is the prerequisite of the highest attainments." Out with the alien was his message: "A purely imitative art will never be a great art." Imitation, of course, was another of those practices the evolutionists had classified as distinctly "feminine" in quality. America was the world of the new, of invention, of the fiercely independent. Clarke's appeal to the artists to "paint America" grew prophetic: "While I write I look out on a deep ravine of street a mile or more in length, flanked on either side by massive banks of buildings rising to varied heights of ten or fifteen stories. The sun has set in a lurid haze of smoke and

cloud; lights flash from a thousand windows along this artificial defile; strong shadows screen the current of struggling life that surges along its paved bottom. Everything is obscure, gigantic, suggestive of the awe-inspiring, even the terrible, and yet flecked with a certain glow, half genial half sardonic. It is a sort of commercial Inferno."

This extraordinary passage anticipates the focus, and even the language, of Marinetti's 1909 "Manifesto of Futurism" by nearly a decade: "We will sing of great crowds excited by work, by pleasure, and by riot; we will sing of the multicolored, polyphonic tides of revolution in the modern capitals; we will sing of the vibrant nightly fervor of arsenals and shipyards blazing with violent electric moons; greedy railway stations that devour smoke-plumed serpents; factories hung on clouds by the crooked lines of their smoke; bridges that stride the rivers like giant gymnasts, flashing in the sun with a glitter of knives; adventurous steamers that sniff the horizon; deep-chested locomotives whose wheels paw the tracks like the hooves of enormous steel horses bridled by tubing; and the sleek flight of planes whose propellers chatter in the wind like banners and seem to cheer like an enthusiastic crowd" (42).

Marinetti himself had clearly learned much from the cadences of Whitman's poetry, but his mechanistic celebration of industry and technology was quite different from Whitman's democratic purpose. In the much less aggressive framework of Clarke's description, a world of difference between early-twentieth-century European and American attitudes toward the new industrial environment lies hidden. Where Marinetti's rhetoric prefigures the extremist masculinism of fascism, Clarke's descriptions try to discover a far more complex continuity between the rural past and the industrial future. Thus his remarks prefigure the developments of several decades of twentieth-century American art, from Stieglitz's photographs of Manhattan of a few years later to O'Keeffe's *East River* paintings of the late twenties—with the urban concerns of the ashcan school and the precisionists' depiction of industrial structures as having an almost "sentient" quality all wedged between.

Clarke lucidly forecast the "tonalist" residues, the emotional and intellectual ambiguities, that would continue to inform the work of these Americans: "This scene—and there are thousands similar in our great cities—is real and near at hand. Yet no artist has caught its spirit or even given a hint on canvas of its strange mingling of solitude and strife, its lights and shadows, its checkered gloom, its mystery; no artist has suggested how it touches the heart, now inspiring it with a sense of

indomitable human energy, and again depressing it with anguish akin to what one feels in a wilderness" (35–47).

Like Caffin and many others among his contemporaries, Clarke saw a direct line of true "Americanism" stretching from the landscape painting of George Inness and the tonalism of Crane, Tryon, Harrison, and Coffin to the urban art that was bound to come. Though he placed his emphasis on subject matter, not on style, his implication was clearly that from Bouguereau to the impressionists, the French influence had been an "alien" intrusion, a diversion that had kept his countrymen from depicting those things that were most central to the American soul. But things were certain to change, for as Melville Wright, another *Brush and Pencil* critic, said in the February 1901 issue, there were "now American artists whose names are comparatively unfamiliar to the public who are doing work in no sense inferior to that of certain European artists whose names are household words" (276).

Even so, William Merritt Chase, Edmund Tarbell, Frank Benson, and Robert Reid—all members of The Ten (actually "The Ten Americans")—and numerous other artists in the impressionist style, became very successful, particularly after 1900. Indeed, American impressionist painting turned into a popular vogue during the 1910s, and impressionists came to rule the yearly exhibitions of contemporary art. It thus predictably turned into the style to despise for most of the younger painters influenced by the Armory Show of 1913. Many painters who had started out in a tonalist mode—though without fully understanding its moods—soon shifted over to the cheery materialism of the impressionists. Among the more adventurous American artists, however, the nationalist mood of the country during the first decade of the twentieth century continued to express itself in a search for stylistic *liberation* from Europe—not, as has often been assumed, in belated attempts to "catch up" with the Europeans.

Issues of gender difference were on everyone's mind at the start of the twentieth century. The "Americanist" quotient of "native" art therefore came to be praised or condemned more and more in terms of its "gendered" qualities. The early decades of twentieth-century culture were, in ideological terms, largely an acting out of the "new manhood" philosophy espoused by the ruling group of "native Americans" (the term the Anglo-Dutch elite of the period liked to use to identify themselves). As Jackson Lears notes in *No Place of Grace*, "crusades for physical vigor swept the educated bourgeoisie in both Europe and America. By 1900,

the *Atlantic Monthly* noticed 'a sort of satiety of civilization, which is leading in all the departments of life to a temporary reversal of the softening of manners made during the century. The revived love of war is not an isolated phenomenon.' Martial bellicosity paralleled the growing enthusiasm for boxing, football, bicycling and outdoor life in general" (107–8). Soon the "feminine" component in American culture would find itself in full retreat.

The elite, in its search for evidences of creative "vitality" in American art, therefore began to focus ever more intently on its "mentality." Percival Pollard, for instance, in his book *Their Day in Court* (1909), while discussing the topic "Women, Womanists, and Manners," insisted that "one can never assert often enough that American art is essentially feminine" (34), reiterating Caffin's objections of a few years earlier. This censure of the lack of manly energies in "native" culture was repeated over and over among those dissatisfied with the bulk of the work being exhibited at the numerous annuals that had sprung up all over the country. On the other hand, claims about the manly qualities of the work of favored artists became legion. In their little book *Aims and Ideals of Representative American Painters* (1901), for instance, John Rummell and E. M. Berlin emphasized that George Inness "has exerted a strong influence on the present generation of American landscape-painters, who, without imitating him directly, have acquired much of his virility and his breadth of vision" (43).

Even among the acknowledged tonalist masters the new cult of virility intruded, making them self-conscious about what was now increasingly seen as a problematic mix of "male" and "female" elements in their art that now began to cast an element of self-doubt over their life's work. In his *Art Talks with Henry Ward Ranger* (1914), for instance, Ralcy Husted Bell, the artist's Boswell, recorded Ranger's personal doubts about the masculinity quotient of his art as compared to the achievements of the "real men" who had civilized the American wilderness: "Sometimes I feel that I, a poor descendant of these men, mark a decadence by merely painting amidst the scenes of their heroic labours instead of doing more virile work" (82).

When we try to determine the various influences that helped to make O'Keeffe's art such a quintessentially American visual language, a knowledge of these undercurrents of gender ideology at the turn of the century is crucial. She spent her childhood, and grew to adulthood, in a world of ever increasing gender-political dichotomies. This was a

period in which instruction at the American art schools was still very conservative and focused on art as a tool for the inculcation of moral precepts: a core of what the sophisticates of the turn of the century had learned to identify as "feminized" art. This work concentrated on genre, anecdote, and pious religious imagery but also included narratives of humane social concern. Such work had still remained the staple of middle America's taste for art.

But the new industrial millionaires' lavish expenditures on French Salon paintings were becoming instrumental in establishing the field of art as a potentially very lucrative career path for even the most ambitious young artistic entrepreneurs. In 1887, the year of O'Keeffe's birth, Rosa Bonheur's *The Horse Fair* had brought $53,000 at auction, a record price, topped only by Meissonier's *1807*, which sold for $60,000, the highest price ever paid for an oil painting in the United States. These were phenomenal sums for that time and, as gestures of conspicuous consumption, entirely comparable to the multimillion-dollar prices being paid today for the privilege of owning works by the heroes of abstract expressionism—prices even O'Keeffe's own most-sought-after works have yet to match.

Such record prices had made it easy to convince many Americans that being an artist could be a very dignified and manly career. A generation of artists—led by William Merritt Chase—began to cultivate a public presence not unlike that of the successful European painters. The ever -growing roster of Americans seeking instruction at the Paris art schools had, by 1890, even led to vocal complaints from French students, who claimed that they were being crowded out by these foreign invaders—many of whom were women. Whistler, Sargent, and numerous other expatriates inspired a host of younger artists to crowd the American annuals with European-styled society portraits in the grand manner, as well as with nudes of the sort Caffin hoped would help emancipate the American art scene from its prissy feminine focus.

As we have seen, however, the "internationalism" of these artists increasingly ran into opposition from critics in search of an American art with indigenous virtues. In her very thorough and informative study *American Art at the Nineteenth-Century Paris Salons* Lois Fink has speculated that these critics' increasing demand for "virile" forms of expression "suggests an approach based on the exterior, material world, on 'realist' art rather than on subjective expressions of form or feeling. Thus, to associate the 'virile' and 'manly' with true American qualities

was to approve of art recognizable to all in form and content, and to deny the validity of imaginative, ambiguous, or individualistic approaches" (287). But as the prominent turn-of-the-century art critic Leila Mechlin made clear in an article for the June 1906 issue of *Cosmopolitan Magazine*, if "a decade ago the paintings which were given most homage were those which either told a story or gave expression to some grandiose effect," in recent years, "throwing off the shackles of imitation [American painters] have entered a broader field and become not copiers but interpreters of nature" (178).

Thus, as Caffin's comments also make clear, the attitude of the American art establishment had, at least by 1900, become far more complex than Fink's comments would suggest. The critics had long ceased to be interested in upholding a narrowly "realist" position. Most of the art public had by then come to associate "genre" and "materialism" with the "vulgarity" of "feminine" concerns, and had begun to seek out symbolist or "philosophical" themes. They were eagerly on the lookout for "originality." But the "virility" they wanted to see should express "the spiritual" as it manifested itself in "local" values. Henry Ward Ranger made this point repeatedly in Bell's *Art Talks*: "All landscapes that have been well painted are those in which the painter feels the influence of the hand of man and generations of labour. I think this is one reason why no man has made a success in painting outside his own country. For no matter how well he knows a foreign land superficially, he must still remain an alien" (81).

The dominant sentiment that had developed in American culture, as O'Keeffe was becoming conscious of the art world around her, was that true individualism—and hence true artistry (which was more and more held to be an exclusively masculine trait)—was a factor of "the spirit of place" and hence accessible only to those who understood that "the local is the only universal." As we have seen, these favorite slogans of such eager early modernists as William Carlos Williams and the painters of the Stieglitz circle had already become prominent notions within the American cultural environment well before the turn of the century.

Many critics writing from a post–World War II perspective have come to regard O'Keeffe's patent refusal to adopt the mechanistic tenets of the early-twentieth-century European avant-garde as indicative of her failure as a "genuine" modernist. The effects of the burgeoning gender ideologies of the early decades of this century echo loudly through

such assumptions. The growing international popularity of biological theories concerning the sexes' fundamentally different evolutionary trajectories was to establish a useful new gender-ideological format for what was initially little more than a conventional generational struggle in the art world. The "reactionary, feminine" values of "sentimental realism" were about to be overrun by the "tough, progressive masculinity" of the new avant-garde.

O'Keeffe's mature work, though indelibly shaped by this conflict, came to stand largely outside of it. She cared not a whit for theories. Ideas of gender separation made little sense to her as guidelines for the creation of art. Her work was always, first and foremost, a celebration of the immediacy of sense experience. It was a tribute, not to jingoistic, politicized theories of place, but to the organic sense of connectedness she experienced with the natural environment in which she had grown up. The sense of being that develops in us through our apprehension of, and ever growing familiarity with, the unique textures, volumes, and lines that characterize the locality in which we live became her principal subject matter. She understood that place—whether we like it or not—supplies us with the raw materials for the grammar of our emotions. As such, her work expresses that sense of "the spirit in the material" Caffin had recognized in the work of Twachtman. Her work is the essence of what Edgar Allan Poe had described as sense experience "merged in the sole consciousness of entity," and subsequently also "in that of place." The antecedents of her art are *not* in European modernism, but in the "pregendered" cultural concerns of nineteenth-century American art.

The environment she grew up in was increasingly conflicted about the significance of that background, but even so still strongly influenced by the dreams of a preindustrial generation that had sought social and personal wholeness in nature. O'Keeffe was, like Poe, an intuitive dialectical thinker in an increasingly dualistic (and mechanistic) cultural environment. Her art is sensuous, not "spiritual." Yet through it the pandemocratic theology of the transcendentalists still echoes. Like Poe she disdained the crass economic opportunism of the industrialists and the domestic divisions of labor—of gender-based "aptitudes"—instituted by the bourgeoisie.

O'Keeffe's best work, therefore, is poised, like that of the tonalists who helped create her artistic sensibility, in a realm beyond both the imperialist jingoism of the evolutionists and the self-consciously intellectual and "manly" individualism of the European early modernist

avant-garde. The personal style she developed was constructed from the elements of her American cultural background, but she also took freely from the heady mix of early modernist impulses swirling about her during her New York years. In the process she learned to capture what Poe, in his "Colloqui of Monos and Una," had identified as the "physical pleasure," the "sensual delight immeasurable" we experience when perception and being merge—when we cease to equate aggression with experience and simply let ourselves *see*.

V

The Body in the Landscape

To be a child in the rural midwestern United States is to grow up in a world of sharply etched horizons, sudden storms, and fields of color. In winter, rust-bitten greens and browns and yellows, and pale, scratchy patterns of frost on your knees. Above you white clouds in stone-blue skies, or murky grays, and relentlessly advancing walls of darkness pulsating with lightning and rain to make you run all the way home. In summer, skies in ever shifting hues of blue that weigh on your shoulders and push your feet into dry clumps of old tilled earth. They make you stumble and roll into the yellow-green grass, until you relax and let the warm ground print its messages into your back.

You sense the pressure of the blue sky as it rocks slowly back and forth over your body. The world of edges disappears into the fuzzy reddish half-light of your drowsy eyes, and suddenly you no longer know what is you and what is not. Tentatively you move your legs and a sharp twig scratches your skin. You open your eyes and just above you, wedged against the blue sky, in a huge expanse of red and inky black and fuzzy yellow, floats a poppy on its stem. Without knowing it, you have just learned almost everything there is to know about nature, yourself, and life. Truth is the soil against your fingertips, and reality an alphabet of edges folded against the horizon. Most rural midwesterners have turned from such experiences to religion. Georgia O'Keeffe turned to art.

When you learn so much, so young, about the textures of nature, words must always remain inadequate vehicles of communication, pretentious and inexact. "I do not care for poetry," O'Keeffe once remarked, late in life. "It is almost a complete blind spot for me."* She was as American as she could be in her fundamental distrust of lan-

* In a personal letter to the author dated May 3, 1965.

guage. The volumes, edges, textures, and sounds of the material world were the only language she trusted. That is why she became a painter.

Most Americans believe that there is something of God, or the Goddess, within them. Many are confident that nature is a message from God, that God is in nature. O'Keeffe believed that all we know is the truth we are told by our senses. For her the organic world and the self were coextensive. She hoped that by delineating the discoveries of her senses, she might be able to demonstrate to others that God is the material texture of life. The meaning of life, to her, was a festive, nonprescriptive being-in-the-world. The forms of nature were the catechism of her religion. To paint was to celebrate life and defy the false restrictions we impose on our being in our meager attempts to give ourselves goals. She refused to accept the lies of the language we use to limit ourselves.

In other words, O'Keeffe was not a mystic—she was a humanist and a realist. She had little patience for those who let their lives be guided by illusory long-range goals, or by theories about the way things ought to be. To express the beauty of sense experience was goal enough for her. This confidence in the self-sufficiency of material being, this transcendental materialism—a simple step beyond Poe's pantheistic sense of the "sentient" correspondences between all things in nature—is central to what, as we have seen, is perhaps most American in art: the artist's faith in the material integrity of organic reality as a medium of primary communication between the self and what is other. Most of the principles underlying O'Keeffe's art can readily be found in the work of many of the American artists who had preceded the tonalists: in the mountain ridges of Thomas Cole, in the sharply etched echoes of light that serve to modulate volume in the misty harbors of Fitz Hugh Lane or in the contrasts of darkness and luminescence that roll over the marshes of Martin Johnson Heade.

Heade's odes to single flowers, white or red with a few green leaves on fragile stems, have such a connection as well—whether or not O'Keeffe ever saw them. There can, in any case, be no question that she would have seen some of the popular chromolithographs that brought color to virtually every American farm and middle-class home during the late nineteenth century. O'Keeffe herself vividly remembered that, as a child, she worked from a drawing book published by Louis Prang, the mogul of popular chromolithography. A skilled

10. William Sharp, *American Water Lily* [*Victoria Regia: Complete Bloom*], 1854. Collection, Hirschl & Adler Galleries, New York.

entrepreneur, Prang sold books of art instruction to help merchandise his own products.

American Water Lily, by William Sharp, and printed by his own company in 1854, is a characteristic example of the genre, which often also included Heade-like close-ups of flowers (fig. 10). The chromolithographic process permitted the use of relatively ungarish, painterly color shading in conjunction with fairly subtle gradations of line and texture—details that at this time could otherwise be obtained only through the lithographic printing process. These chromos were the precursors of the poster-sized photographic color reproductions of paintings so popular in our own time. Their slightly glossy surface (not unlike the texture of a color photocopy) could make the petals of flowers seem to have the iridescent texture of human skin. O'Keeffe remembered copying a print of large red roses. Such images undoubtedly gave O'Keeffe her first indications of how nature could be reproduced on a two-dimensional surface.

In the world of sharply delineated surfaces and textures, of edges and outlines, that had been opened up to mass consumption during the years of O'Keeffe's childhood by the invention of the halftone process

11. Pitcher and Manda, photographers, *A Golden Lily*,
ca. 1895.

for the reproduction of photographs, she also undoubtedly fondly
pored over some of the flower close-ups the new popular illustrated
magazines had begun to publish. In such pictures as those she might
have seen in the February 1895 issue of the *Monthly Illustrator*, ac-
companying Charles Abbott's article titled "The Beauty of the Lilies"
(fig. 11), the issues of form and line that were to capture O'Keeffe's
attention as a mature painter find themselves dramatically anticipated.

Though the tonalist art of the 1890s was far too delicate in its color
nuances and its persistent exploration of the emotional ambiguities of
darkness to lend itself to inclusion among the popular themes of chro-
molithography, examples of the style were frequently reproduced in the
period between 1880 and 1915, in illustrated monthly magazines such
as *Harper's*, *Scribner's* and the *Century*. Lavish coffee-table books such as
S. R. Koehler's *American Art* (1886) often printed original etchings pro-
duced by the artists themselves. R. Swain Gifford's version of his paint-
ing *Near the Coast* (see fig. 4) is an excellent example. In addition many

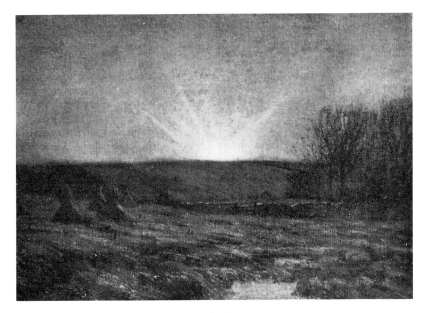

12. Bruce Crane, *Frosty Morning*, ca. 1904.

publishers had begun to use halftone reproductions just around the time O'Keeffe became fascinated with images. The dramatic changes in the realm of visual media caused by these new photoreproductive processes were, in historical terms, at least as significant in separating the visual world of the young from that of their elders as those caused by the introduction of television were to be half a century later.

Nuances of white, gray, and snowlike pale blue are frequently essential elements in O'Keeffe's mature compositions. In the popular magazines as well as the expensive coffee-table art books of the 1890s, tonalist works that focused on such nuances—perhaps because they worked so well in black and white—were among the works most frequently reproduced. Even in mass-produced magazines such as *Brush and Pencil* works such as Bruce Crane's *Frosty Morning* (fig. 12) evoked atmospheric effects very similar to those later to be found in O'Keeffe's paintings as well.

To argue that O'Keeffe might not have seen such illustrations would be like arguing that an eight-year-old of the early 1950s would not have been interested in television. It would have been virtually impossible for a young American fascinated with the forms of the material world

not to have encountered analogous images in the media at the turn of the century. Moreover, no one can doubt that, even in her early teens, O'Keeffe must already have been an intensely alert observer of the visual world around her. The pervasive emphasis placed on the fundamentally *American* qualities of the tonalists' art guaranteed that these works would become an essential feature of the cultural consciousness of virtually every earlier-twentieth-century American modernist painter. They were also reproduced more and more frequently in the phenomenally detailed and very expensive Goupil photogravure process, used, like the etchings, almost exclusively for oversize art books. But their greatest currency came though halftone reproductions for the popular magazines. Still, in whatever form early American modernists such as O'Keeffe and Arthur Dove first encountered the art of the tonalists, they must have recognized in these subtle, haunting images, to a far greater extent than art historians have been willing to recognize, a truly unique "American" focus on nature as the abstract language of the human emotions.

The Landscape in
the Body:
John Vanderpoel

We tend to admire most vividly in others what we know we cannot have, or do, or be ourselves. O'Keeffe was fortunate in encountering among her first professional drawing teachers John Vanderpoel, who had been tragically crippled in a fall when he was fourteen, and who, perhaps because of this, had chosen to devote his life as an artist to the worship of physical perfection. In his work he sought to convey to others his conviction that the glory of the human body was material evidence of the divinity of the soul. In the body he had discovered direct visual analogues to every aspect of the creative yearning he sensed within himself. O'Keeffe was only eighteen when she began to attend Vanderpoel's lectures at the Art Institute of Chicago in 1905–6, but she was already eager to learn how she might express herself through the textures of America. She had felt the landscape in her body. Now Vanderpoel's passion for the body opened her eyes to the mysterious emotional intangibles of volume and line.

Her teacher was able to recognize the universe in the curvature of a woman's mouth. He had seen echoes of eternity in the shadows of bone etched into a man's shoulder. Each body was to him a symphony of graceful movement, a world of pure form to be revealed to the eye by the artist, who was a voyager into sacred territory, charting in line and volume a topography of the soul's intuitions of meaning. The human body had been carved out of the raw materials of nature by the tempestuous ring dance of time. Vanderpoel believed that by faithfully recording the prismatic refractions of light on skin, and the resulting multiplicities of color, tone, and texture, he might be able to make humanity see its high aesthetic purpose. The body was, to him, a grammar

of forms, a secret language encoded by nature. He believed that once we learned to read its messages, it would reveal to us the sacred meaning of our yearning for beauty. Each of its curves was a coherent expression of the spirit—an embodiment of the most profound truths of the human soul. His faith in the glory of physical being represented the humanist essence of transcendental materialism as a tendency in American thought.

Vanderpoel's love affair with the body unquestionably had certain elements in common with the ever burgeoning *mens sana in corpore sano* mentality of the turn of the century's evolutionists. But their new mathematics of amelioration was intent upon codifying the stages of qualitative development each human being had to pass through in order to become part of the evolutionary elite. Their theories of physical perfection were censorious and fiercely exclusionist, expressive of the linear false reasoning Poe blamed for obscuring the organic correspondences between selfhood and nature. In his "Colloqui of Monos and Una" Poe described the new "scientific" man, in "childish exultation at his acquired and still increasing dominion over her elements," as eager to destroy the unity of an idyllic preindustrial nature straight out of Jean-Jacques Rousseau—an era of "holy, august and blissful days, when blue rivers ran undammed, between hills unhewn, into far forest solitudes, primeval, odorous, and unexplored."

Vanderpoel's focus, in contrast, was directly related to Poe's concept of a dialectics of organic being based on the fundamental interconnectedness of Nature (representing what he saw as the "feminine, intuitive" element of selfhood) and ratiocination (the "masculine, analytical" element). Self-conscious being could, Poe had insisted, "only be reached by that *analogy* which speaks in proof-tones to the imagination alone, and to the unaided reason bears no weight." The specter of scientific dualism Poe had denounced as he saw it unfolding around him had already usurped the world in which Vanderpoel was fighting a rearguard battle for Poe's dialectics of organic analogy. His homage to the human figure was about to be swept away in the dualistic, pseudoscientific rhetoric of early-twentieth-century avant-garde theory, with its belief in an art that could "improve" on nature, and its correspondent hostility to "natural form," soon to culminate in Marinetti's futurist diatribes against the nude in art.

Poe's "horror" tales were intended to illustrate modern man's chronic inability to recognize nature as the material embodiment of the androg-

ynous, nongendered soul. His female characters were symbolic repre-
sentations of its "feminine" elements, submerged in the intuitive apper-
ceptions of his narrators, but unrecognized as such by them. Twentieth-
century readers, influenced by the late nineteenth century's vogue for
depictions of the (Aryan) male's heroic "spiritual" transcendence of
woman's "vulgar reproductive materialism," have continued to mis-
understand the positive symbolic function of these female characters
and, in accord with that period's theories of gender dimorphism, have
instead come to see them as vampires.

Baudelaire's erotic obsession with women as man-eating flowers of
evil whose seductive beauty dramatized the evils of female sexuality had
made him interpret Poe's creative and intellectual women as sisters to
the horrific vampire-women who haunted his own fantasies. But Poe
would have seen his French follower's focus on the erotic power of such
women as evidence of a delusive mentality of the sort also exhibited by
Roderick Usher, whose progressive dissociation from nature had cast
him into the madness of "pure abstraction." Poe's benighted narrators
always found themselves adrift in terror because they were unable to
perceive the truths of nature. They could escape the dark, dualistic
morass of antimaterialist metaphysics only through the intercession of
a Morella, a Madeline, or a Ligeia: emanations of the soul, imperfectly
suppressed memories of the androgynous sources of being, "come back
from the dead."

Poe's romantic, preindustrial search for the elemental harmony of
being was thus based on the conviction that "man" had *deteriorated*, not
"evolved," in growing apart from what he saw as the pregendered (and
hence androgynous) harmonies that united the "masculine" and "femi-
nine" elements of the human soul. This aspect of his thinking is most
clearly expressed in his symbolic narrative "Eleonora." As epigraph for
the story Poe used a telling quotation from the medieval philosopher
Ramon Lull: "The soul shall remain safe as long as it maintains its
proper form." Lull believed in the spiritual reunification of all humanity
under Christendom in a progressive unfolding of the truths of the soul
as manifested in the material world and organized by the intellect. Poe's
implication was clear: the travails of the soul were the subtext of his
tale. As was virtually always the case in Poe's narratives, his narrator's
soul undergoes a disastrous transformation. At first he lives harmoni-
ously "all alone" with his cousin Eleonora (though, no doubt to accom-
modate less-than-harmoniously-minded readers, chaperoned by her

mother) in the idyllic presexual childhood world of the "Valley of the Many-Colored Grass." They are one soul, manifested in two complementary material entities.

But then the catastrophe: "Hand in hand about this valley, for fifteen years, roamed I with Eleonora before Love entered into our hearts." Sexuality rears its ugly head: "We sat, locked in each other's embrace, beneath the serpent-like trees, and looked down within the waters of the river of Silence at our images therein. . . . We had drawn the god Eros from that wave." Immediately "a change fell upon all things." The flora and fauna of the valley change as the narrator changes. Nature itself is recast. The world becomes sensual: "The tints of the green carpet deepened; and when, one by one, the white daisies shrank away, there sprang up in place of them, ten by ten of the ruby-red asphodel. And life arose in our paths; for the tall flamingo, hitherto unseen, with all gay glowing birds, flaunted his scarlet plumage before us."

Evidences of fertility now begin to crop up everywhere, and they have a disastrous effect on the harmony of the soul. Almost immediately the narrator's symbolic feminine side, Eleonora, begins to wither away—much like many of the real young women of her generation (including Poe's model for this story, his own "soul mate," Virginia Clemm), who were forced to pay homage to the period's disastrous cult of virtuous feminine invalidism. Soon Eleonora recognizes that "the finger of Death was upon her bosom." The god Eros, the monster of gender-separation, has expelled the narrator from Eden, has driven him away from the female half of his soul. After she dies, "the passions" blind him even further, making him unable to understand what he has lost.

The narrator therefore soon leaves the happy valley of his presexual youth, falsely assuming that he can take Eleonora's spirit with him wherever he goes. In a city, no doubt one filled with all those rectangular obscenities of industrialism that also drove Monos and Una apart, he finds himself crudely burlesquing the soul's chaste world of nongendered unity by engaging in an "abject worship of love." He renounces even the memory of Eleonora, so that he can pursue Eros by courting Ermengarde, whose guttural Germanic name epitomized for Poe the bourgeois world's ugly, gendered deformation of the inner harmony of the natural soul. Even Eleonora's faint memory within the narrator is henceforth lost to him forever, although, in his deluded sexual fervor, he continues to believe the opposite. But Poe had given his readers

specific directions on how to read his narrator's final assertions: "What I shall tell of the earlier period believe; and to what I may relate of the later time, give only such credit as may seem due; or doubt it altogether; or, if doubt it ye cannot, then play unto its riddle the Oedipus" (649–53).

Echoes of Poe's conception of the androgynous nature of the presexual soul, poised between the material world and constructs of the creative imagination, were to remain a prominent feature of what was most distinctly "American" in later-nineteenth-century culture, partly owing to the positive, and active, role of women in the cultural life of the United States. Even Charles Caffin, notwithstanding his desire to rescue his country's art from its state of unmanly flaccidity, was perhaps most "American" in his call for a marriage between spirituality and materialism. His advocacy of a spiritual anchoring of art in matter is still closely related to Poe's conceptions, except that his solution translates Poe's principles of harmony into a gendered dichotomy, in which "spirit" becomes a specifically "male" trait and "matter" comes to represent the "feminine" emotionalism of nature, a "sentimental" focus on the life of the senses for its own sake.

Vanderpoel's conception of the correspondences between nature and the body, on the other hand, was "conservative"—more an expression of Poe's philosophy than of Caffin's incipient modernism. For Vanderpoel, as for Poe, the condition of soul, as reflected in the body, was still part of a nature that transcended gender, no matter how distinctly— even passionately—masculine or feminine the bodies he studied might otherwise be. For him each human being was a visual ballet of lines and volumes expressive of the spiritual aspirations of the soul. Even an eye was not just an eye; it was a poem, full of rhythm, grace, and movement: "The upper lid rises abruptly from the inner corner, and sweeps with graceful curve over the spherical form of the eyeball to the outer corner, while the lower lid starts continuously with the direction of the lower border of the corner, curving but slightly until it sweeps upward to the upper lid, which overlaps it," he wrote in his famous book *The Human Figure*, first published, like Caffin's *Story of American Painting*, in 1907 (19). Vanderpoel believed that "the beauty and grace of the curvature of the lines in the eye are not exceeded by any other form in nature" (24).

Writing in the year of the official birth of cubism, Vanderpoel gave a clear, though blissfully unconscious, indication of the origins of one

aspect of the style in a literalization of the orthodoxies of academic training: Each part of the body, he argued, with its interacting sets of lines and volumes and planes, was a study in complex questions of construction. The head, for instance, was "composed of six planes. . . . Fully to realize the existence of these planes, imagine a cube with all its corners and edges rounded. This will keep the sense of a solid and its planes before the mind's eye" (47).

There was an indelible link between the surfaces of the body and its underlying bone structure, he pointed out. Emphasizing the sculptural intricacies of the human skeleton, he drew delicately shaded portraits of the pelvic bone, of its cavities and spaces, and of its leaflike edges—stressing that a thorough understanding of volume was the key to artistic individuality: "That the third dimension, the dimension of solidity, becomes an important factor, may readily be understood and made interesting by observing that two drawings may be alike in the silhouette, the first and second dimensions, but in the nature of their relief or manifestation of the third dimension may be entirely different" (72).

Though Vanderpoel's observations concerning the structure and delineation of the human body are, of necessity, to a large extent similar to what can be found in other textbooks of anatomy for artists, a uniquely lyrical sense of the interaction between flesh and bone, volume and content, line and texture, echoes through each of his descriptions. Often these take on a distinctly topographical flavor: "A gully is formed in the otherwise full formation of the neck at the sides between the trapezius and the mastoid, which deepens into quite a hollow upon reaching the clavicle, where the bone makes a reverse curve to meet the shoulder-blade" (95). Shadows illuminated the soul: "kept quiet through lack of diffused and reflected light, the relative location of planes and their demarcation become luminous to the student's mind as well as eye" (51). The shadow dance of body and bone was a mountain ridge in the vast continuum of the spirit's material enlightenment (fig. 13).

Thus Vanderpoel insisted that his students must learn to let the lines of the body express the essential but largely intangible correspondences between our emotions and the shapes of nature. In other words, the artist must develop an awareness of exactly that element of "analogy" between matter and mind Poe had declared to be the key to a conscious experience of the organic coherence of all material existence: "If too bony, the forms will look hard and attenuated; if too soft they will

13. John Vanderpoel, *Torso*, ca. 1905.

appear characterless. Note the outward flare all around its base at the entrance of throat into body, which gives it a sense of attachment, suggestive of a tree that grows from the ground rather than a pole that punctures it" (96).

In O'Keeffe's mature work, abstract space and natural volumes were to be joined in exactly the meticulous insistence upon the organic, three-dimensional integrity of each detail she had encountered in her teacher's examples. O'Keeffe was very precise in her acknowledgment of his importance in her development: "Vanderpoel's lectures on drawing the human figure," she recalled, "were held in the auditorium upstairs—a light fresh-feeling room compared to the classrooms in the basement. Vanderpoel was a hunchback. As he lectured he made very large drawings on a sheet of tan paper as high as he could reach. He was very clear—drawing with black and white crayon as he talked. I always looked forward to those lectures. They helped me with the drawings of casts and with the Life Class. When the lectures were printed in his book 'The Human Figure,' I bought the book and treasured it for many years. He was a very kind, generous little man—one of the few real teachers I have known." This is high praise from someone who was frequently severely critical in her judgments of others.

Vanderpoel's close-up views of parts of the human body, such as those reproduced in his book—detailed representations of the curves in an eye, a pair of lips, the sensuous delineation of a woman's thighs, the weight and shape of her breasts, or the deep hollow curve of a pelvic bone—were true landscapes of the body. Driven to art by her desire to capture the essentials of her experience in the forms of nature, O'Keeffe clearly found it easy to respond to Vanderpoel's analogues between the beauty of the human body and the visual calligraphy of the natural world. From him she learned to capture, in the sensuously curving lines and gullies of the landscape, in the subtly rhythmic flanks of trees, and even in the sultry dance of pelvic bones, the world of analogy to be found in nature to the emotions within her.

Yet, notwithstanding O'Keeffe's fond and detailed account of his influence on her, Vanderpoel has received scant attention from her biographers. Sarah Whitaker Peters in *Becoming O'Keeffe* mentions him only in passing; Jan Garden Castro in her *Art and Life of Georgia O'Keeffe* conflates O'Keeffe's dislike for her *anatomy* class (which had a largely technical, medical school–like approach, attaching "long names" to

everything) with her delight in the *life* class Vanderpoel taught, and as a result she assumes that it was only "his insistence on meticulous, careful craftsmanship, not the realist approach of the life drawing classes, that she found valuable" (157). Benita Eisler, in her *O'Keeffe and Stieglitz*, makes the same mistake and collapses Vanderpoel's role in O'Keeffe's artistic education even further by asserting that "his course only helped her to draw casts" (24).

Laurie Lisle is far more accurate in her account of O'Keeffe's progress as a student, but she assumes that O'Keeffe's dislike for the lectures in anatomy and the "dismal dark classroom" in which they were held also translated into a general dislike for life studies, and mistitles Vanderpoel's book. Roxana Robinson, like Lisle, does note O'Keeffe's fondness for Vanderpoel and acknowledges the fact that he was "a well known artist who was listed first among the instructors" (52), but sees no further impact. Jeffrey Hogrefe's *O'Keeffe* continues her biographers' practice of disposing of Vanderpoel in passing as a near-nonentity in her life.

This dismissal of O'Keeffe's early influences is characteristic of the way most of those concerned with O'Keeffe have dealt with her American background. Virtually everyone has been quick to note the painter's uniquely American mentality, but at the same time the most "American" sources for her art have been left largely unexamined. Fortunately Barbara Novak's recent essay "Georgia O'Keeffe and American Intellectual and Visual Traditions," written for the catalog of the opening exhibition of the O'Keeffe museum in Santa Fe, may signal a reversal in this tendency; it perceptively discusses the connections between Emerson, Thoreau, and O'Keeffe's "self-reliant soul" (74).

But if O'Keeffe's roots in the American way of seeing things have been largely ignored, her fate is in this respect no different from that of most early-twentieth-century American painters. Most have found their work judged in terms of the ideologically convenient myth of European modernism's deus ex machina role in jolting American art out of its parlor filled with the bric-a-brac of the nineteenth-century feminine mentality. The sociohistorical convenience of this myth has created a critical atmosphere in the United States in which no artist working before 1950 has had a fair chance of being taken seriously unless he or she could be proven to have had a genealogically sound connection with the French avant-garde of the years before World War I. As a result O'Keeffe's critics and biographers alike have left none of the artist's potential links

to European modernism unexamined; however, they have dismissed as unimportant, and indicative of what they presume to be her inevitably scant and ineffectual American training, such figures as John Vanderpoel. He, in his art and teaching, provided O'Keeffe, at eighteen—a crucial stage in her aesthetic development, and a decade before Alfred Stieglitz entered her life—with both the rationale and the technical fundamentals for her way of seeing.

Vanderpoel's obvious physical nonconformity to the evolutionary ideals of manhood and "potency" made him an outsider to the world of masculine prerogative even during his own time. But this special vantage point also allowed him to develop a humane realism in art not freighted with the gender-ideological implications of so much of the work of his more up-to-date contemporaries. One of his sketches in *The Human Figure* is a superb drawing of the head of a young woman (fig. 14). It could almost have been a study of O'Keeffe herself. Self-possessed and serious, she looks straight at us, her gaze direct, inquisitive and unfaltering, expressive of a luminous intelligence, eager to experience—and make a difference—in the world.

Realism and respect for this woman as a thinking being combine in this portrait, and as such it is a far cry from the simpering, passive, dead-eyed angels and virgins that had become so popular among Vanderpoel's colleagues during the last two decades of the nineteenth century. The listless, self-obsessed, often apparently intellectually paralyzed drawing room and garden denizens who were to populate the work of many American painters between 1900 and 1920 were well characterized in Sadakichi Hartmann's (laudatory) description of Thomas Wilmer Dewing's paintings of women, in the first volume of his *History of American Art* of 1901: Dewing's female subjects, Hartmann pointed out, "seem to be melancholy without reasons, merely because suffering is poetical. When Dewing paints them, he takes good care to avoid expressing even a reflection of the genuinely devout feeling of the Middle Ages, as Rossetti or Henri Martin do,—he depicts the romantic tendency of our refined American ladies, who transform their boudoirs into sanctuaries devoted to the worship of their own individual tastes, who read Swinburne, are fond of orchids, and loll about on divans in their large, solitary parlours, in expectation, perhaps, of a sentimental knight in glittering armour (made of silver dollars) prancing in on a palfrey" (304).

14. John Vanderpoel, *Portrait Head*, ca. 1905.

It would be more than redundant to point out that this newly fash-
ionable "modern" feminine sensibility delineated by artists self-
consciously catering to the tastes of the new American industrial
"aristocracy" can have held absolutely no appeal to such a determined,
self-sufficient young woman as O'Keeffe. This little portrait study of
Vanderpoel's, on the other hand, is very close in spirit to the lively
self-portraits and perceptive studies of friends painted by such under-
appreciated representatives of the first generation of American women
who were professionally trained as artists during the 1870s and 1880s,
and whose work was taken far more seriously during this time than it
is even today—artists such as Cecilia Beaux, Anna Klumpke, and Ellen

15. Ellen Day Hale, *Self Portrait*, 1885. Gift of Nancy Hale Bowers. Courtesy, Museum of Fine Arts, Boston.

Day Hale (fig. 15). Vanderpoel's own less "gendered" approach must have provided O'Keeffe with an encouraging alternative to the new "philosophical" masculinity of his colleagues. No wonder O'Keeffe "always looked forward to those lectures."

A pencil sketch by O'Keeffe of her sister Anita, drawn in 1907, reveals the direct influence of the principles of Vanderpoel's teaching: the characterizing features of the subject's head—an ear, the curve of the nose, the precise shape of the chin, the light falling from a single source upon her neck—are all meticulously rendered and shaded in her teacher's characteristic manner. Only one thing is missing: that insight into the varieties of human experience that, as George Bridgman emphasized in his foreword to Vanderpoel's book, made him able to express the body "with a closeness to nature that has never been equaled" (5).

O'Keeffe, who was as severe a judge of her own work as she was of that of others, must have realized from the start that, even if her figure work at the Chicago Art Institute was good enough to win her a modest student prize, it was still far removed from her teacher's ability to

express his elemental passion for the human body. But she understood that the same energies this "very kind, generous little man" brought to his love affair with the figure were trying to seek expression in her own fascination with the shapes and volumes of rock, leaf, and tree. She still had to find her own way, but she probably already realized that to capture the shapes of nature in an analogous fusion of emotion and thought, of desire and reverence, of material volumes and abstract form—of the "feminine" and the "masculine"—she must turn the hills and gullies Vanderpoel had discovered in the human body into the raw materials for her exploration of the human curves and clavicles of the American land.

The Hazards of Humanism in a Modernist Environment

During O'Keeffe's childhood artists such as Walter Shirlaw, Elihu Vedder, Edwin Howland Blashfield, James Carroll Beckwith, Francis Davis Millet, Henry Siddons Mowbray and others had begun to explore the pseudomythological subject matter that had already brought scandal, fame, and often wealth to the stars of the European art world. But they could not compete in popularity. The European painters, after whom the American impressionists were to pattern their representation of women, liked to flatter their wealthy patrons' "scientifically proven" intellectual superiority over the "weak-minded" sex—either by emphasizing the dead-eyed vacuity of the female cranial cavity, or by painting elaborate lascivious fantasies that documented the primordial force of woman's reproductive nature.

But the Americans, as Samuel Isham stressed in 1905, in his *History of American Painting*, had generally had to account to a different audience. "Even today," Isham pointed out, "the British Philistine and the French Bourgeois (the strength of the two nations) are hostile, and only the long list of acknowledged masterpieces and the authority of the cultured classes keep them from protest. In America, culture is democratic, the leisure class is small, its opinions carry little weight, and it is not very sure of its opinions. The very wealthy have much the same views on art as the rest of the people, and being founded on social habits and moral considerations, they are not likely to be changed by ampler artistic knowledge" (467–68).

Clearly dramatic change in the American art scene would require a change in the country's larger ideological environment. The new masculinity factor in the American political consciousness, symbolized by Teddy Roosevelt's "big stick" diplomacy, still needed to find its way into the larger cultural consciousness of the nation. Meanwhile, American

artists intent upon showing off their international sophistication continued to produce idylls of classically—though whenever possible, at
least diaphanously draped—young women harmoniously interacting
with harps or flowery boughs. Their paintings were usually subdued,
balanced, and carefully controlled in color and texture. As we have
seen, both European and American critics recognized that these painters were in all respects as accomplished as their European counterparts.

Neither the Americans nor the Europeans could lay much claim to
stylistic originality. Their "modernity" resided primarily in their new
determination to show a fundamental continuity embracing woman's
reproductive function, her place in nature, and her inability to think
straight. But where the Europeans, given their "sophisticated" audience,
were able to pursue the "flower of evil" theme to their hearts' content
during the last few decades of the nineteenth century, when it became
the favorite subject matter of the symbolists, the Americans resisted
depicting an imagery so calculated to offend their principal constituency. As Isham pointed out, "to paint the regular Salon pictures in
America was difficult, to sell them well-nigh impossible" (463). Instead
they chose to concentrate on the decorously inane—the "vacuous
flower in a garden" element so effectively described by Sadakichi Hartmann in the paintings of Thomas Wilmer Dewing. The Americans'
chance to pursue a "truly masculine" subject matter in the arts therefore
continued to elude them.

The European painters often used slashing, aggressive brush strokes
to reinforce the suggestion of action and movement. The Americans, on
the other hand, tended to subdue the movement of their brush and the
weight of their pigment to allow subject and environment to blend in a
sensuous harmony of decorative color and line. Even American impressionism tended to distinguish itself from European forms by a greater
emphasis on meticulously juxtaposed patterns of small brush strokes.
Isham here, too, astutely recognized the continuance of an American
humanist tradition in the arts that was hostile to braggadocio: "Art is
still so new an interest with us that we have not yet had time to weary
of the simple, natural things of life, and so be forced to go in search of
the abnormal and eccentric in order to stir a jaded taste." That was,
Isham emphasized, another reason why American art had remained
"notably free from the baleful influence of the 'Salon picture,' the great
'machine' swollen to impracticable dimensions and striving to attract
attention by its strangeness or violence. From this follows also the sec-

ond characteristic of our art, its cheerfulness, its optimism. We are sentimental. We feel profoundly the tender melancholy of the autumn woods or the twilight sky; but we do not like pain nor misery."

Isham was writing in 1905, the year of O'Keeffe's first introduction to the world of the professional artist, and his remarks delineate all the elements that were to make her mature work of the twenties and thirties so fundamentally American: "The aim of the great majority of our painters is for purely artistic qualities rather than for intellectual or anecdotal ones, for beauty of line or form or composition or tone or color. There seems to be a special feeling for pure, sweet color. A gallery of American pictures is apt to have an unusual number of canvases noticeable for their excellence in this respect, and the persistence of the quality for nearly half a century, as well as its generality, suggests that it results to some extent from our clear air and warm sunlight, and may become a permanent characteristic of the school" (561–62).

Though Isham thought he was delineating the likely merits of all indigenous modes of artistic expression, he had failed to account for the effect the United States' growing economic power would have on its cultural preoccupations. Not only was heavy industry beginning to cloud the country's clear skies, but it also demanded that the national interest be expressed through a far more "manly," aggressively mercantile international posture.

Meanwhile, no matter how much the mainstream critics of the period tried to present the work of the tonalists and the American impressionists as a step toward a more "masculine" attitude in American art, only such painters as John Singer Sargent and William Merritt Chase, who could dash paint onto canvas with as much bravura as any European, gained more than local acclaim for their pursuit of true "virility" in art. Sadakichi Hartmann felt the blood of manhood coursing through his own veins more rapidly as he described Chase's method: "With him everything is first impulse, his work is thrown off with *brio*, the enchantment of the brushwork carries it along." Indeed, Hartmann exclaimed, "what a shiver of delight must run through his frame when he dashes in the high lights in his still-life pictures! A woman's face is scarcely as interesting to him as a copper casserole" (1:229–30).

An almost obsessive emphasis on "painterly painting," the use of a well-loaded brush vigorously applied to the canvas, a recognizable use of paint *as* paint, had already come to be well-established as a sign of "virility" in the world of late-nineteenth-century art, long before the

modernists began to insist upon the importance of texture for its own sake. It was generally understood that the painter's canvas was a physical surface existing in and for itself, to be covered with configurations of "pure" paint. As many American as European painters were developing a hostility to what they considered to be the effete pictorial precisionism and the smooth glazes of academic art. From that point of view the works of the French impressionists were part of an international movement already well under way rather than a dramatic departure from rock-solid custom.

What the advent of modernism added to this was little more than to make heavy texture, the residue of the loaded brush—or now, the squeezed tube—officially representative of a "virile" approach to painting. An anecdote the poet William Carlos Williams never tired of recounting illustrates the heady element of masculine in-group coding the "paint as paint" fetish had come to reflect by 1921. In his *Autobiography* Williams told the story as follows: His friend Alanson Hartpence, then working at the Daniel Gallery, had neatly put a puzzled middle-class woman visiting the gallery in her place. She had been trying to determine the forms in one of the paintings. Pointing to a section of the canvas, she asked what "that" was supposed to be. Hartpence studied the section in question with an air of mock-gravity and then announced portentously, "That, madam, is paint" (240).

O'Keeffe's experiences at the Art Students' League in New York during 1907 and 1908 were destined to make her confront the new search for manhood sweeping through the American cultural scene, whose growing elitist focus is well illustrated by this anecdote. Arrogance, a desire to upset the supposedly witless, hopelessly old-fashioned American women who had for so long been a mainstay of the American cultural scene—and thereby to demonstrate the superiority of their "masculine creative freedom"—was typical of the attitude of these rebellious young turks toward what they considered to be the hopelessly "effeminate" qualities of the more traditional focus of American art; to become as conceptually superior to the Philistines and the Bourgeois as they considered their European counterparts to be was the goal of the new generation of artists seeking instruction at the League.

They found their guide in William Merritt Chase, who had developed an interesting dual approach in dealing with his clientele. For the parlors of "real men" he had perfected a genre of bravura still lifes rooted in his Munich training. These virtually always featured dead fish

or game (also virtually always complete with one of those copper casse-roles that had made Hartmann's pulse pound). They were works that still suggest the smell of tobacco smoke and continue to echo with the heated political discussions they were destined to be witness to. To send the hearts of his wealthy women-patrons aflutter, however, Chase painted sunny impressionist scenes in the French manner, featuring parasol-toting young women or adorable children in soft, white, feath-ery flounces romping through fields of heather.

By the time O'Keeffe came under his tutelage, he was part of the reigning aristocracy of "virile" society portrait painters, along with such international stars as Anders Zorn, Giovanni Boldini, John Singer Sar-gent, and Joaquin Sorolla. Their work was characterized by the liberal application of broad strokes of "paint in motion." The visual bravura of their sensational technical skills had made them, as Hartmann noted, something akin to sword fighters in the field of art: they were "the most skillful wielders of the brush whom modern art has produced. Each of their brushstrokes tells. They are wizards who with a few dashing lines, a few turns of the wrist, can produce the pictorial resemblance of any object that comes under their eyes" (2:220).

O'Keeffe's *Dead Rabbit and Copper Pot* (fig. 16), a still life done in the Chase manner during her year at the Art Students' League, shows that she dutifully tried to copy the master's technique, and that she had learned a few things about chiaroscuro. What is particularly interesting, however, is the "masculine" subject matter of the painting. Chase taught numerous female students, but most of these crowded into his popular "plein air" classes and chose to pursue the sweetness of his whites, blues, and greens. O'Keeffe's still life represents a far less typical, and therefore all the more telling, instance of one of his women students' trying one of his "male-focused" subjects.

O'Keeffe was able to suppress her own sensibility only partially in this painting. Her venture into this bravura style of painting turns away from the sword fighter's "dash and 'go'" of Chase's work—an aspect of the man's teaching she still vividly recollected many years later. Chase made his dead fish and fowl surge and glisten with an almost tangible materiality, until even these lowly creatures became worthy trophies for the manly warriors of the new sport-conscious ruling class. O'Keeffe's own exercise in the master's style, however, though technically good enough to satisfy Chase, was no more than a modest, static elegy to a small dead animal; she painted its meager body and feathery pelt with

16. Georgia O'Keeffe, *Dead Rabbit and Copper Pot*, 1908. The Permanent
Collection of the Art Students League of New York. © 1998 The Georgia O'Keeffe
Foundation /Artists Rights Society (ARS), New York.

such tactile delicacy that her image negates any of the masculinity fac-
tors her teacher habitually worked into this subject matter.

The painting thus helps us gain insight into the perceptual criteria
governing O'Keeffe's sensibility around the age of twenty-one. Like
many of the more restive younger painters of her generation she would
have considered impressionism old hat—a style to avoid. By 1908 no
promise of creative liberation could remain in that realm of visual ex-
pression for an ambitious young artist seeking to express her own sense
of the world.

Chase's self-consciously "masculine" still life mode, however, no
matter how "old fashioned," would have been more of a challenge. And
the man's way of painting these still lifes expressed a joy in the mere
materiality of objects that clearly appealed to her. O'Keeffe later ac-
knowledged Chase's sensuous, material enthusiasms and his very
American delight in objects as objects: "His love of style—color—paint

as paint—was lively. I loved the color in the brass and copper pots and pans, peppers, onions and other things we painted for him."

She looked and learned, but she liked the objects Chase called to her attention better than his manner of painting them. Chase always asserted the authority of the artist over his subject matter. Indeed, the impressionists had, at first, seemed unusually "virile" to many critics, precisely because, instead of acting like "slaves to nature," they asserted their authority over everything they surveyed. The impressionist painter's eye was the vehicle of his incorporating ego: he decomposed and recomposed the forms and textures of the material world according to his will. This was also the attitude underlying Chase's instruction, and in this he was much like Kenyon Cox, who taught the anatomy classes she reluctantly attended at the League, and who painted women as if they were stone sculptures destined to linger forever in green fields. Those correspondences between herself and the objects of the material world she was seeking to expresss were unimportant to him. Instead, the artist's authority was everything.

As a result she took to studying the person who did the teaching, instead of the techniques taught: "I only remember the tall, very thin man in his loose clothes standing talking. The figure had a relaxed kind of grace that fascinated me and is very vivid to me now. To lift his hand seemed an effort, but it was a fine gesture when he did lift it. The face was very sour. The women in his Life Class were terrified of his sharp criticism."

To O'Keeffe there was something repulsive in this aggressive master-slave relationship between the artist and the material world. An incident that occurred during her first stay in New York, early in 1908, remained with her throughout her life. On a clear, moonlit night she had seen "two tall poplar trees breathing—rustling in the light spring air. The foliage was thick and dark and soft—the grass bright in the moonlight." The next day she set out to evoke her sense of those shapes and textures: "I covered the canvas as best I could and thought the trees particularly beautiful. I showed the painting to a student whose paintings I liked. He immediately told me that there was no color in my trees—that they should be painted with spots of red and blue and green like the Impressionists. I said that I hadn't seen anything like that in my trees the night before. He insisted that it was there and I just hadn't seen it, that I didn't understand. And he took my painting and began painting on it to show me. He painted on the trees—the very part that I

thought was so good. He tried to explain to me about the Impression-
ists. I hadn't heard anything like that before—I didn't understand it and
I thought he had spoiled my painting."

This anecdote tells us a great deal about O'Keeffe's ideas concerning
the role of the artist in the world, as well as about her early understand-
ing of the tyranny of style. She clearly remembered the incident as a
case of ideological rape. The male student who violated her painting
with his arrogant assumption of authority also violated her perception
of a creative dialectic between the artist and the material world. He tried
to force her to accept his imperial masculine conception of the artist's
executive privilege to dominate and manipulate nature.

Defiantly, O'Keeffe tried to recapture her original conception: "I took
the painting and worked on it again. I couldn't get it to be like the
beautiful night I had seen and when I painted over what he had done,
the whole thing was sticky and much worked over and dried very
badly—but I kept it for years. It represented an effort toward something
that had meaning to me—much more than the work at school."

O'Keeffe's remarkable sense of equilibrium as a person was a major
factor in her refusal to arrogate to herself the role of conqueror, or to
submit willingly to the position of victim. Instead she studied the welter
of styles whose advocates were warring around her, and selected for her
own use whatever she found intriguing. At this point in her career she
had clearly chosen to express herself in the contemplative mode of the
tonalists, for this painting that meant so much to her, "much more than
the work at school," with its foliage that was "thick and dark and soft—
the grass bright in the moonlight," was clearly directly influenced by
their work. She had chosen their integrated, contemplative manner
over the aggressive stance of Chase and Cox—and the fellow student
who attacked her work was trying to force her into submission to the
"dominant" style.

The more she had to counter the attempts of others to impose their
wills on her, the more her personal strength became for her a source of
creative exhilaration. The rigid ideals of "masculinity" and "femininity"
propounded by her teachers as stylistic concepts in art had very little to
do with her own desire to capture the human wonder—the intangible
emotions, the creative fervor—that nature, and the objects in nature,
evoked in her. She wanted to find a way to express the nongendered
essence of the gendered human body: she wanted, whether she knew it

or not, to recapture the fading memory of the great preindustrial American colloqui of Monos and Una that was being drowned out by the prejudicial gender rhetoric of the new evolutionary elite. As that din grew louder, the position of "the woman painter," as any painter who happened to be a woman was habitually identified, became still more difficult in the American cultural environment than it had been even a mere decade earlier.

When George William Sheldon, in 1890, asserted that at the Society of Women Artists in Paris the work shown was in every respect equal to that of male painters, he displayed what the Europeans of the later nineteenth century liked to see as a typical American cultural naïveté about the artistic and intellectual potential of women—a naïveté that had also produced the ill-advised social liberties allowed to American women within the framework of the country's vulgar populism. Henry James, all too sensitive to the Europeans' amused sense of superiority, had made that theme the subject of the tribulations of such heroines as Daisy Miller (1878) or Isabel Archer of *Portrait of a Lady* (1881), whose intelligence and independence and naive American optimism about gender equality had lured them into actions that would destroy their own chances for domestic happiness.

James had still written about his heroines with a mixture of sympathy, concern, and pedagogic fervor; but by the time Edith Wharton published *The Custom of the Country* in 1912, she did not hesitate to portray Undine Spragg as a vulgar American social vampire adept at depleting the intellectual energies of the men she depredated while having no claim to any of these qualities herself. The social attitudes toward women of independence had by then changed sufficiently to make such instances of vicious satirical censure as acceptable to the general American reading public as they had already been for decades in Europe.

The situation in the visual arts was no different by this time. The opening up of the art field to women had, as we have seen, made it possible for Rosa Bonheur's *The Horse Fair* to fetch the second highest auction price ever paid for a painting in America during the 1880s. That had been a sensational event. To place it in its proper perspective, one would have to imagine a painting by a contemporary woman outdistancing the prices paid for major works by Picasso and coming in second only to Vincent van Gogh, the way Bonheur came in second only to Meissonnier. Even today the market value of O'Keeffe, no matter

how popular, sought-after, and consequently expensive her work has become, still remains, within the framework of today's most meretriciously conspicuous expenditures on art, no more than "second tier."

As Lois Fink has documented, during the 1880s and 1890s, among American artists in Paris, women were more prominent than among any other group, "representing on the average about 25 percent" (135). Though this did not mean that women were widely accepted as artists (many of the most famous French teachers, as well as the Ecole des Beaux Arts, refused to accept them as students), their presence nonetheless bred something of a cultural acquiesence to the idea that women could legitimately be artists, and that their subject matter could be as "serious" as that of the men. This relatively open attitude to subject matter was challenged as soon as the male artists and critics began their inevitable counterattack on the women who, they believed, were beginning to threaten their livelihood.

Their attempt to drive artists who happened to be female into a thematic ghetto that would marginalize them effectively was one of the first products of the argument, developed between 1890 and 1910, that "serious" art needed to cultivate its inherently "manly" qualities. Sarah Burns, in her excellent recent study of this period, *Inventing the Modern Artist: Art and Culture in Gilded Age America*, has identified this process felicitously as "the regulation of artistic masculinity" (100 ff.).

As long as women kept to subjects that were suited to their nature, the masculinist critics contended, they could be tolerated on the margins of the real art world, but when they attempted to become philosophical and enter the world of the intellect, their claims to artistic legitimacy became simply laughable. Women should instead be content to remain in a separate sphere—where they could express their own, if not exactly equal, at least "legitimate," feminine modes of perception.

Sadakichi Hartmann, at the opening of the twentieth century, articulated the principal arguments of this new approach: "Women push themselves to the foreground everywhere," he noted, "but the result is rather dissatisfactory and tiresome." Why, he asked sententiously, "do women always paint such trifling subjects? Why do they always imitate men, instead of trying to solve problems which have never been touched before? The women artists have still to come (Rosa Bonheur was a mere suggestion) who can throw a new radiance over art by the psycho-physiological elements of their sex, and only then the large number of women will be justified in modern art. The woman who can

paint men as we have painted women, and paint women as we have painted men, will win for herself the laurel wreath of fame." Hartmann, however, was not holding his breath. He understood that there were a few "conscientious women workers of more or less talent" round and about, but even Clara MacChesney, who was one of the few women "whose art shows some individuality," distinguished herself "by a monotony of tone which is only surpassed by her monotony of subjects."

Hartmann tried not to sound too overtly sexist—after all, most of his readers were still likely to be women—but he used epithets and descriptive qualifiers that would make it hard for anyone to mistake his meaning. Cecilia Beaux, for instance, with all her "brilliancy and refinement," was really no better at hiding her anatomical deficiencies in a man's world than any of her less talented sisters. She did not have the aggressive weaponry of the real artist: "Miss Beaux lacks the penetrative glance, her observation rests on the external picturesqueness of things." Her works suffered "from superficiality and a certain trickiness," and, worst of all, "her drawing is often uncertain, and would, undoubtedly, improve by anatomical studies in the life class. Trousers generally have legs inside." Beneath the surface appeal of her work "there is a good deal of drab, a rigidity, inherent in her personality; she has not yet learned to animate her art with emotional and intellectual dashes that flash forth from the storm clouds of genius" (1:288–93).

What makes Hartmann's remarks particularly fascinating is that the language he uses to criticize Beaux is virtually identical to that used by Robert Hughes, four years short of a century later, in his recent, largely negative assessment of O'Keeffe in *American Visions*. Hughes, with as much skepticism as Hartmann had shown about the aesthetic judgment of those among his contemporaries responsible for the prominence of Cecilia Beaux, points out that O'Keeffe "remains the most famous woman artist America ever produced, eclipsing even Mary Cassatt." He then proceeds (just as Hartmann did after he had disposed of Cecilia Beaux's thimbleful of merits with the flick of a wrist) to delineate all her deficiencies at leisure. Where Hartmann found Beaux's drawing "often uncertain," Hughes insists even more emphatically that "O'Keeffe's weaknesses were mainly of drawing." Her line, unlike that of a real artist such as Charles Sheeler, was that of a woman better off stitching quilts, for it "could not resist irrelevant crotchets, and her paintings of the Church of San Francisco de Assis at Taos so exaggerate the organic curves of its adobe shapes that they look boneless and woozy."

Furthermore, just as Hartmann complained about Beaux's constitutional inability to fill out a man's trousers properly, so Hughes opines that "most of the time O'Keeffe's draftsmanship was serviceable, no more." Where Hartmann finds Beaux concentrating on the "external picturesqueness of things," Hughes berates O'Keeffe for making many of her bone paintings "look as sentimental as kitsch surrealism" (391–95). Both Hartmann and Hughes allow a place in their hearts for these women's appropriately feminine palettes. Hartmann finds Beaux's colors "agreeable" (1:289), while Hughes gives benevolent approval to O'Keeffe's "delicate elaborations of color" (395). A century of progress may have changed some of the terms Hughes uses, but his opinions remain locked dead-on to the antifeminine arguments of the new "cultural masculinists" of the years just after 1900.

Hartmann was one of the most "progressive" critics of his time, and, much like Charles Caffin, one of Alfred Stieglitz's personal favorites. Yet compared to Hartmann's deliberate unwillingness to recognize the merits of Beaux's work, the open, critically nuanced, and generally appreciative commentaries on the work of artists who happened to be women to be found in the writings of older critics such as George William Sheldon become all the more striking. Robert Hughes, for his part, as the art critic of *Time Magazine* represents the current voice of mainstream American criticism, reliably crotchety and opinionated as we have come to feel a good critic ought to be. Many see him as a trustworthy spokesperson for "common sense" in the arts. Thus his critique of O'Keeffe's presumed deficiencies can be seen as characteristic of the problems her art has continued to pose to the twentieth century art establishment as a whole. Together, Hartmann and Hughes present the precise circumference of Georgia O'Keeffe's life as an artist within the confines of the world according to modernism. And as they make crystal clear, she must always remain an outsider to that world.

As distant inheritors of the late nineteenth century's appetite for "the new," for "innovation," and for whatever we choose to consider progress in the arts or the sciences, we tend to forget that the culture of modernism is fundamentally aligned with the change in the social conceptualization of gender roles that occurred toward the turn of the century. There can be no doubt that modernism was able to sweep away many of the cobwebs that had settled on the nineteenth-century realist tradition, and many of the new modes of expression it brought to the

arts have enriched our cultural environment immeasurably. But in our enthusiasm for modernism's admonition to its followers to "make it new," we tend to overlook that this new mentality also came equipped with a built-in new justification of antifeminine and racist attitudes. Indeed, the new culture of modernism was perhaps most modern in its discovery of the cult of "manhood."

In that respect Hartmann's obvious antifeminine prejudice was a bellwether of the arrogant, prejudicial, and deliberately exclusionary critical practices that rapidly became popular throughout Western culture as part of the modernist revolution. The "manly" critical values of modernism also explain the virtually exact reprise of the negative categories of Hartmann's critique of Cecilia Beaux in Hughes's critique of Georgia O'Keeffe nearly a century later. The "manly" exclusionary values of modernism created the reputations of numerous early-twentieth-century critics, whose stern dismissal of entire styles of painting, as well as of most artists who did not fit their narrow definition of "quality" in art, came to be seen as indicative of the correctness of their judgment. The ascendancy of that authoritarian viewpoint was to become virtually absolute in the work of critics such as Clement Greenberg during the years immediately following World War II. This appetite for absolutist criticism has, in turn, created the current anomaly of an art market (whose ascendancy can, in turn, be traced to the economics of late-nineteenth-century culture) that deliberately encourages the public to rate the quality of works of art according to the amount of money spent on them rather than according to the works' expressive intensity, cohesiveness, humanity, and sincerity.

This meretricious, exclusionary, and profoundly prejudicial "big stick aesthetic" today dominates much of the art world. Style has completely overrun meaning. The capacity to dominate reality through "form" and to "re-form" it to fit one's own synthetic authority had, by 1900, already widely come to be seen as the key to creativity. By the end of the first decade of the twentieth century the artist's ability to force the objects of the material world into subjection, just as O'Keeffe's teachers—and the fellow student who had tried to "re-form" her painting—had tried to have her do at the Art Students' League, had come to represent the triumph of man's formal authority over nature, a genuine "triumph of the will" of evolutionary masculinity over the forces of degeneration. Respect for content as content, respect for the forms of

nature as forms of nature, was seen as a capitulation to feminine forces: to the status quo, to nature, and hence also to "imitative" and "reproductive" tendencies. Robert Hughes, indeed, showed himself to be perhaps most directly of one mind with Hartmann, most absolutely conformist in his presumed modernist nonconformism, when he declared that contrary to popular opinion, "there was no sense" in which O'Keeffe "could be called a major formal artist." The whole of twentieth-century antifeminine thought is submerged in that judgment: how, after all, could she, *as a woman*?

The modernist emphasis on form as form, in its simplistic dualistic self-positioning as the "manly" answer to the "sentimental" nineteenth-century concern with content as content, has proved to be one of the principal ingredients of the stew of cultural preconceptions that today forces artists to transform themselves into self-promoting concept sellers. There have been clear indications over the past decade or so that the hegemony of form as an end in itself in the arts is finally beginning to break apart; one, indeed, is the fact that, in Hughes's disparaging term, O'Keeffe has become "the diva of [women's] independence." But the politics of our art world still continues to encourage the devaluation of precisely those elements celebrating the link between what is human and what is most meaningful in the material world. O'Keeffe's art represents, in virtually all of its aspects, a "third way" of seeing the world, different from both modernism and the mainstreams of traditional art, but linked very closely to social tendencies in American nineteenth-century culture. These, in turn, were the result of a unique confluence of historical conditions: a frontier environment that delayed the development of the repressive middle-class cult of female invalidism outside the urban centers, an emphasis on rugged self-reliance with its accompanying hostility to authority and inherited class divisions, and a strong belief in the organic bond between the person and nature. That O'Keeffe's art continues to intrigue people is an indication that those qualities have been able to survive more than a century of concerted assault on the part of gender ideologues and cultural elitists.

VIII

The "Woman Artist" and the Great Transition

The imperialist mentality of "evolutionary superiority" encouraged by the economic needs of the industrial powers of a century ago required a search for "true masculinity" in the arts. Anything that smacked of "effeminacy" or "sentimentality" rapidly came to be devalued as old-fashioned and part of the "feminine" legacy of art in America. Art had to be "virile" to be worthy of one's attention. No wonder there was a sudden upswing in the use of that word in the critical vocabulary of the years after 1900.

The technocratic evolutionists' credo was deceptively simple and, of course, perfectly logical. Science—particularly the research of numerous physicians, physiologists, and biologists—had conclusively shown that women were fundamentally deficient in the production of those vital essences responsible for a man's personal "vitality," both of the physical and of the intellectual variety. This was part of nature's plan. In line with the inalterable mechanisms of evolution, men and women were destined to develop separately toward fundamentally divergent conditions of optimal functional efficiency. Men were thinkers, intellectuals whose superior cogitative abilities would ultimately permit them to transcend the rule of nature. Women, on the other hand, must concentrate exclusively on their appointed function as the incubators of all future generations. Since this task required them to be obsessively focused on the mundane facts of material reality, they should abandon all pretense to a life of the intellect and resign themselves to taking charge of all those vulgar material details of everyday life the masculine intellect could not be expected to address in its quest for superman status. The continued evolution of the human species depended on the social

and economic elite's willingness to facilitate a steady acceleration of the fundamental social and sexual "dimorphism" of men and women.

Unfortunately, women continued to pose a threat to the upward-striving male even after having been relegated to the role of specialized reproductive machines, exclusively occupied with the sexual functions of the body and the mundane consumerism suited to their low level of creative vitality. For science had proved that the gray matter of the human brain was produced by the ductless glands of the body. The "vital essence" of the human species, responsible for all human progress, was contained in precisely those generative fluids the male was forced to deplete each time he tried to satisfy woman's insatiable reproductive urge. Brown-Séquard—the famous physiologist at the Collège de France, whose "recent discovery of the source of perpetual youth" George William Sheldon had noted in 1890—as well as numerous other biologists and medical researchers had demonstrated conclusively that the proper containment of this magic potion was the key to all intellectual evolution and therefore also clearly all economic development. Even immortality might be just around the corner.

By the second decade of the twentieth century the vital essence theory of evolutionary excellence had become a subject of widespread interest among intellectuals, and by the twenties it had turned into an international obsession leading to truly extravagant assumptions. Ezra Pound, for instance, speculated in the "Translator's Postscript" to his 1921 translation of Remy de Gourmont's already extravagant speculations on the causes and future of sexual dimorphism, *The Natural Philosophy of Love* (1903) that "Species would have developed in accordance with, or their development would have been affected by the relative discharge and retention of the fluid; this proportion being both a matter of quantity and of quality, some animals profiting hardly at all by the alluvial Nile-flood; the baboon retaining nothing; men apparently stupefying themselves in some cases by excess, and in other cases discharging apparently only a surplus at high pressure; the imbecile or the genius, the 'strong-minded.'"

Thus, as Pound indicates here, and as most of his masculine contemporaries had come to believe, only those men who had been able to retain an outstanding amount of their "essence" could be expected to become part of the intellectual and spiritual elite of the new technocratic order. After all, Pound stressed, "it is more than likely that the

brain itself, is, in origin and development, only a sort of great clot of genital fluid held in suspense or reserve."

Pound did not want to get sidetracked into any less than scientific "digression on feminism," but he was crystal clear in his general agreement with his contemporaries' skepticism about women's capacity to join in the bounty of man's "alluvial Nile-flood": "One offers woman as the accumulation of hereditary aptitudes, better than man in the 'useful gestures,' the perfections; but to man, given what we have of history, the 'inventions,' the new gestures, the extravagance, the wild shots, the impractical" (every truly "creative" and artistic effort, in other words) "because in him occurs the new up-jut, the new bathing of the cerebral tissues in the residuum, in *la mousse* of the life sap." In short, culture represented a continuous struggle between what was feminine (and hence imitative, retentive, instinctual, and animalistic) and what was masculine (and hence creative, progressive, intellectual, and spiritual).

Culture was therefore the product of "man—really the phallus or spermatozoid—charging, head-on, the female chaos." Indeed, in the masculine and the feminine sexual functions, the separate roles of "culture" and "nature" had been defined in their most pristine manifestation: "The mind is an up-spurt of sperm, no, let me alter that; trying to watch the process: the sperm, the form-creator, the substance which compels the ovule to evolve in a given pattern" (169–70). Pound left no doubt that this meant that "mind" must "compel" the body—woman, as the vehicle of nature, matter, and instinct—to do its bidding, in order to maintain the evolutionary advance of mankind.

I have quoted Pound here at such length because, incredible as this may seem to us now, the opinions he expressed were perfectly representative of the mainstream of thought about gender during the first few decades of the twentieth century. But where most of his contemporaries, given the awkward nature of this subject matter, tended to be extremely circumlocutory in their speculations, Pound enjoyed being as provocative as possible, and thus his remarks give us a rare, no-holds-barred insight into ideas that habitually remained far more veiled in the writings of his contemporaries.

What had happened in American culture as O'Keeffe was growing up was that the new industrial elite and its entourage of acolytes and dependents—the intellectuals, the research scientists, academics, artists, writers, and critics—had finally begun to catch up with an imperialist

mind-set that had already established itself firmly among the ruling classes of Europe since well before the turn of the century. Social Darwinists such as William Graham Sumner found it easy to convince them that they were the chosen few—masters of seminal continence, whose magnificent accumulation of gray matter was proof of their inherent right to lead mankind's evolutionary advance. Their credo was simple, and, as the biologists had made perfectly clear, unassailable on scientific grounds. Nature had come up with the idea of evolution with American business in mind. The American millionaire was clearly the highest specimen of human evolution to be found anywhere in the world. But it was equally clear that nature had not intended women to be part of this evolutionary advance.

Darwin's teaching had shown, and scores of European philosophers and scientists had already confirmed, that the males of the evolutionary elite could be expected to evolve into something of a new species—a physical, social, and economic superman. But this could happen only if the iron laws of qualitative social stratification were followed to the letter. Science—in the form of the evolutionary biologists' completely objective speculations—had shown conclusively that women were fundamentally deficient in the production of exactly that all-important "cerebral fluid" the male was able to produce in such impressive quantities. In some women—if one were to "ascribe a cognate role to the ovule," to return to Ezra Pound's learned disquisition—"the ovular bath could still account for the refreshment of the female mind, and the recharging, regracing of its 'traditional aptitudes'"; but, in general, the reproductive process had such a devastating impact on her intellect that "where one woman appears to benefit by an alluvial clarifying, ten dozen appear to be swamped" (171).

Thus each gender must learn to concentrate on its separate role in the evolutionary process. The scientific logic behind this theorem of the necessary dimorphic development of the sexes had clearly been proven to be unassailable. Men were the thinkers and creators whose superior cogitative abilities would ultimately permit them to transcend the rule of nature. Women, on the other hand, were like the flowers. It was their task to lure the male and be fertilized. All they needed to do was to concentrate on their nature-ordained function as ambulant wombs.

However, every sexual encounter, including those necessary to propagate the evolving human race, could only deplete a man's intellectual potential and by extension his chances for immortality—or, for that

matter, as Brown-Séquard had believed, his ability to maintain "perpetual youth." He should therefore try to steel himself, not only against the erotic temptations of women, who were, quite literally, nature's vampires, but also against their general influence in his life, for to be contaminated with the values of women was clearly to slide back down the evolutionary ladder man had been climbing so laboriously. The "lower races" in their "sexual excesses" and their "mental and emotional instability" were dramatic examples of what happened to those who had not been able to shake off the regressive influence of woman (read: "brute" nature). Only by cultivating a healthy mind in a strong and healthy—because continent—body (hence the period's new obsession with sports and physical education) could man, in a triumph of will, secure his membership in the vanguard of the evolutionary aristocracy: that small band of creative geniuses, the supermen of the human race, responsible for virtually all economic and cultural progress in the world.

The foregoing is, of necessity, a schematic conflation of a welter of often disparate and sometimes contradictory notions. But though these ideas became the official basis for social policy only in Nazi Germany and Fascist Italy, they had a dramatic impact on virtually every aspect of European and American culture during the first three decades of the twentieth century.* No matter how ridiculous these notions may seem to us now, they were widely accepted at this time, and with the same sort of quasi-religious eagerness still apparent today in the evolutionary biologists' exaggerated claims concerning the significance of certain DNA configurations. Our geneticists concoct theories of essential social and physiological determinism based on no greater measure of proof than those underlying the assumptions of their colleagues of a century ago. Though most of us may at best have only an inkling of the cultural politics underlying such speculations, they have, whether we realize it or not, a dramatic effect on the way in which we see the world and on how we perceive our social responsibilities within it.

In a similar fashion the often entirely spurious findings of the turn-of-the-century biologists had a rapid and lasting impact on the roles women were allowed to occupy in the arts. Theories of fundamental gender dimorphism came to reign supreme, and within this context the designation "woman painter" soon came to be a shorthand for any female artist in pursuit of the supposedly unique "psycho-physiological

* These developments are delineated in detail in my book *Evil Sisters*, q.v.

elements" of her sex that Hartmann had already claimed to be her ex-
clusive responsibility as early as 1901.

O'Keeffe, at least partially as a result of her experiences at the Art
Students' League, became quite familiar with the "new wave" of gender
prejudice she had been able to avoid to some extent in Vanderpoel's
classes at the school of the Chicago Art Institute. No wonder she came
to despise being identified as a "woman artist." She emphasized that to
her the term signified an arbitrary ghetto of social limitations, a willfully
restrictive, gendered designation of her work that was not at all expres-
sive of the range of her artistic ambitions.* No person of her indepen-
dence of mind could have felt differently, for during the early years of
the twentieth century, as the cult of manhood prospered, the term
"woman artist" rapidly took on an element of acidic condemnation. The
critics of the period had begun to use it as a code word to designate
anyone who, because of the presumed limitations imposed on her by
the accident of her sex, could never hope to "be called a major formal
artist."

As the first decade of the twentieth century was coming to a close,
O'Keeffe's prognosis of her chance to be taken seriously as an artist was
therefore quite understandably rather bleak. Toward the end of her first
sojourn in New York she went with a group of fellow students to Lake
George. The gender issue had to be on her mind, if only as a result of
the possessive behavior of the males around her: "One night a boy and
I rowed across the lake. He was furious with me because I wanted to let
another boy go with us." O'Keeffe herself responded by quietly observ-
ing the dark harmonies of the natural world in deep shadow: "marshes
with tall cattails, a patch of water, more marsh, then the woods with a
few birch trees shining white at the edge on beyond. In the darkness it
all looked just like I felt—wet and swampy and gloomy, very gloomy.
In the morning I painted it. My memory of it is that it was probably my
best painting that summer. It was the second thing I had to say after
those trees at night on Riverside Drive."

The setting O'Keeffe here describes represents, even more than the
first of the two paintings from her time at the Art Students' League she
was to recall so fondly late in life, the themes and the emotional focus
of an American tonalist painting. The nature around her echoed the
sense of loss she felt as a world of harmony, social coherence, and spon-

* In conversation with the author, Abiquiu, 1975.

17. C. Yarnall Abbott, *Sentinels*, photograph, ca. 1908.

taneous being seemed to recede ever further from her grasp. O'Keeffe's painting therefore also sounds, once again, like a depiction of one of Poe's gender-based dismal swamps. In visual terms it was most likely very similar to C. Yarnall Abbott's tonalist photograph *Sentinels*, reproduced in the January 1909 issue of *Camera Work* (fig. 17): water, woods, and birch trees—"wet and swampy and gloomy, very gloomy." But there was, no doubt, also much of the atmosphere of Dwight Tryon's *Early Morning, September* (fig. 18)—a likely source of inspiration for both Abbott and O'Keeffe—in the young artist's effort to paint her feelings.

Notwithstanding the attempts of critics such as Charles Caffin to turn the work of the tonalists into an art reflective of the brave new spirit of pure intellectual masculinity, the closest links of this movement were clearly with the intuitively gender-dialectical American art environment that was as rapidly waning as the light in their paintings. A relatively conservative painter-critic such as Samuel Isham had no trouble recognizing the push-pull between what was more and more coming to be seen as the "masculine" intellect and "feminine" intuition in the work of

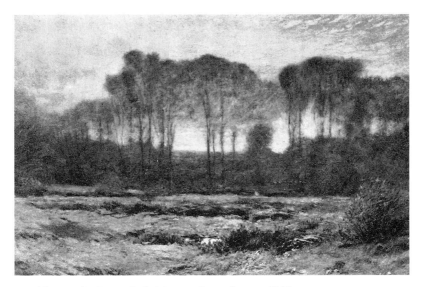

18. Dwight Tryon, *Early Morning, September*, ca. 1905.

a painter such as Tryon: in the latter's work, Isham said, "the poetry is built upon the solid fact. Rocks, groves, streams and sky are knit together as firmly and logically as a proposition of Euclid; but on this reality he begins to work with mists and shifting lights and feathery spring foliage until it almost disappears under the shimmering web of poetry that he has wrapped around it, yet underneath still lie the stone walls and the gray ridges of New England rock ready to emerge in all their uncompromising strength the instant the east wind sweeps up the enveloping veil."

The trees in Tryon's work, Isham pointed out, take on "something of the adolescent grace of the Early Renaissance sculptures, and they are not collected in solid masses, but stretch across the picture in a diaphanous line only kept from monotony by the delicate differentiation of detail, the individuality of the trunks, the spots of light breaking through, the varied line of their tops. The color is kept within one milky, luminous tone that softens and transmutes whatever more violent tints may lie beneath to something in harmony, though there is no monontony. It is not a messing together of warring colors into one soiled monotone but each is pure and distinct for all its delicacy" (457). In other words, there was still no emphasis on "evolutionary masculinity" here.

Instead Isham here unmistakably describes that ideal world of mind become matter that Edgar Allan Poe had dreamed of more than half a century earlier as resulting from the harmonious reunification of Monos and Una after the ravages of the world of industrial distortion—of "harsh mathematical reason"—had run their course. Instead of the harsh, gendered conflict that had developed between the heart and the head, between nature and the intellect, between intuition and science, Tryon's world—the world of the tonalists—Isham emphasized, "carried on the best inspiration of the earlier American school." Tryon and a painter such as Inness, though their temperaments were otherwise not comparable, had learned to "paint American landscape with deep, personal feeling and with a *technique* complete, original and modern" (454). The pregendered harmonies of these painters' work extended to their willingness to make form and content interact, overlap, fuse—be as one—rather than to let form muscle out content.

O'Keeffe, distraught by the supermasculine posturing of her fellow students, by the ever increasing prominence of a divisive gender ideology of which she wanted no part, and by her teachers' arrogant attempts to dominate nature rather than let it speak for them, sought to buck these trends by painting in the tonalist mode. Throughout her life O'Keeffe would, with striking regularity, continue to paint images that represented a tonalist impulse adapted to her more modernist environment. Tonalism helped her forge a style whose elemental tactile-visual intelligence could turn mind into matter, and matter into an expression of emotions freed from the rectangular obscenities of dimorphic gender evolution.

O'Keeffe's recent popular success as America's "most famous woman painter" has a sharply ironic dimension. During most of her life as an artist, the public and the critics tried to find every possible indication of a specifically "female mentality" in her work, intent upon pushing her into that "ghetto" of the "woman artist" she wanted no part of; her subsequent celebrity within the context of the feminist movement has actually been based on a perpetuation—though now in what is meant to be a positive tribute to her artistry—of the same "dimorphist" insistence on the supposedly essential "femininity" of her art.

O'Keeffe, however, wanted to have her work merely express a human consciousness that would speak specifically of *humane* values *beyond* gender—values that could counteract the divisive social fictions of gender separation that had become popular as she was growing up. Her

work had its perceptual origins in a largely forgotten movement of poetic subjectivism in art we can only continue to read as "feminine" rather than as "humanist" in nature as long as we continue to subscribe to the dimorphist fictions that came to be promulgated as "science" in Western culture around 1900. It was not that O'Keeffe "resented" being a woman—not at all. She was very happy to be spared having to participate in the masculinist posturing of the men around her. She was a levelheaded person, perfectly content to celebrate the physiological differences between the sexes and the complex variegation of personal erotic identities these differences brought with them. She was also well aware of the superficial, and largely socially induced, *psychological* differences that the physiological differences between the sexes had produced in the way most men and women perceive their being in the world, and consequently their relationship to each other. But she despised the ever increasing pseudoscientific din of the evolutionists who had invaded the art world with their gender-ideological prejudices.

She recognized that the human qualities that matter all stand beyond gender. She saw them as related to what we see and fail to see. There is no physiological difference between men's and women's eyes. If men and women saw objects differently—if some men failed to see what she saw as she saw it—that was not the result of an "essential" difference between men and women, but a psychological one, created by social conditioning. As a woman—as a denigrated, yet desired "body"—she had no difficulty recognizing herself in the American land. She did not see nature as "feminine." She saw it as the source of everything that brings out our sense of interconnectedness with what exists in nature beyond ourselves, as the "oversoul" of one's being in the world. Intuition, visual thinking, was as important to her as "the intellect." The colloqui of Monos and Una took place in the nongendered spaces between the body and nature. She sought to return to that essential knowledge of the eye—that world of intuited correspondences, of "*analogy* that speaks in proof-tones to the imagination alone, and to the unaided reason bears no weight," as Poe had said.

Between 1880 and 1920 Poe's nostalgia for the world of the pregendered soul became the blueprint for the "intuitive" imagery of the international symbolist movement. But in Europe Poe's ideas were filtered through Baudelaire's language-clouded and heavily tendentious reformulation and misinterpretation of Poe's intentions. The remaining vestiges of his gender symbolism were transformed into a characteristically

European misogynist take on what Poe had seen as the "feminine side" of the bipartite human soul: a destroying materialist vampire out to wreak havoc in the realm of contemplative spiritual masculinity. By 1915 this attitude had also become a dominant theme in American culture.

But in the pre–Armory Show years of turn-of-the-century American culture, tonalism provided a complex, homegrown echo of Poe's far more positive dreams of a humane, pregendered world of natural harmonies. This element, in turn, became a major factor in the development of certain stylistic characteristics of pre–World War II American art. Much of O'Keeffe's work falls into this category. For instance, Edward Steichen's otherworldly evocation of Lake George at sunset (fig. 19) is a painting O'Keeffe certainly knew from the reproduction of it in Charles Caffin's *The Story of American Painting*. The painting is extremely close in feeling and structure to Steichen's photograph *Moonrise—New Milford, Connecticut* of 1904, reproduced by Stieglitz in the April 1906 issue of *Camera Work*. In fact, most of the landscape photography in *Camera Work* tended to be of a tonalist nature. Both painting and photograph, in turn, are, in mood and conception, remarkably similar to such works of O'Keeffe's as her *Red Hills, Lake George* of 1927 (fig. 20). As Charles Eldredge has pointed out in his *American Imagination and Symbolist Painting*, there is a close link between O'Keeffe's abstractions of the 1910s and the work of the American symbolist-tonalist painters, just as there is a direct line connecting the American tonalists with the poetic imagination of the mid-nineteenth-century transcendentalist movement, and in particular the poetic imagination of Edgar Allan Poe.

Indeed, as Eldredge has also pointed out, American painters such as Albert Ryder often, like the European symbolists, attempted to capture Poe's moods (or even, on occasion, to illustrate certain of his writings) in their work. In Ryder's well-known *Moonlit Cove*, probably painted during the 1890s but first exhibited at the Armory Show of 1913, the existential darkness Poe evoked in his *Narrative of A. Gordon Pym* finds expression in the prowling, bearlike sentience of the towering coastline. Work such as Arthur Dow's 1895 design for a poster to advertise the magazine *Modern Art* is a more subdued evocation of the same mysterious sense of interconnectedness between the self and nature to be found in Steichen's early work, the paintings of O'Keeffe and Dove, and Poe's complex blend of intuition and logic.

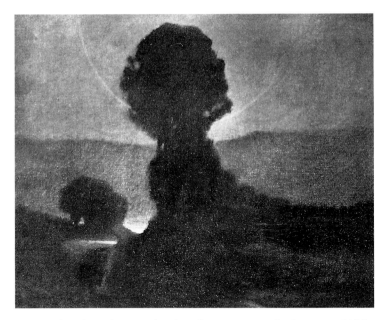

19. Edward Steichen, *Road to the Lake: Moonring, Lake George*, ca. 1906.

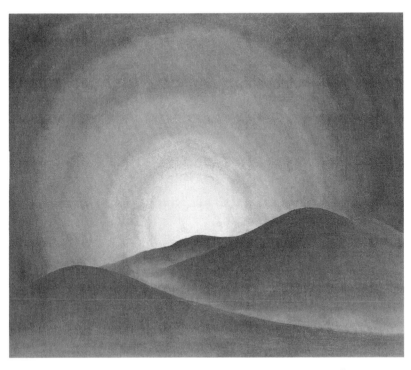

20. Georgia O'Keeffe, *Red Hills, Lake George*, 1927. The Phillips Collection, Washington, D.C. © 1998 The Georgia O'Keeffe Foundation /Artists Rights Society (ARS), New York.

The late symbolist-tonalist American painters shared with Poe, and, through their work, extended to O'Keeffe, another characteristic of the organic continuity of his preindustrial American poetical imagination. Their recognition of the existence of direct psychological links between the condition of the human mind and the natural world in which it exists, that sense Poe described of the "sentience of inanimate things," their direct effect upon what he called "the *morale*" of one's existence, also forms the basis for the sometimes rather "eerie" hold certain of O'Keeffe's paintings of soil, of skulls, of flowers, and even of the buildings of New York continue to exert over us once we have seen them. In these works we seem to sense—irrationally, but irrefutably—the very heartbeat of the seemingly inanimate objects she depicts: a heartbeat that somehow, inexplicably, echoes our own.

For such paintings, too, O'Keeffe most likely relied on American precedents. A work such as John Humphreys Johnston's *The Mysteries of Night*, painted around 1899 and reproduced in Caffin's *Story of American Painting*, can be interpreted in as many ways as one of Poe's tales of mystery and imagination, but, like everything in Poe, the artist's mysteries are rooted in the complex, intuitive ebb and flow of correspondences between the human body and the material world (fig. 21). We need take but a very small step from imagery of this sort to the seemingly innocuous, yet oddly sentient Vanderpoel gullies of Gottardo Piazzoni's California hills painted around 1914 (fig. 22). In Piazzoni's painting the body of the earth is being groomed by flealike farmers: human beings whose existential significance is dwarfed by a nature that in its pachydermic stolidity merely tolerates their parasitic presence.

To move from the mysterious power of the California landscape depicted by Piazzoni to the more modern planes, lines, and volumes of Helen Forbes's *A Vale in Death Valley* of 1930 (fig. 23) also requires little adjustment. In her painting, however, the flesh of the earth seems vulnerable and confined as it searches restlessly to liberate itself from its progressive erosion. This painting, in turn, has an almost visceral conceptual link to the images of the sensuous New Mexico hills O'Keeffe was beginning to produce at just about the same time (fig. 24).

In other words, rather than being a creation of modernism as such, O'Keeffe's art can be placed within a remarkable continuity in American art that has defined itself in spite of, and in some cases quite deliberately against, the pervasive influence of European modernism. For most of this century we have been taught to regard this resistance as a sign of the

21. J. Humphreys Johnston, *The Mysteries of Night*, ca. 1899.

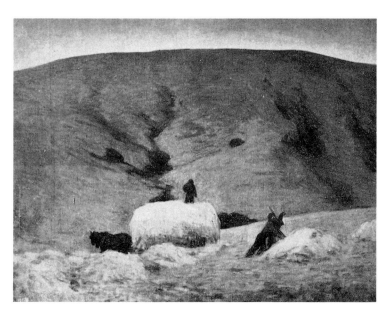

22. Gottardo Piazzoni, *The Hay Makers*, ca. 1914.

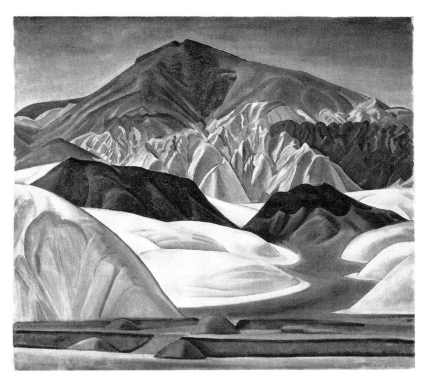

23. Helen Forbes, *A Vale in Death Valley*, 1930. Private collection.

24. Georgia O'Keeffe, *Out Back of Marie's II*, 1930. Oil on canvas, 24½ × 36½ inches. Gift of the Burnett Foundation. © The Georgia O'Keeffe Museum. The Georgia O'Keeffe Foundation / Artists Rights Society (ARS), New York.

hopeless provincialism of the American artist. Perhaps it is time for us to learn to accept the notion that artists such as Georgia O'Keeffe, while adopting the stylistic elements of modernism they found useful, in fact made a conscious choice to resist the antihumanist ideological baggage of the early European modernist movement.

It is certainly time for us to begin to recognize that for painters such as O'Keeffe, the theme of the symbolic colloqui of Monos and Una was far more central than any thought of compliance with the mechanistic evolutionary dreams of the technocrats. As is clearly indicated by O'Keeffe's account of the behavior of the male students at the Art Students' League and her very precise descriptions of the tonalist paintings she painted in an intuitive act of response to their, to her, so unacceptable behavior, she may not have cared much about complex philosophical disquisitions, but her philosophical intuition had been able to define the cultural mood around her with accuracy and acerbity. The tonalist mood of the nature she painted reflected the state of her spirit.

O'Keeffe, then, developed her art in an intuitive response to the welter of movements swirling around her. At the same time she consciously avoided a descent into the maelstrom of gratuitous modernist gesturing. She did not reject modernism out of hand; she took from it what she deemed usable. But she used only what she liked, to re-create her own version of the early American dream of a world of the senses in which gender divisions would have no meaning. She had no room for the extreme theories of gender difference that allowed F. T. Marinetti to declare, in 1915, that "modern woman" was "as a mother, as a wife, and as a lover, a closed circle, purely animal and wholly without usefulness" (75).

As we shall see in what follows, the gender issue was coming to the fore in virtually every aspect of daily life during the 1910s, the decade in which O'Keeffe succeeded in formulating the basic principles of her art. But our cultural emphasis on the "triumph" of modernism during this period has made us forget the gender prejudices on which most of the modernist values of twentieth-century art are based. This process of cultural forgetting, in turn, explains why these modernist preconceptions have continued to influence our sociocultural conceptualization of gender difference. Though they were quite self-evidently male-constructed, many of the elements of the theory of essential gender dimorphism have, in fact, become a major factor in the thinking of an

influential segment of the contemporary feminist movement. The supporters of this point of view are usually disciples of Carl Gustav Jung and tend to argue that there are certain essential feminine "intuitive" qualities that must forever separate the way women perceive reality from the way men do.

Fortunately there has recently been a tendency, effectively articulated by Anne Middleton Wagner in her book *Three Artists (Three Women): Modernism and the Art of Hesse, Krasner, and O'Keeffe*, to acknowledge the frustration of many artists who happen to be women at being characterized as "women artists." As Wagner stresses, it would serve no purpose to deny that the social environment in which these women lived made "being a woman . . . *the* condition of artistic identity, bracketing and modifying it in ways that were and continue to be inescapable" (2). After all, the artists involved had no choice in the matter. But the term remains, in its form and function, a *male* exclusionary tool, identifying *any woman* automatically as an exception, as a divergence from a clearly identifiable "norm," as "other." As long as the designation "man artist" sounds ridiculous but "woman artist" does not, residues of the prejudicial theory of dimorphic gender evolution will continue to marginalize all artists who happen to be women.

But if the term "woman painter" is exclusionary, the same can be said about preconceptions related to subject matter. Charles Caffin had felt the need to rescue the tonalists' subject matter as masculine precisely because so many of his contemporaries were already beginning to regard any quiet, poetic evocation of nature as "effeminate." Specific kinds of subject matter—flowers, for instance—came more and more to be seen as "proper" to the "woman painter"—although there is a long and honorable tradition of work by "men painters" in the field. Even Wagner, though she tries to place essentialist readings of O'Keeffe's art into their proper sociohistorical perspective, continues to essentialize O'Keeffe's *subject matter* by insisting that her paintings of flowers "literalize 'femininity' by tying the concept down to botanical bodies and their transparent analogies" (98).

Wagner implies that O'Keeffe chose to paint flowers as a way of thumbing her nose at her critics ("the visual version of something like 'You want feminine, I'll give you feminine'"). But though O'Keeffe may have chosen to paint flowers *in spite of* the critics' prejudices, that is very different from assuming that she painted flowers *to spite* them. O'Keeffe

wanted to show that "even" flowers could express the nongendered elements of emotional experience echoed in *all* the shapes of nature. If "the men's" spurious theories of dimorphism had metaphorized all flowers into markers of the "feminine," she intended to show otherwise. But, as we shall note in due course, even she was not able to foresee how quixotic that attempt would prove to be.

Technocracy versus the
Color of Mood

Vanderpoel had already stressed that technique and knowledge of detail must always remain secondary to the artist's awareness of nature as color, tone, texture, light, and shade, as a universal language of organic forms. He had also stressed that an artist's treatment of the parts of an object should always remain in harmony with the inherent integrity of the form as a whole. It is safe to assume that O'Keeffe's manner of using line in her work was, by the second decade of the new century, well on its way to becoming as "firm and assertive" as Vanderpoel had insisted it should be in the work of any mature artist. For one thing, she had tried her hand at commercial art—a thriving field, inherently much concerned with issues of immediacy and simplification. As Charles Eldredge has pointed out in *Georgia O'Keeffe, American and Modern*, she had also undoubtedly learned much from the simplification and stylization of organic form characteristic of "the flowing patterns of Art Nouveau"—a "formal vocabulary [that] was nearly ubiquitous in American art and design at the turn of the century, and [that] provides one obvious foundation for O'Keeffe's organic inventions" (162).

Another considerable influence would have been the field of magazine illustration—one that had come to be so respected that most critics of the period accepted it as an area of legitimate artistic endeavor. Samuel Isham and Sadakichi Hartmann devoted considerable space to the field in their histories of American painting, while magazines such as the *Artist* and the *International Studio* often ran features on illustration. Even in mundane general interest monthlies such as the *Cosmopolitan* one could encounter sophisticated modern drawings. The flat, would-be *cloisonniste* silhouette drawings James Preston produced in May 1906 for "Sleepy-Eye," a story by Anton Chekov, are representative

25. James Preston, *Varka Jumps Up, and, Looking around Her, Remembers Where She Is,* 1906.

of the playfully innovative work that often could be found in such mag-
azines alongside far more routine narrative drawings (fig. 25).

American versions of Japonisme probably exerted a considerable in-
fluence on O'Keeffe's way of seeing the world well before she came
under the direct influence of the teachings of Arthur Dow, for the
pages of most of the popular art magazines—and in particular the *Inter-
national Studio*, were filled with analyses of "oriental decorative prac-
tices." With tonalist, symbolist, japoniste, fauvist—and, soon, cubist—
impulses vying for her attention, these were, as O'Keeffe was always the
first to admit, confusing years. But by the time she began to attend a
drawing class taught by Alon Bement at the University of Virginia dur-
ing the summer of 1912, she was ready to consolidate the welter of
influences she had undergone during the first decade of the new cen-
tury. Bement was an ardent follower of Arthur Wesley Dow, and Dow's
theories, filtered through Bement's teaching, were to provide O'Keeffe
with a sensible method for joining the traditional forms of conceptual-
ization she had learned from John Vanderpoel with the contemplative

transcendental materialism of the tonalists and the more anarchic modernist impulses that were beginning to confront her on all sides.

Early students of O'Keeffe's life and work tended to disparage the importance of Dow's influence on her development as an artist, in order to focus greater attention on her link with Stieglitz. In recent years, however, Dow's influence has been exaggerated until many now see him as her main formative influence—an equally reductive point of view that, one can only hope, recently reached its dead end in Jeffrey Hogrefe's patently absurd declaration that "practically everything Georgia O'Keeffe would become as a mature artist she acquired in those few classes" (44) she took with Bement in the summer of 1912. O'Keeffe, characteristically, listened, learned, and, instead of adopting the Dow-Bement approach to art uncritically, she continued to go her own way. In 1976 she recalled her role as a teaching associate of Bement's during three summers at the University of Virginia with self-evident pride in her youthful independence. She remembered how the man had fussed over her skepticism about the validity of his—and Dow's—ideas: "The second year going down from New York, Bement said, 'Now I don't want you to get up right after me and tell the class that what I say isn't so and to pay no attention to me.'"

O'Keeffe's anecdote clearly indicates her unwillingness to leave Bement's—or for that matter, anyone else's—teachings unexamined. Too great a reliance on formulas—stylistic crutches—of any sort, she implied, makes for bad art. The artist's principal task was to express deep *personal* feeling. One should never allow one's contact with the inarticulable insights of the human soul to be severed by mere theories and requirements. The narrow dictates of fashion were a blindfold to authentic experience. The true artist was an intuitive dialectician picking and choosing among all available stylistic and theoretical options to develop ever more expressive analogues between the poetry of human longing and the forms of nature.

No wonder, then, that although O'Keeffe valued Bement as "a very good teacher," she did not consider him to be "a painter at all. He had no courage and I believe that to create one's own world in any of the arts takes courage." In today's cultural environment, in which the pit and pendulum of fashion and theory—of imitation and conceptualization—have all but become the entire circumference of the artist's universe, O'Keeffe's concept of artistic courage may seem quaint and

inefficient. Why bother to talk about courage when all you need is a marketable gimmick (and a critic who can sell that gimmick to the right "art investors")? But the whole point of O'Keeffe's emphasis on artistic courage is its suggestion—rapidly also becoming arcane—that the artist must be strong enough to be willing to accept failure—to countenance producing maudlin work in pursuit of great ideas; that not every experiment is "art" simply because it is an experiment; and that much of the mark of a true artist is to recognize that trying to make art that means something means falling on one's face most of the time.

In the wake of the modernists' almost exclusive emphasis on form— on "art as art"—contemporary culture has learned to glorify concepts of expression over expression itself. This realm of art as theory has become a "fail-safe" formula for the "intellectual" identification of what is art, dependent not so much on the artist as on the critic for its raw materials. Such a process of "making art" as a form of theorizing must of necessity stay as far removed from the risk-fraught realm of complex emotional subjectivity as possible, for to concretize subjectivity in art is always a risky business. The maudlin and the sublime are often merely a brush stroke apart in any work of art that sets out to capture the emotional essentials of human experience.

As O'Keeffe implied in her remarks about Bement, the artist needs to exhibit courage to venture into this realm, particularly when living in a world dominated by the modernist mind-set, which values theories of irony and distance over emotional continuities and sentiment in much the same single-minded fashion as the nineteenth century valued sentiment over immediacy and innovation. In line with the imperialist mind-set of early-twentieth-century evolutionary politics we have come to see even emotion itself as maudlin, as "effeminate." O'Keeffe, with her dialectical perception of the role of the artist, recognized that the truth of art must integrate and ultimately overarch these dualistic extremes. She recognized that Bement was too obsessed with the teachings of Dow to be willing to risk doing the wrong thing.

O'Keeffe's assessment of Bement's lack of courage as an artist is, therefore, also a comment on the function of theory in art. If the creative imagination tries to shy away from emotional risk—from the tempestuous oceans and Ryderesque cloudscapes of human longing—it may not fall into maudlin failure, but neither is it likely to produce the lasting sensuous embrace of O'Keeffe's best work. The twentieth century's theoreticians of modernism and their Bement-like acolytes, ranging from

Sadakichi Hartmann to Robert Hughes and beyond, have, O'Keeffe's remark implies, stripped art of its core of courage by their disapproval of emotional risk taking, an approach they have clearly chosen to confine to the ghetto of "women artists." O'Keeffe's response to their theorizing, throughout her life, was to insist that it is better to try and to fail in one's attempts to integrate the intellect and the emotions than not to try at all. Courage—that so-called virility of the great experimental artists the critics went on and on about—was not a gender issue at all: it was an expression of the integrated ego, a colloqui of Monos and Una in defiance of the rectangular obscenities of the regimented mind.

But if O'Keeffe refused to imitate Bement's slavish pursuit of Dow's teachings, that did not mean that she did not learn and grow from her contact with the ideas he articulated for her. They cannot but have influenced her understanding of the budding modernist movement's insistence on an extreme simplification of line, volume, and perspective: elements she had not yet come to terms with when she first encountered the watercolors of Rodin at Stieglitz's gallery 291 in 1908. But as her description of the two "real" paintings she did at the Art Students' League clearly indicates, she had already encountered many evidences of this tendency in the work of the late tonalists. She could not have avoided encountering their work while visiting the galleries or any of the numerous annual exhibitions of American art being held in cities throughout the United States during this period.

After the turn of the century paintings integrating symbolist and tonalist qualities had become commonplace at these exhibitions. Many of these works blended elements of the newly popular psychology of the unconscious with a tonalist conception of form. Dow, too, continued to pursue tonalist goals into the new century, but more than most of his colleagues he began to combine patterns of essential organic line with flat fields of subdued color that were given texture and depth by the grain of the paper or the canvas on which he printed or painted them. In every one of these images, however, it remained his intention, not to surpass or move away from nature, but rather to reaffirm the correspondences between the forms of nature and the emotions.

Several of the members of Stieglitz's Photo-Secession movement, including Gertrude Käsebier, Alvin Langdon Coburn, and Clarence White, had at one time or another during the years around the turn of the century fallen under the influence of Dow's way of seeing. The artist and book illustrator Pamela Colman Smith, who like these photogra-

phers subsequently moved into Stieglitz's circle, also felt the influence of Dow's teaching. This creative interaction between Dow's entourage and the early Stieglitz circle is by no means accidental. The photographer's belief that the "pictorialist" must seek out equivalences between the emotions and nature was exactly Dow's own point of view, and they had the same antecedents in the nineteenth-century American way of seeing. Dow was as interested in photography as Stieglitz was in painting.

Indeed, since the monochromatic subtleties of the photogravure process lent themselves particularly well to the representation of tonalist themes, it is not surprising that both *Camera Notes* (1897–1903), the magazine Stieglitz edited for the Camera Club of New York, and *Camera Work* placed great emphasis on tonalist landscape photographs that ranged from William B. Post's *Intervale, Winter*, published in the July 1901 issue of *Camera Notes* and uncannily similar in composition and mood to some of Bruce Crane's paintings of the 1890s, to such works as Yarnall Abbott's *Sentinels* in the January 1909 issue of *Camera Work* (see fig. 17). Many of Stieglitz's own photographs from *An Icy Night* and *Spring Showers* to such late works as *Clouds—Music no. 1* (1922, fig. 26) further enhanced the enduring link between the concerns of the Stieglitz circle and those of the tonalists.

These late tonalist-symbolist images, so influential in the articulation of O'Keeffe's visual aesthetic, virtually always combined an evocation of the intangible nuances of mood with a determined simplification of the representation of organic volumes. Perspective often came to be schematized into a system of overlapping planes that could be considered in line with some of the structural concerns of early cubism. The influence of Asian art expressed itself in a focus on outline and silhouette analogous to that to be found in the work of illustrators such as James Preston.

Indeed, most of the progressively minded artists of this period were trying to find new ways to express emotions and psychological realities through stylized, simplified, sharply delineated forms. Gottardo Piazzoni's *Reflection* of 1904 is an excellent example of this tendency (fig. 27). The work of the tonalist-symbolists therefore forms a far more direct bridge between the central concerns of earlier American art movements and the stylistic and philosophical explorations of the early-twentieth-century American modernists than that of either the American impressionists or the mechanistic structures of most of the

26. Alfred Stieglitz, *Clouds* [*Music—No. 1*], photograph, 1922. The Alfred Stieglitz Collection, Gift of Alfred Stieglitz. Courtesy, Museum of Fine Arts, Boston.

European avant-garde. Arthur Dow's oeuvre *was part* of this bridge; he did not by any means build it.

The flattened, stylized, abstracted organic linearity of Japanese art, and particularly that of Hokusai, had fascinated Dow at an early date. His interest was fueled further by discussions with Ernest Fenollosa, the pioneer Spanish-American scholar of Asian literature and art born in Salem, Massachussetts, who, in 1890, became curator of Oriental Art at the Boston Museum of Fine Arts, and who was also destined to become a factor in the development of twentieth-century American literature through his later influence on the work and the thinking of Ezra Pound.

Dow's strong personal belief in the philosophical principles underlying the tonalist movement soon led him toward a search for a calligraphy of the emotions that could serve to express the "wholeness," the implicit emotional complexity, of the art image as a nondidactic yet

27. Gottardo Piazzoni, *Reflection*, 1904. Courtesy of
the Oakland Museum of California, Gift of the Estate
of Marjorie Eaton by exchange.

transcendent "thing in itself." He sought to create an aesthetic entity
that, though beyond practical use as a tool for the inculcation of specific
social, moral, or historical sentiments, would, by being anchored in the
visual language of organic form, continue to exist as a nonspecific peda-
gogic medium, by providing analogues between the shapes of nature
and the otherwise intangible nuances of human feeling. His intentions,
like those of the other American tonalist-symbolist painters and pho-
tographers—including many of those who were his students—thus
corresponded closely to the "spiritual" objectives of many of the early
European modernists. They also predate Stieglitz's adoption of a similar
agenda for photography.

But European modernism would soon abandon the emotional "spiritualism" of Kandinsky's *Concerning the Spiritual in Art* in favor of the speculative evolutionist intellectualism of philosophers such as Henri Bergson. Soon, heavily influenced by Picasso's misunderstanding of Cézanne's fundamentally organic intentions, as well as by the laconic nihilism of Duchamp and Picabia, and the loud antifeminine posturing of the futurists, the Europeans would come to see art as primarily an expression of the mechanistic triumph of the human mind over nature—an expression of the evolutionary elite's intellectual capacity to transcend the trivial imitative concerns of all conventional forms of art.

In contrast to this attitude, Dow, like Stieglitz, and like most serious American artists of this period, continued to pursue the tonalists' belief in the overarching, cohesive spiritual harmony of nature and therefore also continued to avoid any disparagement of nature as a source of inspiration for the artist. The chilly New York day Birge Harrison evoked in his painting *The Flat Iron after Rain* (fig. 28), for instance, has far more in common with the tonalist cityscapes Stieglitz was producing at just about the same time than the work of either artist had with the essentially intellectual experiments of the European postimpressionists and fauves. Stieglitz wanted to prove that the camera, rather than being merely a tool of mechanical reproduction, could evoke the color of mood as well as the products of any painter, and Harrison wanted to show that the Europeans' obsession with primary colors was about to rob the world of the philosophical nuances of the transcendental imagination.

The inability of impressionist, postimpressionist, and fauvist art to convey real emotional depth lay, Harrison insisted, "in the physical impossibility of securing with pigments and brushes any approximation to the infinitely fine and delicate color vibration of nature—where no spot or dash or stroke of pure color is anywhere visible." For Harrison, as a true tonalist, the emotional inauthenticity of the postimpressionist mode became most obvious in its inability to capture the subtleties of moonlight: "It can easily be seen that in this subdued light the sibilant vibration of powerful color-tones would be fatally out of place and their use detract seriously from the brooding sense of mystery which gives to night its most poignant charm" (44). On reading his book *Landscape Painting*, one begins to suspect that through Harrison's mind, as he wrote these remarks, there rumbled, though well beyond what he allowed himself to articulate, echoes of Poe's biting condemnation of the

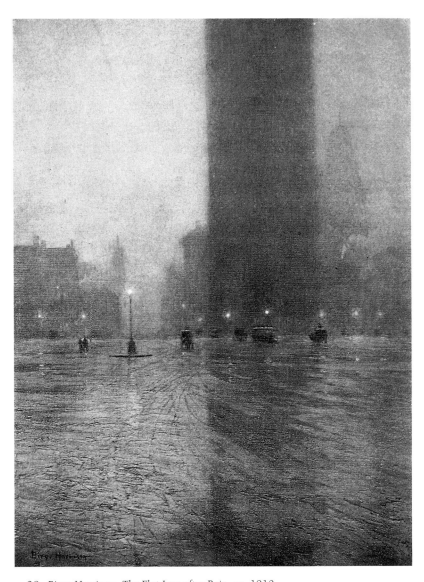

28. Birge Harrison, *The Flat Iron after Rain*, ca. 1910.

crass materialism of industrial society's "new men" : "A man of large purse has usually a very little soul which he keeps in it" ("The Philosophy of Furniture," 465).

Certainly it is a "traditional" concern for the emotional complexities of artistic expression that continues to move us in the works of artists such as Harrison and Stieglitz. It is their ability to capture the intangible interaction among nature, our perception of the city as object, and our sense of being—the link between nature and culture—that continues to speak to us. It is, of course, also precisely these qualities that draw us back time and again to the art of Georgia O'Keeffe.

Most critics have emphasized the "internationalism" of Stieglitz and Dow, and have extrapolated from that an active interest in international art movements on O'Keeffe's part as well. But the artistic sensibility that linked these two men, and that, in turn, was soon to link both with O'Keeffe, found its origin, as we have seen, squarely in their American background, and in their conviction that it was the artist's task to be a minister in the ecumenical, transcendently material holy house of nature with its magic altars of organic matter. Indeed, neither Dow nor Stieglitz sought to transcend the material world on the wings of metaphysical theory. Instead they tried to find themselves in the sonorous chords of darkness that echoed through the fading light of a dying social coherence urgently reconstructed in matter. But where Dow sought inspiration from river villages and cloudscapes, Stieglitz for a while became content to find his America in the city.

When Alon Bement alerted O'Keeffe to the significance of Dow's belief that the artist should strive to abstract the organic lines of the objects in the material world toward their essence, she heard him articulate ideas that had already been swirling about her for many years, and that corresponded closely to her own sense of the purposes of art. When she studied Dow's book *Composition* (first published in 1899, and in its seventh edition by 1913) with its paeans to Japanese design, she recognized in his words her American background. "The Japanese," Dow pointed out, "knew no division into Representative and Decorative; they thought of painting as the art of two dimensions, the art of rhythm and harmony, in which modelling and nature-imitation are subordinate."

At the same time, however, Dow pointed out, the Japanese artist continued to love "nature and went to her for his subjects," if not to imitate "her." "The winding brook with wild iris, the wave and spray,

the landscape, were to him themes for art to be translated into terms of line or dark-and-light or color" (6). Essential line, simplification, purity of focus—these are the recurring themes of *Composition*. Modern art was to be the means by which humanity might clarify its emotional bond with the forms of nature. Dow perceived Japanese art through an American tonalist filter.

In addition to reading Dow's book and listening to Bement's disquisitions, O'Keeffe also attended Dow's classes at Columbia Teachers College in 1914. His insistence that Western culture's attempts to separate the spheres of "high" art and "decoration" were artificial probably made it easier for her to think of a career in commercial art. If she wanted to be independent, she would have to be able to provide for herself, and a career in "high art" was, given the developing cultural hostility toward women who wanted to be painters, not likely to be a viable option. She might become a teacher, or she might be able to find a niche in commercial art. Between 1914 and 1918 she was to give both options a try. But whereas her days as a teacher at Columbia College in South Carolina and in Canyon at West Texas State Normal College have received considerable attention, her interest in the field of commercial art has been largely neglected. Her efforts in that direction, which she pursued in tandem with her more adventurous "high art" experiments in abstraction of around 1915–16, give us an interesting perspective on O'Keeffe's cultural environment during this period of transition.

The Masses and the
Matter of Mind

Book and magazine illustration had proliferated dramatically in both Europe and the United States during the 1890s and the first decade of the twentieth century. Numerous artists had found in illustration a respectable source of income that could support their more "serious," if far less remunerative, endeavors. Arthur Dove, for instance, before he became one of America's first abstract painters, frequently contributed narrative drawings to the popular monthly magazines. These were very lively, but quite conventional, although they had a gritty, satirical edge (fig. 29). At this time Dove was clearly patterning his illustrations after the work of John Sloan, whom he had befriended, and who considered him to be "a nice sort of young chap" (66).

The presence of so many thoroughly trained, often quite inventive artists caused even stern critics such as Sadakichi Hartmann to recognize the importance of the new form, if with a certain truculence. Hartmann complained that the huge demand for illustrations had already devalued the medium: "The artists, unwilling to refuse any commissions, became neglectful and, in consequence, less serious and original in their work" (2:110).

Even so, illustration had become a major factor in American culture as O'Keeffe was growing up. Stieglitz's magazines *Camera Notes* and *Camera Work*, with their superb and, to a large extent, still unequaled attention to the nuances of reproduction, were, in popular terms, mere foam on the crest of a gigantic wave of public fascination with pictures. By 1915 Eugen Neuhaus even claimed in *The Galleries of the Exposition*, his critical perambulation of the Panama-Pacific International Exposition in San Francisco, that "the astonishing development of illustration in America" (58) was having a noticeable effect on the public's capacity to appreciate art. Artists and critics alike regarded illustration as potentially a legitimate branch of "the fine arts."

" 'CAP'N, YOU WANT TA MAKE A THOUSAND DOLLARS?' "

29. Arthur Dove, *Cap'n You Want ta Make a Thousand Dollars?*, 1906.

But as Hartmann's remarks indicate, most editors had already learned that, merely by adding attractive drawings and photographs, they could seduce an ever larger segment of the population into buying magazines that, until the beginning of the 1880s, remained far too intimidating to the average reader, with their uninviting pages of densely packed type. Illustration changed their look and opened up the market to less determined readers. Between 1900 and 1920 popular illustrated magazines came to fulfill a function closely analogous to the role movies and comic books were to have from the twenties through the fifties, and that television has occupied ever since.

As the mass market's taste for images increased the mainstream magazines' profitability, their editors fell back more and more frequently on a narrowly defined pseudophotographic, "bourgeois realist" mode of illustration. The often quirky, easily recognizable personal styles of the artist-illustrators of the 1890s were rapidly replaced by the work of a conformist horde of highly skilled, but stylistically virtually interchangeable, professional illustrators.

The businessmen in charge of the bottom line liked to use catch-

phrases such as "good taste" and "journalistic standards" to justify this development, but editors such as Ambrose Bierce of *Cosmopolitan Magazine* recognized that to the more imaginative souls among their readers such work as James Preston's silhouettes was far more eye-catching than still another bland panel of realist narrative by a hack. As a result, magazines like the *Cosmopolitan*, to draw attention to themselves, soon began to emphasize the originality of their illustrations. Max Eastman, editor of the upstart left-political periodical *The Masses*, went so far as to insist—in his little book *Journalism versus Art*, a set of four essays published by Alfred A. Knopf in 1916—that the artists and writers responsible for *The Masses* had made it a point "to bring out a magazine which should publish art and literature without any canons of good journalism" (7).

For a young artist such as O'Keeffe, hungry for authentic experience, the innovative, frequently very spare and "modern" line drawings featured in *The Masses* must have provided a dramatic contrast to what Eastman termed the "monotony so idealized, entrenched, and confirmed by commercial success" (46) characteristic of most other magazine art. From its first issue of January 1911, *The Masses* proved to be the most acerbic and controversial new left-wing political monthly in the country. Time and again it ran into trouble with the censors, and its enemies finally succeeded in making it bite the dust in December 1917. But during the few years it saw publication, it provided its readers with a steady barrage of brilliant satirical and political drawings by some of the most adventurous American artists of the time. An extraordinary range of still remembered and unjustly forgotten painters published their work in its pages. Members of the ashcan school such as Sloan and George Bellows were regular contributors, as were early modernists like Stuart Davis, Arthur B. Davies (one of the key organizers of the Armory Show), and Maurice Sterne. From the summer of 1915 on, Georgia O'Keeffe became one of the very select group of radical spirits who formed the magazine's core of subscribers.

During this period of its existence, *The Masses* was—along with Alfred Stieglitz's short-lived, experimental *291*, to which O'Keeffe also subscribed—in terms of its graphics, by far the most visually adventurous American magazine around. Biting political cartoons by Sloan, Bellows, Stuart Davis, Boardman Robinson, Robert Minor, and Art Young were supplemented by work in which the political content took a backseat to the image as art object. In these images the influence of

30. Ilonka Karasz,
Slumming, from
The Masses, April 1916.

modernism was clear. An emphasis on simplified, flattened volumes and line was typical, and the artists made full use of the startling black and white contrasts the printing process made possible.

But, in fact, the most daring and unusual graphics in the magazine were not produced by artists who have remained—or have since become—famous. Instead they came from designer-illustrators such as Ilonka Karasz, who was almost a decade younger than O'Keeffe. Karasz, a recent immigrant from Hungary, would go on to do numerous remarkably inventive covers for the *New Yorker* from that magazine's inception in 1925 through 1973. Her stark image of a wealthy young woman pictured in front of a row of brownstone working-class storefronts, titled *Slumming* (fig. 30) and published in the April 1916 issue of *The Masses*, is an excellent example of the striking visual experiments in line drawing O'Keeffe encountered in the magazine.

Drawings such as the playful pagan nudes (fig. 31) of Hugo Gellert must also have caught O'Keeffe's eye. Gellert was another Hungarian-American. He would soon develop into a brilliant social-expressionist painter and muralist, and—during the Depression years—he became one of the most acerbic political satirists on the staff of the *New Masses*. His experiments in black and white for the original *Masses* no doubt helped direct O'Keeffe's attention to an exploration of the striking optical effects her now so familiar white "gullies" of outline added to the visual impact of her watercolors from this period (figs. 32 and 33).

31. Hugo Gellert, *Nude*, from *The Masses*, June 1916.

32. Georgia O'Keeffe, *Landscape with Crows*, 1916–18, from the *Canyon Suite*.
Kemper Museum of Contemporary Art & Design, Kansas City, Missouri.
Bebe and Crosby Kemper Collection. Gift of Mr. and Mrs. R. Crosby Kemper, Jr.
© 1998 The Georgia O'Keeffe Foundation / Artists Rights Society
(ARS), New York.

33. Georgia O'Keeffe, *Morning Sky with Houses, No. 2*, 1916. © 1998 The
Georgia O'Keeffe Foundation / Artists Rights Society (ARS), New York.

But the most consistently adventurous images published by *The
Masses* were produced by Frank Walts, who was perhaps also the most
original and innovative American graphic artist of the period, although
today he is so completely forgotten that we know neither the date of his
birth nor that of his death. Walts's current obscurity is, given the bril-
liance of his designs, a true object lesson in the way history disposes of
artists whose works are too quirky to pigeonhole. Most of what little we
know about him comes from Art Young's 1928 memoir *On My Way*:
"Frank Walts, the son of an Indiana preacher, was a [*Masses*] regular.
Walts traversed New York with a pen and sketch pad as eager for picto-
rial subjects as a hunter for game. He made many striking and artistic
cover designs. Solitary, particular, uncompromising, occasionally doing
posters for the theaters, this boy Walts interested me. He devised a pair
of spectacles through which he could look straight ahead and yet see
what was behind him. He invented a fountain brush, preferring it to a
pen for sketching" (290).

Walts's fountain brush became a major factor in the success of his

spectacular modernist cover designs for *The Masses*. Bold, strong in line, and able to capture the essence of a subject through the use of a few well-chosen details, his sketches sometimes became graphic analogues to Constantin Brancusi's sculptural forms, which, in fact, may well have been the underlying inspiration for these drawings. Indeed, a number of them were produced in the year of the Armory Show, including a striking, heavily simplified and abstracted image of a young woman that was subsequently used as the cover for the March 1914 issue of *The Masses* (fig. 34). The cover of the February 1916 issue, published when O'Keeffe was certainly receiving the magazine, featured another of his drawings in which a satire of fashion became the source for an abstract design (fig. 35). Fascinating—if probably unconscious—echoes of Walts's brushwork can be found in such watercolors of O'Keeffe's as her *Trees and Picket Fence* of 1918 (fig. 36).

In addition to *The Masses*—with its radical political focus and its staff of illustrators who were, as a matter of fact, quite divided in their opinion of modernism—another magazine had begun to take a calculated stance in favor of elegantly stylized, "modernist" line drawings. But its subdued modernist tone had a very different purpose. Correctly sizing up the snob appeal modernism had already begun to acquire among the social and intellectual elite as a convenient way of separating the "high"-minded from the vulgar concerns of the masses, *Vanity Fair* had, by 1916, evolved from the fashion magazine *Dress* into an up-to-date, sophisticated, often flippant, source of cultural enlightenment for the new, educated, self-confidently "modern" American leisure class, a class that saw itself as the evolutionary elite of civilization.

As early as 1914, *Vanity Fair* featured a humorous piece in which P. G. Wodehouse claimed to have invented "Futurist writing," and which contained passages that were awfully close in content to the serious stuff the dadaists were to produce at the Cafe Voltaire in Zurich the following year. Also in 1914, the magazine published a group of Anne Brigman's very beautiful and lyrical photographs of female nudes in the rugged California landscape, several of which had been published earlier in Stieglitz's *Camera Work*. In August, it featured a group of—this time seriously intended—"Cubist Poems" by Max Weber, and in June 1915, the magazine nominated Stieglitz to its "Hall of Fame," in tribute to his efforts in behalf of modern art.

Among ads for the latest corsets and facial creams and a steady procession of photographs of famous stage actresses and movie stars, as

MARCH, 1914 10 CENTS

The MASSES

34. Frank Walts, Cover, *The Masses*, March 1914.

35. Frank Walts,
Cover, *The Masses*,
February 1916.

36. Georgia O'Keeffe,
Trees and Picket Fence,
1918. Milwaukee Art
Museum, Gift of
Mrs. Harry Lynde
Bradley. © 1998 The
Georgia O'Keeffe
Foundation / Artists
Rights Society (ARS),
New York.

well as numerous fashionable studies of young women determinedly dancing in open-air settings and usually clad only in diaphanous veils, or less (each dancer dutifully identified as a serious student of the artistic principles of Isadora Duncan or Ruth St. Denis), *Vanity Fair* also published short articles on current cultural matters. Between 1915 and 1917, for instance, as the magazine continued to grow in popularity, it ran an impressive and intelligently appreciative series of articles about the newest movements and masters of European and American art, including Cézanne, Matisse, Picasso, Arthur Davies, Ernest Lawson, Allen Tucker, Max Weber, Duchamp, Boccioni, Picabia, Brancusi, Wyndham Lewis, Jacob Epstein, Elie Nadelman, Rouault, and many others, all accompanied by well-chosen reproductions of these artists' most challenging work. It also featured, on its contents page, every month, a witty and elegant decoration, by such Beardsley- and Art Nouveau–inspired illustrators as Gluyas Williams, Robert Locher, and the expert draftsman Sidney Joseph (fig. 37), whose styles were clear harbingers of the art deco magazine art of the twenties. The decorations on the contents page of *Vanity Fair* for the months of November 1916 and August 1917 were by Georgia O'Keeffe (figs. 38 and 39).

Since they had been printed in the pages of a magazine, these were two drawings O'Keeffe was not able to destroy that fateful day after her arrival at the Fifty-ninth Street studio when she decided to dispose of most of her early work. Consequently they give us a unique insight into the styles she was drawn to during her brief venture into the realm of "decorative art." The structure of these two black-and-white ink drawings makes it clear that O'Keeffe had combined the broad simplifications of Frank Walts with Sidney Joseph's sharply etched, stylized, witty, but self-consciously "decadent" line drawings.

But O'Keeffe's *Vanity Fair* decoration of November 1916, in particular, which was captioned "After the ball is over, the New York débutante retires to her maidenly couch," also suggests another, equally interesting influence. O'Keeffe's exploration of the decorative interaction of flowery patterns against a proliferation of flattened planes corresponds closely to the imaginative and brilliantly realized color covers Helen Dryden had been designing for *Vogue* magazine. Born in Baltimore in 1887, Dryden was O'Keeffe's exact contemporary, and by the mid-1910s she was already well on her way to becoming a major figure in American industrial art (the design of the 1937 Studebaker was to be her handiwork). She had studied at the Pennsylvania Academy of

37. Sidney Joseph, masthead decoration, *Vanity Fair*, November 1915.

Drawn by Georgia O'Keeffe

After the ball is over, the New York débutante retires to her maidenly couch

38. Georgia O'Keeffe, *After the Ball Is Over the New York Débutante Retires to Her Maidenly Couch*, masthead decoration, *Vanity Fair*, November 1916.

Fine Arts, and by 1911 she was contributing covers to *Vogue* in which her use of flattened color fields and strong, stylized, yet still predominantly "organic," outlines clearly showed the influence of Arthur Dow's theories.

By 1914, Dryden's covers had become much more stylized in a linear fashion. They were now emphatically two-dimensional: beautifully composed planes of flat color, contained by sharply etched, heavily stylized patterns of line, not unlike those of Sidney Joseph, but far less self-consciously erotic in subject matter. Between 1914 and 1918 Dryden contributed numerous covers of this nature to *Vogue*, work in which Dow's ideal of an American decorative art after the Japanese example seemed well on its way to fruition.

THE FRIGHTENED HORSES AND THE INQUISITIVE FISH
Suggestion—by Georgia O'Keefe—for a stained glass window for the swimming pool in a Rocky Mountain Country Club

39. Georgia O'Keeffe, *The Frightened Horses and the Inquisitive Fish*, masthead decoration, *Vanity Fair*, August 1917.

40. Ilonka Karasz, Cover, *The Masses*, December 1915.

O'Keeffe's drawing of a debutante for *Vanity Fair* clearly owes a great deal to what she had learned from Dryden's sense of design (as well as, to a lesser extent, from such other major *Vogue* and *Vanity Fair* cover artists as George Plank and Georges Lepape), but what is perhaps most interesting in O'Keeffe's design is not what it takes from the *Vanity Fair* and *Vogue* artists, but how much of their design characteristics it manages to *avoid*. The free-flowing, rather loosely contained quality of her composition remains far more closely related to the organic sense of line and playful irreverence of *The Masses* artists than to the "value-free" stylized intellectualism characteristic of the *Vanity Fair* contingent.

This aspect of O'Keeffe's decorations becomes even more pronounced in her design for the August 1917 issue of *Vanity Fair*, which is captioned: "THE FRIGHTENED HORSES AND THE INQUISITIVE FISH; Suggestion—by Georgia O'Keefe [*sic*]—for a stained glass window for the swimming pool of a Rocky Mountain Country Club." In this work, stylized, yet three-dimensionally modeled dancers (O'Keeffe's own ironic commentary on the vogue for back-to-nature dancing as a form of self-expression among young women) are set against shapes that could be either towering waves or shallow mountains, but that are, in any case, deliberately organic in their modulation. A drawing by Ilonka Karasz, used as the cover of the December 1915 issue of *The Masses* and depicting a quite uninhibited, and quite tipsy, dancing debutante (fig. 40), provides an uncanny anticipation of both the satirical spirit and the stylistic focus of O'Keeffe's decoration.

At this crucial stage in her development O'Keeffe, like the artists of *The Masses*, clearly made a conscious decision not to abandon her focus on organic form. European modernism by this time had moved beyond the "spiritual," toward a flattened (and hence, in the cubist sense, largely mechanistic) visual world reflecting the "intellectual superiority" of the "synthetic spirit": what were considered to be the "virile," intellectual qualities of mind. O'Keeffe clearly remained unwilling to abandon "nature"—the guiding emotive energies of organic form—to pursue "culture," the mind's ability to control and manipulate the "subjective chaos" of material reality.

In consequence O'Keeffe's explorations of "decorative art" give us a fleeting, but in historical terms quite significant, indication of the impact of *The Masses* artists on the development of O'Keeffe's style. Add this to the welter of modernist influences, both from abroad and from what she had seen of Arthur Dove's explorations of organic abstraction,

tonalist art, and Arthur Dow's theories, and it becomes apparent that the various elements of her style were rapidly beginning to develop into a distinctly personal version of American transcendental materialism, as an intuitive, yet fundamentally pragmatic, pantheism of sense experience. The joyful reverence of her American contemporaries for the structural integrity of organic form in particular helped teach O'Keeffe to express her personal identity in the "sensual delight" of a nongendered exploration of the many shapes—the many "bodies"—of nature, unsullied by the subjective interference of personality. O'Keeffe was slowly discovering that unique calligraphy of the emotions—that "sole consciousness of entity"—that, in her mature work, would ultimately become "merged in that of *place*," as Poe had expressed it in his "Colloqui of Monos and Una" (450).

This intuitive materialist dialectic between nature and the senses expressed itself in the body's apperception and celebration of the sensory immortality of the material world, in what Poe had termed a "keen, perfect, self-existing sentiment of *duration*"—a "sixth sense" representing "the first obvious and certain step of the intemporal soul upon the threshold of the temporal Eternity": a marriage of matter and mind in an otherwise dualistic, bigendered world (449). But in the intellectual environment of the 1910s this imagery of the nongendered harmony of the soul had become hopelessly outdated. The "battle of the sexes" had become a convenient, yet, in practical terms, anything but metaphoric, explanation for the crass colonial territorialism and economic expansionism of the Western imperialist nations.

Within this cultural context, the clash between European modernism and O'Keeffe's American background became a "gendered" confrontation that was to form the core of her intellectual formation between 1909—the year in which she first encountered the "masculinity-factor" of modernist theory at the Art Students' League—and 1919, the year in which she painted her triumphant resolution of the issue of gender in art, the *Fifty-ninth Street Studio*. To understand the precise nature of Georgia O'Keeffe's remarkable achievement as an artist, we are therefore also forced to disinter the patriarchal ideology of early modernist art.

Economics and the
Myth of Modernist
Martyrdom

At the instigation of Alon Bement, O'Keeffe read Kandinsky's *Concerning the Spiritual in Art*. That essay's emphasis on the correspondences among emotion, color, sound, and form undoubtedly encouraged her to explore the more abstract relationships between visual "music" and inner experience. But the issues of abstraction, simplification of form, and "evolutionary experimentation" were bound to confront anyone at all interested in the arts during the mid-1910s. Today art historians have a tendency to portray the early modernist painters, like the impressionists, as embattled, lonely geniuses bravely struggling against a sometimes brutal united front of reactionary philistines. To be sure, the 1910s were a lively time in art—not because the early modernists were being ignored, but rather because what they were doing had captured virtually everyone's attention.

The art world had become splintered into numerous factions. The virtual stranglehold movements such as abstract expressionism and minimalism exerted over the critics' attention during the fifties, sixties, and seventies would have been inconceivable during the 1910s. Artists were exploring a thousand different approaches, and debates were raging everywhere. If the modernists had to cope with a certain amount of negative press, that was so *because* they were being given an unprecedented amount of critical attention, because they were taken more seriously than virtually any other movement.

True, the first issue of *291*, dated March 1915, indignantly attacked as "idiotic" a review of a show of watercolors by John Marin at Stieglitz's Photo-Secession Galleries. But it was not the reviewer's ignorance of avant-garde art that troubled the Stieglitz contingent; it was rather his blasé attitude toward Marin's abstractions. "This style of art is now

about the most common thing in the world. Its novelty is gone," the reviewer had said, with a very modernist air of boredom.

Our image of the early modernists—including the American contingent—as a small beleaguered group of martyrs is therefore to a large extent inaccurate. The notion of their martyrdom in the cause of art, which they actively fostered, is considerably undercut by the voluminous documentary evidence of the, often quite sympathetic, publicity given to their work in the popular media of the mid-1910s.

Arthur Jerome Eddy, one of the modernists' earliest and staunchest supporters, acknowledged the popularity of the new art as early as 1914. In his book *Cubists and Post-Impressionism*, Eddy emphasized how positively impressed he was with the American art world's receptivity to the avant-garde. It was true, he pointed out, that, on the opening of the Armory Show in 1913, many of "the older men" "rushed into print with language as violent as the press would accept." But, acknowledged Eddy, "six months later this feeling of angry opposition largely subsided."

Eddy stressed that even among the most conservative members of the art establishment "suggestions that would not have been listened to before the International are now discussed as quite within the range of possibilities." The younger painters "were naturally much more tolerant. They were more—they were both *curious* and *receptive*. Many of them searched with eager eye for valuable hints, for ways and means to perfect their own art" (194).

Art historians have, for generations now, dragged up quotations from a small group of the initial "philistine" newspaper accounts of the Armory Show Eddy noted. Over and over again they have treated us to the cartoons of Duchamp's *Nude Descending a Staircase* as *An Explosion in a Shingle Factory* or *Rude Descending a Staircase* to show how unenlightened the public was. But in their eagerness to maintain the myth of modernist martyrdom, the critics rarely stop to consider that in the rowdy, irreverent newspaper world of that time, *any* public issue that drew a great deal of public attention was fair game for these jokesters.

Historically speaking, it is a lot more surprising that at the time of the Armory Show, the *New York Times* on Sunday, March 9, 1913, devoted almost an entire page to a somewhat diffident, but even so quite informative, interview with Henri Matisse by Clara MacChesney than that the same newspaper should have followed that article a week later with an intemperate attack on the cubists and futurists by O'Keeffe's old

nemesis from the Art Students' League, Kenyon Cox. MacChesney's interview emphasized that while Matisse's name had at first been "spoken of with bated breath, and even horror, or with the most uproarious ridicule," it had not taken long to convert "many, even of our most conservative critics and art lovers, to his point of view." MacChesney ended her interview with a telling remark about what, in historical terms, is the clearest proof of the public's intense interest in Matisse's art: "M. Matisse sells his canvasses as fast as he can paint them, but, if the report is true, speculators buy the majority." Modernist art was already becoming an "instrument" for investors—not a situation that called for van Gogh–like despair on the part of struggling modernists.

During the formative period of any new movement in art, no matter how wide its support, or how immediate its public impact may be, there will always be vocal opposition from those who find themselves being superseded. It has been a time-honored practice among those concerned with the marketing of art to play up such instances of opposition. This sort of publicity actually helps bring the art to the public's attention, and thus almost invariably serves to drive up prices. It has little to do with the day-to-day economics of the "average" artist. For if the lesser-known early modernist painters found it difficult to sell their paintings, so did most of the lesser-known "conservative" artists.

Just as in the case of the public reception of impressionism thirty years earlier, there were several considered—though not always blindly enthusiastic—discussions of the new art for every one of the journalistic jokes eagerly reported by the historians of twentieth-century modernist art. These often astute critical assessments merit at least as much attention as the negative remarks, for, though our romantic notions of artists—and even collectors—as heroes in the struggle for enlightenment are undeniably attractive, they ultimately make us overlook the true "cultural" significance, that is, the sociopolitical context, of the advent of the ideology of modernism.

That significance was strikingly expressed in another notice from that first issue of *291*. In it, we are told that the dealer "Montross sold almost all his Matisses but he says the masses only laughed at them." What then follows places the social attitude of the more vociferous modernists and its core of supporters—the readers of *291* and magazines such as *Vanity Fair*—neatly into perspective: "Stieglitz has had two exhibitions of Matisse's work, and he also says 'The Masses laughed.' And he adds that Masses = M asses = 1000 asses."

Drawn by John Sloan.

A SLIGHT ATTACK OF THIRD DIMENTIA BROUGHT ON BY EXCESSIVE STUDY OF THE MUCH-TALKED OF CUBIST
PICTURES IN THE INTERNATIONAL EXHIBITION AT NEW YORK.

41. John Sloan, *A Slight Attack of Third Dimentia Brought On by
Excessive Study of the Much-Talked of Cubist Pictures in the International
Exhibition at New York*, drawing from *The Masses*, April 1913.

John Sloan had a remarkable, if flippant, intuition of the new intel-
lectual conformism modernism was likely to breed, when, in response
to the Armory Show, he drew a cartoon of a future world dominated by
cubism for the April 1913 issue of *The Masses* (fig. 41). But, of course,
as an advocate of those benighted inferiors Stieglitz professed to disdain
so much, he could not be expected to have enough intellectual sophisti-

cation to join the modernist elite. Instead his populist doubts about the long-range effects of the mechanistic value system he detected in the work of the European modernists branded him as a clumsy, old-fashioned humanist, a social "reactionary." Ironically, the romantic cult of misunderstood modernism successfully transformed negative publicity of this sort into a test of judgment that helped separate the "men" from the "girls" in the world of culture.

In the context of historical trends, it is far more significant to discover that in New York, early in 1915, "Montross sold almost all his Matisses" than to be told that the "uncouth" masses "only laughed" at those works. The "power elite" clearly stood behind the new art—and not because that new art represented a superior aesthetic, but because the smart money had recognized a particularly promising long-term investment—an investment in the "manly" future of the evolutionary elite. Their main problem now was to find a way to force the "effeminate" supporters of a democratic, preindustrial American culture into retreat.

XII

Modernism and the Politics of Gender

In the first issue of *291* Agnes Ernst Meyer triumphantly announced the ascendancy of the new mechanistic worldview of modernist art: Given the inevitable dominance of science in the service of human evolution, she argued, humanity was about to leave the unstable world of the emotions behind. With the discoveries of Picasso, art was approaching the evolutionary stage of "pure reason." As part of that development, a new, "impersonal and reasoned," truly "scientific" form of criticism— one that would presumably substitute razor-sharp, manly, hard-edged, objective judgment for the subjectivist dithering of the conservative critics—was now becoming possible. According to Meyer, the technocratic millennium was here. It was not unreasonable for her to be so effusive, for the same years that saw the triumph of early modernism also constituted a crucial period of innovation in Western social theory. A majority of the period's researchers working in a group of largely speculative fields that had lately been upgraded to "science" status— evolutionary biologists, sociologists, anthropologists, and psychoanalysts—had, as we have seen, become engaged in the consolidation of a phenomenally broad-based, and socially approved, system of race, class, and gender prejudice.

To disparage the importance of modernist art as a historical development would be ludicrous. It disposed of cultural cobwebs that had turned much of the art world into a display window for the social delusions and the sexual fears of the international middle-class mind. Moreover, modernism was certainly also not *responsible* for the sexist-racist evolutionism that was sweeping through Western culture. But, given its rhetoric of innovation and artistic evolution, its claims to "spiritual" and "conceptual" superiority, its celebration of technological organization and psychoanalytical truths, it becomes obvious that many of the aes-

thetic principles of the new movements in art were very directly *shaped* by the new "scientific," gender-based theories pitting intellectual evolution against biological degeneration.

As we have seen, the biologists had, by the second decade of the twentieth century, finally succeeded in finding an incontrovertible physiological basis for the evident intellectual and artistic inferiority of women. The scattershot arguments against the "feminine" mentality of the various cultural critics of the years just before and after the turn of the century therefore now took on an aura of solid truth. Speculation had become fact. Testosterone (though not yet officially identified as such) was the answer to all the world's ills. The biologists' recognition that the masculine vital essence was the source of all creative, technological, and intellectual evolution had given the theory of dimorphic gender evolution the status of a cultural commonplace.

Moreover, Henri Bergson, a professor at the Collège de France, like Brown-Séquard before him, had conveniently come along to turn this biological fact into a dignified philosophical theory—at least that is what most of the philosopher's followers assumed. For though Bergson's ideas were too complicated and elaborate for most of the evolutionary elite, stripped-down, simplified versions of his philosophical system, adapted for use by his lay contemporaries, tended to suggest that modern technological advances were a direct testimony to the intellectual evolution of the mind. In fact every aspect of our reality was determined by the synthetic power of thought. The intellect thus had, in a very real sense, "created" evolution out of the matter of mind. But, then, where did that matter come from? If all thought was a becoming, the will to life itself must be the impetus to thought. Pound's "alluvial Nile-flood" was already beginning to crest in the form of the philosopher's concept of a mysterious vital essence—he called it the "élan vital"—underlying all intellectual evolution.

This "élan vital" represented the organism's intuitive will to "become" an entity, its will to action, and must therefore be the source of all creative evolution. In animals this will existed on such a primitive level— as instinct—that it might as well be considered virtually nonexistent. In humans, however, the progressive accumulation of vital energies had created a sudden qualitative leap in the evolutionary potentialities of the living organism. Above the primitive homogeneities of instinctual being, therefore, the (inferior) intuitive "élan vital" of the lower organisms had been gathered and "energized" into a spiritual will to action by

the growth of the human intellect. Thus vitalized, mind was now able to soar into an empyrean of ever more sophisticated intellectual diversity. But this process of spiritual becoming was constantly being subverted by a contrary, negative, energy: the will to stasis, to nondevelopment, to the mere reproduction of what already existed—a kind of self-cloning syndrome still governing the primitive organisms, overtaken by, but even so still submerged, in the materialist matrix of human development.

Bergson's philosophy was only one of the many theories of this sort that had proliferated since the late nineteenth century, inspired by Charles Darwin and Herbert Spencer. The biologists of the period obviously lost no time in supplying the missing link between such high-flown philosophical theories and pragmatic physiological truths that put these matters in their proper perspective for the average person: the creative "élan vital" was clearly the masculine essence, that "vitality" with which nature had infused his seminal matter. Both the physiological bases and the evolutionary justification for Pound's supposition that the mind was "an up-spurt of sperm" were now in place. Given woman's dependence on "an ovular bath" to lay any claim to participation in this up-spurt, F. T. Marinetti's remark that away from the crib and the kitchen woman represented "a closed circle, purely animal and wholly without usefulness," was therefore clearly in accord with the latest findings of the scientists.

Any man who, henceforth, dared to question the separate spheres of "creative masculinity" and "female eroticism" was certain to be accused of mental and social degeneracy. When Paul Jordan Smith, in 1916, published a little book in support of the feminist movement, a Methodist minister attacked him in the *San Francisco Examiner* as "an enemy of Christianity, an enemy of society, disseminator of social poison, preacher of a nauseating philosophy"—so an advertisement for the book in the May 1916 issue of *The Masses* noted for the amusement of its feminist readership. Another of San Francisco's moral guardians, as the advertisement gleefully emphasized, was even more intemperate: "In Mr. Smith we have a fine specimen of the effeminate man. The book is a farrago of the soul-cries and self-outbursts of sensualists in skirts who have been caught by the glamor of unconventionality and want the rules changed. Sensuality, neurasthenia and an insatiable egotism are celebrated in this book along with Emma Goldman, Ellen Key and other ladies for whom the measure of morality is its distance from the

standard of the neighborhood. Erotic ladies with a smattering of philosophy, such as Havelock Ellis preaches in his books on sex, Paul Jordan Smith pronounces 'the great seers of modern literature.' His book reeks of flesh."

Ironically, what these critics saw as the most "offensive" proposal of Smith's book—that "woman must have the right of free selection, and must not be forced, because of any economic consideration, either to enter or to maintain a marriage relation that is distasteful"—was itself based on a racist/eugenicist concern about "species degeneration" on the part of its author. This concern, in turn, had its origin in Smith's unwavering faith in the scientists' discovery of the absolute functional dimorphism of men and women: "It is axiomatic in biological science," Smith asserted, "that structure and function go hand in hand. And the whole structure of woman indicates conservation; that of man, aggression." For Smith it was equally axiomatic that the separate functions of the sexes were ordained by nature, for "these life attitudes have a physiological basis to guarantee their permanence. It is found for example that the rate of anabolism, or tissue construction, is higher in woman than in man, and conversely, that katabolism, or tissue degeneration, is more rapid in man than in woman" (5).

Smith's little book on feminism was—as much as Ezra Pound's masculinist paean to the seminal constitution of the brain—a typical example of the reckless extrapolations, based on a few, largely speculative, fragments of subjectively interpreted experimental research, that scientists and lay people of this period had become accustomed to make in the service of objective truth. Thus Smith was able to build, from the biologists' premise that there must be a fundamental anabolic/catabolic "chemical" divergence between the sexes, an evolutionist scenario that could be seen as "feminist" only because it celebrated woman as "instinctively eugenicist" in her reproductive impulses. That, and only that, was the basis for Smith's belief that woman should be allowed the "free selection" of her mates—the argument that had conjured up such violent images of feminine eroticism gone wild in the overheated minds of his critics. In fact, Smith's underlying premise for his argument was an integral part of the racist-sexist mainstream of early-twentieth-century social thought.

As "the great conserver of social values," Smith argued, woman needed to have freedom of choice, so that she might stay clear of the "anarchic and race-indifferent" impulses in the male. "Absolute

freedom of selection, on the part of the woman, of the father of her child is one of the essential rights of motherhood, and is necessary to the larger life of the race." Woman, "with superior intuition, would reconcile eugenics with love" (9–10). Thus she would become "mother" to a new breed, for "her great task is to raise the level of racial quality" (62). It was her role in nature to remind humanity "that life is not justified by what we have thus far attained, that we are a long way from our ideal humanity, and that we are not to strive alone for present values, but for the beyond-man,—the superman. We are to remember Nietzsche's caution that we are the bridge and not the goal. And it is the woman nature to constantly remind society of that ideal and reshape it to that great end" (8).

Much of this, of course, superficially sounds like an updated version of Poe's "Colloqui of Monos and Una"—but Smith's argument is based far more directly on the dualistic structure underlying Bergson's concept of the "élan vital" as an "intuitive drive" that remained static and merely "reproductive" without the afflatus of the intellect. Bergson's system presupposes the superiority of the intellect over intuition but accepts intuition as the "source" of the intellect. Smith, too, sees both separation and cooperation: "When intuition and reason are both seen to be ways to truth, and necessary in any life solution,—then it will be possible for man and woman together, and both free, body and soul, to face the more fundamental problems of life as their high spiritual business" (63).

For Smith, as for Bergson, woman represents "intuition" and man "reason." In both Poe and the transcendentalists intuition and reason are not "separate but equal"; instead they are one: Poe's masculine and feminine elements of the soul are constantly seeking *unification*—they sense themselves as crippled, distorted, and incomplete as long as they are apart. One could say that they are symbolic "part-object" manifestations of a soul that can be whole only when Monos and Una become an androgynous entity *in a single body*. Poe thus regarded emotion and intellect as inseparable. Ligeia (who, in Poe's story with that title "came and departed as a shadow" in the narrator's "closed study") represents his own *integrated* soul: she conjoins intellect (she is a woman of "immense learning") *and* emotion (she is also "the most violently a prey to the tumultuous vultures of stern passion") (657).

Ligeia is, clearly, very much a projection of Poe's own personality. It is only when the story's narrator unwisely immerses himself in meta-

physical speculation, and forgets to acknowledge the essential integra-
tion of matter and mind represented by Ligeia, that she falls ill—
though, as the narrator is to discover—she cannot truly "die" within
himself. But given the, in modernist terms, so "reactionary" implica-
tions of Poe's intention to have us read Ligeia as a personification of the
androgynous human soul, it is not at all surprising that she would have
come to be misinterpreted as a "vampire" by generations of twentieth-
century males raised to regard any evidence of intellect in a woman as
a sign of "degeneration."

Thus, whereas for Poe humanity could hope to progress only by
striving for the *reunification* of the male and female components of the
human soul, the theorists of dimorphic gender evolution believed that
only the complete *suppression* of the vestiges of feminine "primitivism"
within themselves, through a permanent separation of male and female
functions in society, could serve the cause of human evolution. The
"feminist" component of Paul Jordan Smith's solution was his proposal
of a "separate but equal" concept of gender that would counter his
contemporaries' almost universal conviction that women were inferior
to men.

As all this plainly indicates, very little is ever simple and linear in
history. Philosophies advocating feminism in the service of the Mas-
ter Race, or celebrating modernism as a salutary answer to the intel-
lectual pretensions of women, were jostling for attention alongside a
complex, and by no means all-positive, nostalgia for a preindustrial hu-
manism many saw as embodied exclusively in the social values of
women. A truly monumental confusion of motives had thus come to
reign supreme in American culture in the years following the Armory
Show. There was only one topic everyone seemed able to agree on: the
fundamental functional dimorphism of the sexes. From our late-twen-
tieth-century retrospective vantage point the underlying practical—
political—motives for that unusual unanimity were perhaps summa-
rized most succinctly by the famous political satirist Art Young, who
spoke for the period's small and embattled group of genuinely progres-
sive socialists and feminists.

In the December 1915 issue of *The Masses* (fig. 42), Young needed
only a picture and one brusque word to illuminate the hidden eco-
nomic and social underpinnings of his contemporaries' virtually uncon-
tested celebration of gender dimorphism. The diamond-studded super-
man who, in this image, commands young womanhood to "breed" has

42. Art Young, *BREED!*, drawing from *The Masses*, December 1915.

no patience for fancy theories. He is looking only for a short-term solution to the evolutionary elite's wartime manpower problems.

But whatever the actual sociopolitical motives for the new biological theories of sexual dimorphism may have been, their long-range effects were to be nothing short of tragic for generations of women. In the January 19, 1922, issue of the centrist humor magazine *Life*, a young, still virtually unknown Dorothy Parker was to use the phenomenal popularity of Edith Hull's romance novel *The Sheik* (soon also to be a major motion picture starring Rudolph Valentino) to give a sardonic account of the social etiquette that was coming to be associated with the new science of fundamental gender dimorphism. Hull's novel had set out to prove conclusively that in the womb of even the most ardently feminist female an eagerly submissive mother-to-be was waiting to be liberated, provided, of course, that her suitor proved to be man enough to be willing to knock the resistance out of her:

> The heroine reels back for more.
> They play like happy kids,—
> He tells his love, then knocks her for
> A row of pyramids.
>
> She revels in his gallant deeds;
> Her passions higher mount

Each time he languidly proceeds
 To drop her for the count.
They marry in the end—they do
 In all such compositions—
And now, no doubt, he'll knock her through
 Another twelve editions.

So if you'd knock the ladies dead,
Just use your right and go ahead.

But the supermen of the early decades of the twentieth century had not yet been able to control what they considered to be the most unfortunate side effect of the new system. For, as specialized reproductive machines, exclusively occupied with the sexual functions of the body, women would continue to pose a threat to the upward striving male with their vampirelike demands upon his gray matter. Any male seeking superman status therefore needed to follow a regimen that would concentrate on the proper containment and judicious distribution of his vital fluids. F. T. Marinetti summarized the modernist opinion by remarking that once men stopped sentimentalizing women and finally learned to regard them as no more than useful domestic animals, "the carnal life will be reduced to the conservation of the species, and that will be so much gain for the growing stature of man" (73).

No wonder, then, that some of the most perceptive and progressive artists and writers of early-twentieth-century American culture refused to see militantly masculine art movements like futurism as "liberating." They were not necessarily being held back by vestiges of American "provincialism" about the purposes of art, as we have come to assume. Their diffidence about the modernist attitude takes on a much different character when we place it next to Marinetti's antifeminine and antihumanist stance. John Sloan made that clear in a cartoon published in the January 1916 issue of *The Masses*, exposing the arrogant attitude of the futurists toward women who, in search of sound training as artists, continued to follow the tradition-sanctioned path of honing their craft by copying acknowledged masterpieces.

Sloan's "antimodern" message takes on a far more progressive focus once we place it within its proper context as part of the magazine's commitment to the struggle for women's rights. The woman who stands for the past in Sloan's cartoon stands for more than "imitation," we now realize; she stands for a system of humane values rapidly being supplanted by the mechanistic worldview of the futurist. He: "That's the

THE PAST AND THE FUTURIST

"That's the way with you people, you're always copying."
"Well, at least we're not copying you."

43. John Sloan, *The Past and the Futurist*, drawing from *The Masses*,
January 1916.

way with you people, you're always copying." She: "Well, at least we're not copying you" (fig. 43). The complex range of social and "scientific" references imbedded in this dialogue must remain a closed book to anyone unfamiliar with the period's politically charged theories of gender dimorphism.

The findings of the biologists or the rantings of modernists such as Marinetti and Pound did not necessarily have an immediate effect on the life of the average American, but the spread of dimorphist ideas among those who did not care for theory was assured by the wealth of easily understood imagery in popular culture highlighting the "superman/flowerwoman" dichotomy. There was, of course, an even greater proliferation of images that portrayed women who were unwilling to comply with their new biological destiny as sexual vampires incessantly depleting hapless males who had been unable to keep their minds on the evolutionary advance.

There was good reason for this fear. The elite no longer had any use for those who were "average." Populism was out. The whole point of modernist thinking—in art as well as science—was to facilitate the separation of the superior, the intellectual supermen, from the inferior, the wage slaves and the decorative domestic flowers whose only purpose in life was to serve the evolutionary elite. An art that remained accessible to everyone became therefore by that very definition an inferior, and hence "effeminate," art. The elite *liked* the fact that the newspapers and such obviously socialist magazines as *The Masses* attacked the pretentiousness and obscurantism of the new art: it proved that their opponents were—mentally and socially—indeed inferior.

No wonder a self-consciously up-to-date elitist magazine such as *Vanity Fair* therefore made a point of featuring modernist art and giving it exactly that open and appreciative coverage most of us assume to have been absent from the American press during these years. Advertisers clearly also had little trouble identifying the magazine's target audience. The November 19, 1916, issue—the same one that featured Georgia O'Keeffe's first published drawing on its contents page—also contained an advertisement for the products of a certain Madame Helena Rubinstein—one of the up-and-coming leaders of society's effort to make women over.

As any advertising executive knows, you cannot afford to talk about issues that are over your target audience's heads. You have to talk about what they can understand. The text of the advertisement is therefore a

reasonable indication of what was on the mind of every society woman—or, at least, every woman who wanted to become one: "Much has been said," the advertisement reads, "of strength and stature for the evolution of man to superman, but to evolve from woman to super-woman, the great requirement is beauty—beauty of soul, mind and body—and woman of today needs no age-long evolution. The super-woman today is the woman who makes the most of herself. To retain her fresh, pure beauty of complexion until an advanced age is her aim. She can do this by consulting Madame Helena Rubinstein and obtain-ing the benefit of her skill and world-wide experience." There was, however, absolutely nothing the Madame could do for you with her creams and potions, the advertisement implied, if you insisted on caus-ing your skin to wrinkle by thinking too much. Judging from what was to become of Madame Rubinstein's little business as the years went on, her efforts to keep the women of the evolutionary elite focused on their special role in the dimorphic evolution of the sexes did not go unheeded.

The extreme gender polarization that took center stage in Western culture during the early decades of the twentieth century had, as we have seen, come to influence the thinking of such "progressive" Ameri-can critics as Sadakichi Hartmann and Charles Caffin as early as the turn of the century. But by the 1910s even the more mainstream critics had begun to see a need to censure American art for continuing to tolerate "effeminate" nineteenth-century cultural values. However, like the new social theorists, these critics, though unanimous in their con-demnation of any sign of femininity in art, rarely agreed on what the precise stylistic manifestations of this failing actually were. Thus though they eagerly acknowledged the "virile" qualities of artists whose work they considered to have special merit, few of them were able to agree upon the exact virility quotient of each style.

Margaret Steele Anderson, for instance, commented in her book *The Study of Modern Painting* (1914) that the work of Gari Melchers ex-hibited "a freshness, a vigor and a masculinity which we do not see too frequently in our figure-painting" (234). But Willard Huntington Wright considered a wide variety of European as well as American painters such as Melchers and Maurice Prendergast to be "modern dec-adents." In his book *Modern Painting* (1915) he derided their work (un-like that of such an artist as Othon Friesz, who had "a reputation for virility") as "faded" and "feminine." They were perhaps "most devitaliz-

ing" in their "sterile" attempts to advocate a "retrogression to primitive ideals. Though using the modern methods of simplification, these men revert to a static and dead past" (320–22). Wright liked the work of synchromists such as Morgan Russell much better but cautioned that they needed to guard their allotment of gray matter very carefully to remain successful: "purity of expression, in order to be highly potent, must embody a pure conception"(298).

Henry Rankin Poore, on the other hand, considered the new art as little more than an attempt to market the childish (and hence clearly effeminate) efforts of a wimpy bunch of charlatans. In his 1913 diatribe *The New Tendency in Art: Post Impressionism, Cubism, Futurism*, he authoritatively asserted that "the effort to back away from man's estate and recoil from its obligations, seeking absolution for incompetency of expression beneath the shelter of the primitive vision of childhood is unmanly" (28). The "balance of power in the empire of art" was being subverted by such inartistic displays of hormonal imbalance:

> Our rating of manhood decides that physique is but one third of the man, use of that physique for labor (physical performance), another third, and an expansion toward mental possibilities, the last of the tripartite organism.
>
> The latest comers in art discount the physique of art, enfeeble a manly use of that physique to the grade of childhood's capacity, and present the last third for a complete whole.

Such an "unsymmetrical development of man himself" obviously flew in the face of the processes of evolution. Poore was unable to believe that anyone could be perverse enough to be willing to do so without a clearly defined ulterior motive: "Anyone who willingly adopts the role of childhood in both conception and expression is not sincere with himself. His attempted return to childhood involves an avowal of disbelief, not only in his own growth, but in the growth of the race, and in so grave a premise we must detect insincerity" (35–36).

Poore was convinced that modernism was a product of degenerate eroticism—the product, therefore, of racial inferiors, of "the stimulated brain of the Romance nations." Fortunately the Nordic spirit of manhood was still alive and well in "the keen Yankee mind. The fact is the Yankee does not feel that he has reached the end of his road, and, moreover, a large part of his sagacity lies in keeping this open. The fact that in literature, painting, music, and sculpture American and English

art has been practically uninfluenced by 'Primitivolatry' and 'Savage-opathy' is evidence that these nations are ascending instead of descending" (49).

Of course such low blows against the manly vigor of the new art could not remain unanswered, and Arthur Jerome Eddy, one of the country's leading industrial millionaires *and* an important early collector of modernist art, was clearly no slouch in the masculinity department himself. He therefore took up Poore's gauntlet. In his book *The New Competition* (1912) he had already sung the praises of a muscular, no-nonsense social Darwinist approach to "cooperation" as the next great stage in economic development, an argument presciently designed to convince his contemporaries that big business was being victimized by the narrow self-concern of labor unions, and that the future of civilization therfore resided in the squelching of all antitrust legislation.

In his *Cubists and Post-Impressionism* Eddy set out to prove that modernist art was as manly as any cooperative Yankee boss could possibly wish it to be. Indeed, said Eddy, the paintings of the cubists and futurists were "not so radical and extravagant as they seem, but are, in fact, only an illustration of what is going on in the minds of men generally" (32). However, being an ardent nationalist, Eddy also set himself the task of expanding the ranks of the manly among American artists. In tribute to Winslow Homer, for instance, he proposed that critics adopt a new term to accommodate the special talents of this "greatest of *American*-Impressionists—he was a Virile-Impressionist." Homer, Eddy insisted, represented the artistic coming of age of "a *young, vigorous,* and *virile* country" (191). What was more, Eddy concluded, the younger American painters were "so strong, so virile, so muscular—let us say," that it was reasonable to insist that "*better pictures are being painted in America today than Homer painted*" (195–96).

What is particularly interesting in these debates concerning the "masculinity" or "effeminacy" quotient of the new art is how close to the surface the critics' political and economic considerations tended to be. Since the ruling classes of the 1910s had absolutely no patience with anyone who might attempt to curtail their ability to make money (let alone force them to share their wealth with others), it stood to reason that the terms "socialism" and "effeminacy" soon became virtually interchangeable in the minds of many. In 1912, for instance, in an article entitled "What Is the Matter with Our National Academy?" for *Harper's Weekly*, excoriating the imitative mediocrity of the institution in ques-

tion, James Gibbons Huneker pointed out that the work of George Bellows, at least, was worth looking at because "no pitying socialistic note spoils his virile art." Huneker must have suffered considerable disappointment when Bellows's work soon after began to make its appearance in the pages of *The Masses.*

The very close ties between *The Masses* and the American feminist movement represented therefore not only a pragmatic political alliance but an emotional one as well, based on the recognition that socialism and the women's movement had a common enemy in the masculinist pretenses of the evolutionary elite. *The Masses*, from its very incipience, featured numerous articles and cartoons in support of feminism and the woman suffrage movement. As early as December 1911 it had published a special "Woman's Number," and its "Woman's Citizenship Number" of November 1915 no doubt reached Georgia O'Keeffe in Columbia, South Carolina, as part of her recently acquired subscription to the magazine. The issue had a cover by Stuart Davis and articles by Floyd Dell and Max Eastman; it also included a number of acerbic cartoons, such as Glenn Coleman's pointed commentary on the economics of sexual dimorphism, in which a visibly exhausted mother, "overheard on Hester Street," remarks angrily to a suffrage canvasser: "You'll have to ask the head of the house—I only do the work."

In the same issue Jeannette Eaton pointed out that the popular women's magazines were performing "a fundamental service to the established order" by teaching woman "what to do for the baby, what is the right way to puff her hair and why she should win her daughter's confidence." A few years of such reading, Eaton remarked, was sure to destroy a woman's "ambitions, her independence, [and] the assertion of her own free personality." A poem by Jean Starr Untermeyer suggested that a woman who had first sought liberation from her existential doubts by marrying, then by being the perfect mother, only to be driven further into the darkness of her fears, had come to a crucial realization when she finally asked herself:

> Whence will come the cleansing flame—
> Must it be the fire of my own heart?
> And the sword of deliverance—
> Must it be made with my own hands?

Eastman, in his essay "Confessions of a Suffrage Orator," took on the biological essentialists of sexual dimorphism: "If society expects a girl to become a fully developed, active and intelligent individual, she will

probably do it. If society expects her to remain a doll-baby all her life, she will make a noble effort to that. In either case she will not altogether succeed, for there are hereditary limitations, but the responsibility for the main trend of the result is with the social conscience." There was more than a touch of eugenicist thought in his argument, but at least he did not place the full responsibility for the evolutionary advance on dimorphism as such: "an actual tendency to *select* the more intelligent, rather than a mere training of the intelligence of all, is the main force in racial evolution."

Floyd Dell, the magazine's managing editor, and probably the most coherent, levelheaded, and logical thinker among the very small contingent of males who dared to believe that men's and women's natural intellectual and emotional abilities and deficiencies paralleled each other, attacked the false science of biological determinism in his lead article, "Adventures in Anti-Land." Mocking the deterministic innuendos of William T. Sedgwick, one of the period's most famous biologists, he satirized the eminent man's dramatic discovery that the human female's monthly period—and by extension her reproductive function—was destined to cripple her forever and ever:

> I knew that women had babies, and that every twenty-eight—in short, I knew. But I did not know the dreadful significance of these things. I did not know that they cut woman off forever from political and intellectual life.
>
> But they do! These great scientific authorities say so, and it must be true. These things, innocent as they always seemed to me, have marked woman as a thing apart from the life of mankind. She does not think as man thinks; her whole psychology is deranged by the fact of her sex; much of the time she is practically insane, and at no time is she to be trusted to take part in man's affairs. She is chronically queer; of an "unstable preciosity." She is not in fact a person at all, capable of thinking and acting for herself; others must think and act for her. If permitted to behave as a free and independent human being, she would do injury to herself and the community.

Dell asserts that "this witch-doctor view of womankind" had far more to do with superstition, with primitive masculine fears concerning "the dreadful magic of childbirth," than anything remotely connected with science, and he proceeds to point out the logical discontinuities in dimorphist thought: "Having established these dark facts about woman,

they tell you to cherish her, worship her, make her the queen of the kitchen and the nursery and the bedroom, the consolation and delight of your life. *Why*, I should like to know?" And he ends his article with an outrageously immodest proposal: "Suppose it were true that women are like men, only, to us, sweeter, lovelier, more desirable companions—and with the same sense, the same interests, the same need of work and play? I could go on living in that kind of world. And, frankly, I can't live in the other. I'd just as soon commit suicide."

In the January 1916 issue Dell reported on the clinical research of Leta Stetter Hollingsworth which showed that by mixing the charts of men's and women's responses to certain tests of "muscular control, steadiness, speed and accuracy of perception, and fatiguability," Hollingsworth had demonstrated that "not only is it impossible to tell by the chart of any given case when the menstrual period is occurring, but it is impossible to tell whether a given chart is that of a man or a woman." But Dell remained one of a tiny minority of men willing to conceive of women as their intellectual equals.

On August 25, 1915, O'Keeffe had written Anita Pollitzer that she had just read Dell's *Women as World Builders* (1913) "and got quite excited over it" (143). No wonder, for Dell's no-nonsense, eminently practical voice no doubt gave her a renewed determination to let nothing keep her from being a professional artist. Dell's little book was a tribute to "self-sufficient, able, broadly imaginative and healthy-minded" (20) women such as Charlotte Perkins Gilman, Beatrice Webb, Emma Goldman, Ellen Key, and Dora Marsden—older contemporaries, women who, like Margaret Dreier Robins of the National Women's Trade Union League, had stood up and called out to all women: "Long enough have you dreamed contemptible dreams" (75).

Dell also cited Whitman's tribute to an older, "frontier" image of American womanhood (from "A Woman Waits for Me," 1856), one that had still flourished fitfully during O'Keeffe's childhood, and one that described almost word for word the self-image O'Keeffe was to adhere to for the rest of her life:

> They are not one jot less than I am,
> They are tann'd in the face by shining suns and blowing winds,
> Their flesh has the old divine suppleness and strength,
> They know how to swim, row, ride, wrestle, shoot, run, strike,
> retreat, advance, resist, defend themselves,

> They are ultimate in their own right—they are calm, clear,
> well-possessed of themselves.

Poetry may have been a "blind spot" for O'Keeffe, but these lines were crystal clear. Dell ended his little book by celebrating Dora Marsden's concept of the freewoman: "She called upon women to be individuals, and sought to demolish in their minds any lingering desire for Authority." His closing summary of Marsden's ideas cannot but have moved O'Keeffe deeply: "Freedom! That is the first word and the last with Dora Marsden. She makes women understand for the first time what freedom means. She makes them want to be free. She nerves them to the effort of emancipation. She sows in a fertile soil the dragon's teeth which shall spring up as a band of capable females, knowing what they want and taking it, asking no leave from anybody, doing things and enjoying life—Freewomen!"

O'Keeffe, in 1915, was a young woman eager for creative independence in a world in which sexism and racism had become guiding principles in the national front against seminal profligacy, socialism, and all other forms of economic and moral "degeneracy" that might require the evolutionary elite to share some of its wealth with those who "only did the work." She was a member of the National Women's Party (an affiliation she would continue to maintain throughout her life) and—at this intellectual crucible of her formation as an artist—avidly gathering any information that might challenge her thinking as she was about to embark on her first real teaching position at Columbia College. "I am just doing what I feel like," she wrote to Anita Pollitzer—and it was a heady experience not to be constrained by dogma: "I was getting such twists in my head from doing as I pleased that it is almost impossible to come down to earth" (144).

The world can only be grateful that O'Keeffe, spurred by Alon Bement's and Anita Pollitzer's infectious enthusiasm for radical ideas, had been able to link up the nongendered strain of humanism in her American background with the feminist socialism and iconoclastic imagery of the small, but vociferous, intoxicatingly opinionated and free-spirited, group of artists and writers associated with *The Masses*. Their example clearly helped her make up her mind that the false "reality"—the "evolutionary morality" of sexual dimorphism—was not worth coming "down to earth" for. She had begun to realize that, instead of continuing to "cater to someone" when she painted, she should learn to express

herself (145) and capture the nongendered coherence of her inner being in the intoxicating sensuous materialism of the natural world that meant so much to her.

Though not at all a "political activist," and a revolutionary only in her quiet refusal to capitulate to the dictates of intellectual and social fashion, she had come to realize that she was an outsider in a cultural environment that had moved very rapidly from a pragmatic acceptance of the intellectual and artistic accomplishments of women to the new "me Tarzan, you Jane" mentality of the evolutionists. Her sense of self-identity had been forged in a world still guided by the anti-industrial ideals of Poe's "Colloqui of Monos and Una." Throughout her life she would continue to insist that the intellectual and artistic abilities of men and women had nothing to do with the physiological incidentals of gender. She did not for a moment deny that the existing social ramifications of gender helped shape the focus of a person's outlook on the world—and she treated the intellectual pretensions of the men around her with bemusement. Indeed, she often expressed a distinct sense of relief that they did not think of her as "one of the boys," but she had equally little patience for women who had internalized the "feminine-ist" rhetoric of dimorphism. As Floyd Dell emphasized in *Women as World Builders*, such women merely exploited the disdainful homage offered by men to "an inferior being, with a weak body, a stunted mind, poor in creative power, poor in imagination, poor in critical capacity—a being who does not know how to work, nor how to talk, nor how to play" (18).

Within the framework of the "science" of sexual dimorphism the seemingly harmless and convenient designation "woman painter" had come to be a way to identify any female artist who had accepted her function as a reproductive—rather than a creative—woman. Such "women painters" were widely expected to be eager to express those "psycho-physiological elements" of their sex Sadakichi Hartmann had delineated in his *History of American Art*.

It is therefore not at all surprising that O'Keeffe came to despise the term as a typical example of the way the critics tried to make her fit their expectations. During the 1970s, some women who saw themselves as conduits for a special kind of "woman-art"—and had accepted the early-twentieth-century party line about the supposedly unique "psycho-physiological" qualities of the feminine imagination—wanted to pay homage to her as a shaman of the "woman-soul." But O'Keeffe was

deeply offended by their assumption that she was a true icon of femininity. They had even, she remarked with palpable disdain, resorted to leaving white flowers on her doorstep at Abiquiu. At one point she had become so irritated by it all that she had wanted to pick up a shotgun and go after the intruders.* It distressed her that women who saw themselves as "feminists" were actually intent upon reviving the sexist rhetoric of dimorphism she had tried to counteract throughout her career. It struck her as the height of foolishness for these women to attempt to celebrate her art by freighting it with the same gendered interpretations the male art critics of the twenties and thirties had used to marginalize it. She wanted men and women to look at her work as expressive of the essence of what it is to be human—not "woman"—in the world.

* In conversation with the author, Abiquiu, September 1975. The remark was clearly meant to be understood as hyperbolic. O'Keeffe had only peripheral vision by this time of her life.

Lighthouses and Fog:
The Watercolors

On January 1, 1916, Anita Pollitzer showed Alfred Stieglitz some of O'Keeffe's watercolors. The photographer's response, she reported, had been something of the order of "Finally, a woman on paper!"—a remark that, whether apocryphal or actual, was to become celebrated in art history for all the wrong reasons: the great impresario of American modernism had finally found a woman good enough to be worthy of his attention. But the masculine condescension implicit in Stieglitz's remark no doubt galled O'Keeffe nearly as much as this muted expression of approval must have pleased her.

The letter she wrote to Pollitzer in response to the news is indicative of her mixed emotions. After receiving the news, she said, she had "worked till nearly morning—The thing seems to express in a way what I want it to but—it also seems rather effeminate—it is essentially a woman's thing——satisfies me in a way—I don't know whether the fault is with the execution or with what I tried to say—I've doubted over it——and wondered over it till I had just about decided it wasnt any use to keep on amusing myself ruining perfectly good paper trying to express myself——I wasn't even sure that I had anything worth express-ing——There are things we want to say—but saying them is pretty nervy. . . ." She was not at all sure that either Pollitzer or Stieglitz had really understood what she had tried to do in her work: "I wonder what I said—I wonder if any of you got what I tried to say—Isn't it damnable that I cant talk to you If Stieglitz says any more about them—ask him why he liked them——" (147).

She wanted to be an *artist*. That Stieglitz liked her work was im-mensely important: "It makes me want to keep on——and I had almost decided that it was a fool's game. . . ." But he had branded her work as that of "a woman on paper." Perhaps she was—but if what she was

doing was indeed "essentially a woman's thing," and if, therefore, it was "effeminate," then it could not represent the *human*, nongendered, imagery she was looking for. She did not know where "the fault" in her approach was to be found—but she was determined to keep searching. To explore abstraction might be the answer.

As the European nations went to war to protect the economic infrastructure of their evolutionary manhood, those who wanted to make American art more virile discovered in modernism the Apollonian voice of the supermen of culture. The elegiac values of tonalism were not muscular enough for this new environment. The avant-garde had determined, even while Arthur Jerome Eddy was trying to rescue the American version of impressionism from such allegations, that the style pandered to the vacuous materialism of mindless women. Abstraction was the true source of mental acumen in art. Artists who favored realism lacked that "spiritual dimension" Caffin, Hartmann, and others recognized in the artists Stieglitz was championing. Such considerations must have been very much on O'Keeffe's mind when she began to explore abstraction. Emphasizing "the spiritual in art" might help her transcend the "effeminate" qualities in her work.

Students of O'Keeffe's work have generally tied the drawings and watercolors of the period between 1915 and her arrival in New York in 1918 to a relatively narrow axis of direct influences from Stieglitz, the magazines *Camera Work* and *291*, the writings of Kandinsky, and the (in O'Keeffe's case at most very distant) example of Picasso and Francis Picabia. It is certainly true that what she had begun to pick up from some of these sources was a factor in liberating her from the stylistic indecision which appears to have held her creativity in check before that time. But in fact their influence served only to enhance the shaping force of her American eye. O'Keeffe's work, like that of such figures as John Marin, Arthur Dove, and Marsden Hartley, was given its form first and foremost by its "organic," humanist predisposition. That predisposition was expressive of a reflective moral aesthetic very different from the predominantly antihumanist and determinedly antifeminine mood that was beginning to prevail among the European modernists. The Americans, on the other hand, generally continued to see art as the abstracted—the calligraphic—expression of a largely benevolent nature.

Still, when O'Keeffe embarked on her explorations of abstracted natural forms, theories linking abstraction to the life of the mind and to evolutionary transcendence of the material world were everywhere. In-

deed, for a brief period during the 1910s Henri Bergson's theories promised to provide a theoretical bridge between the Americans' and the Europeans' very different conceptions of the uses, in art, of cubist and futurist analytical and synthetic principles for the abstraction of organic form. Bergson's emphasis on "intuition" as the energizing core of creative evolution had, for both the Americans and the Europeans, in effect, legitimized the "subjective" in art.

He had argued in *Matter and Memory* (1896, American edition 1911), *Creative Evolution* (1907, American edition 1911), and *An Introduction to Metaphysics* (1903, American edition 1913) that consciousness, being part of the continuous preconceptual flow of duration, manifested itself first in the person as intuition. The intellect composed and organized what was essentially inarticulable and continuous into static, and hence merely approximative, units of conceptualization, somewhat like the frames of a movie—isolated until they became individually identifiable. The mind's ability to translate these static images into ideas was the source of creative evolution, but only if the mind maintained its contact with the intuitive dimension of consciousness. By itself the intellect could produce only mechanistic, self-contained, closed structures of thought. The further evolution of thought therefore depended on the "élan vital"—the intuitive, self-renewing, energies of the life force—which Bergson saw as the will to progress, to break through the paralysis of static, closed, mechanistic intellectual systems. A creative society, Bergson therefore emphasized, could thrive only on action. It must be ruthless in its will to destroy whatever tendencies toward internal stasis, toward "devitalization," might be pitted against it—whether these took the form of calcified ideas or of static social systems.

To the American artists Bergson's philosophy seemed, at first, an attempt to forge a bridge between matter and memory, to prove the logical continuity between intuition and intellect. But though many of the European modernist artists had, like Kandinsky, begun to explore abstraction as a means of "externalizing" the spiritual dimension in human intuition, most soon shifted their attention to the pursuit of abstraction as a celebration of the intellectual superiority of the synthetic capacities of mind rather than an expression of the essential qualities of human emotion. In the long run, both in the arts and within the context of social discourse, Bergson's central contention that intuition was a prerational system of checks and balances, capable of exposing

the limitations of existing rational processes, translated itself into a jus-
tification of what can perhaps best be called a "situational opportun-
ism." The core of this pop-Bergsonist pragmatism was an up-to-date,
mechanistic, intellectualized justification of irrational action in the
name of higher metaphysical reasoning. In this guise Bergson's theories
fit beautifully with the "discovery" of the unconscious by the psychoan-
alysts, as well as with the racist and sexist classifications of "evolution-
ary adaptability" developed by the biologists.

Pop-Bergsonism was a system that all too easily came to stand for the
social justification of aggression and violence in the name of evolution.
After all, the "élan vital," as the masculine vital essence, was the pre-
rational source of progress—part of the sexual energies that, in nature,
belonged to the "feminine" realm, but that, properly sublimated into
"creative action," became the source of all forms of intellectual tran-
scendence. Bergson's system thus appeared to justify innovation for its
own sake as a manifestation of evolutionary progress. William Carlos
Williams's formulation of the modernist painters and poets' battle cry to
"Make it New" found its inspiration in Bergson's ideas as surely as did
the imperialist powers' convenient justification of World War I as nec-
essary to the cause of human evolution.

Arthur Jerome Eddy, characteristically, exulted in this viewpoint in
his jingoistic foreword to the 1919 edition of *Cubists and Post-Impres-
sionism*: "We should realize that one of the bright sides of the war is the
superb way our Government is bursting century-old shackles" (ix). We
should realize, he added, that "empires will expand as fast as their ex-
pansion is consistent with the progress of mankind." Men should re-
joice that war permits them to die for "things the mind of man can only
dimly grasp and the speech of man but vaguely define. They give their
lives because the period of great strivings and great sacrifices has been
reached, because the womb of progress has borne its burden the allot-
ted time and the pains of deliverance are upon us" (xi). "The beauty
of it all," exulted Eddy in a truly Bergsonian frenzy of metaphysical ad-
umbration, "is that those of us who are left and those who are to come
will be nobler men and women—made so by the purification of sac-
rifice" (xiii).

The quite literally suicidal antihumanist enthusiasm for the "cleans-
ing power of war" expressed by influential figures in the modernist
movement such as T. E. Hulme (who translated Bergson's *Introduction
to Metaphysics*), and by artists such as Gaudier-Brzeska, Franz Marc,

August Macke, and Umberto Boccioni, is indicative of the ease with which the modernists fell into this deadly evolutionist rhetoric. (Always a practical future-ist as well as an idealist, Eddy had wisely begun to acquire their work well before they obligingly helped "purify" the world by offering their lives in the trenches.)

The proto-fascist bombast of F. T. Marinetti, in addition, showed how easily the Bergsonian system could be adapted to fit the gender wars, through the equation of masculinity with aggression, "creativity," and individual freedom, and femininity with stasis, "imitation," and collectivism. "Woman," who, as guardian of "passeism" and of "the family, suffocator of vital energies," was no more than "a closed circle," represented the past, always threatening to subvert the noble, truly masculine qualities in modern life with her decadent eroticism. Therefore the futurists would "glorify war—the world's only hygiene—militarism, patriotism, the destructive gesture of freedom-bringers, beautiful ideas worth dying for, and scorn for woman," as Marinetti had formulated it in his "Futurist Manifesto" (1909).

The mechanistic, machinelike perfection of modern scientific methods would help the world get rid of the preindustrial mentality and destroy the tonalists' sickly nostalgia for a nongendered concept of human nature: "Thus we will transform the *nevermore* of Edgar Poe into a sharp joy and will teach people to love the beauty of an emotion or a sensation *to the degree that it is unique and destined to vanish* irreparably. . . . The simple, doleful reign of endlessly soliloquizing vegetation is over. With us begins the reign of the man whose roots are cut, of the multiplied man who mixes himself with iron, who is fed by electricity and no longer understands anything except the lust for danger and daily heroism" (67).

O'Keeffe, as she did so often, stood on the sidelines while the men tried to talk themselves into being Tarzan, and in January 1918 pronounced her definitive judgment on the era of Bergsonian evolution: "It looks as though the War is going to last a long time and I dont see how Im going to be able to stand folks It shows them up so queerly so rottenly——so pitifully——and so disgustingly" (167).

Sarah Whitaker Peters has suggested that O'Keeffe was "a maverick mystic" (78), because she was interested in Kandinsky's theories and was acquainted with several theosophists as well as a few of the followers of Ouspensky, Blavatsky, and Gurdjieff who hung around 291 and Stieglitz's subsequent galleries—characters such as Claude Bragdon, an

architect and author of the pop-spiritualist best-seller *Old Lamps for New*. In a collection of observations on the nature of the feminine, *Delphic Woman* (1936), he succinctly defined the spiritualist perception of womanhood: "The life of woman is inevitably *sacrificial*, because she is the human embodiment of the Eternal Feminine." As "the divine nature in its love-aspect," her "biological burden, with its entailed suffering, is only the physical symbol of that incorporeal burden imposed by her 'qualities'—her passivity, her psychic sensitivity, her emotional impressionability." She therefore "represents the emotional nature, the feeling soul, in contradistinction to the reasoning mind."

In other words, like that of Paul Jordan Smith before him, Bragdon's "homage" to woman was entirely in line with the gender ideologies of the time. "Woman" was "intuition" incarnate. There was no room at Bragdon's inn for "Amazonian" women. The world's regeneration could come only through the intervention of women who, no matter how much they had been mistreated by nature and culture, were happy to turn the other cheek: the "Delphic Sisterhood, those who are *spiritually* free and nurse no rancor," who, having cleansed their minds of materialism, "have been able to *reverse themselves* without any loss of their essential *fémininité*, with their love-nature still uppermost and unimpaired" (63–66). Bragdon's view can be seen as representative of what the "spiritualist" circles of the period thought about the role of women in society.

As matter-of-fact, as clear-thinking, and as much in tune with the material world as O'Keeffe was, as disdainful as she was of the pretentious dimorphist claptrap of the "scientists" and their woman-bashing acolytes in the modernist movement, O'Keeffe was obviously not a likely target for conversion to the world of "Delphic Womanhood." Discussions concerning "the spiritual in art" usually ended up with men proving to her why she should sit still and play dead. What might lie beyond this world would appear to have interested O'Keeffe not nearly as much as how she might best be able to celebrate the living mystery of material nature. She wanted to live to be a hundred years old, not because she hated the agonies of material being, but because she enjoyed them far too much to want to say goodbye to her beloved canyons and arroyos.

The earth was her universe: that profound joy of the senses in texture, in tangible beauty. Her creativity was sparked by the inexpressible excitement of feeling grass, rocks, or sand underfoot, of holding a

smooth stone in her hand, of hearing color, touching the music of a flower's petals. To see the sounds of a symphony in the curve of a bone was transcendence enough for her. Sense experience in all its forms was not *of* God, but God to her. She was unwilling to sacrifice her world to any cause—least of all to the mysticism of men who sought sainthood in the sacrifices of women. Many of those who admire O'Keeffe's work, astounded by the energy, the quiet warmth, and the enjoyment it radiates, think that she must have been driven by mystical impulses, that she must have been guided by otherworldly voices or cradled by angels. But O'Keeffe's only guidance came from the invisible bond she felt between her body and the landscape. She was animated not by heavenly ghosts but by the weight of the sky molding her being into the curves of the earth.

At the same time there can be no question that like most other younger American artists, O'Keeffe was kept busy exploring every new "ism" that came along during the 1910s. As Arthur Jerome Eddy pointed out, many among the younger American painters were keeping their options open as they "searched with eager eye for valuable hints, for ways and means to perfect their own art" (194). It was, therefore, not unusual for O'Keeffe to have begun to explore the issue of abstraction in her own work. What *is* unusual is that those explorations resulted so rapidly in a truly distinctive personal imagery.

The ideas presented to her by her teachers, her visits to a wide variety of galleries and museums, her avid study of the drawings and articles in *The Masses*, her interest in the decorative art of the artists of *Vogue* and *Vanity Fair*, the stage designs of Leon Bakst, the experiments of the European modernists, an occasional *Camera Work*, and the proto-dadaist concerns of the magazine *291* all played a role in the development of her art. The spontaneity of her letters of this period and the length of her subsequent career as an artist tend to make us think of her as still young and inexperienced—in art as in life. But in 1917 she would turn thirty: within the framework of her time she was a woman entering upon middle age. Neither as a person nor as an artist can she therefore, despite what critics have often implied, be regarded either directly or indirectly as the "creation" of Alfred Stieglitz.

When Stieglitz saw O'Keeffe's drawings and watercolors for the first time, he saw the work of an artist whose personal vision had already found independent expression. There was a strong element of American transcendental materialism in his own conception of the links between

mind and matter, and he therefore understood her intentions better than most of her more immediate contemporaries. O'Keeffe was quick to recognize this. "You are more the size of the plains than most folks," she wrote to him from Canyon, Texas, in September 1916. "I seem to feel that you know without as much telling as other folks need" (156).

The charcoals of 1915 that had led Stieglitz to his "woman on paper" verdict had shown an interesting range of influences, but their connection with symbolism was immediately apparent, and it is this connection that may have helped him make up his mind about their "female" qualities. After all, not only were women given to depicting images symbolic of their femininity, but Marinetti—who, as the main spokesman for the futurists, was riding high just then—had recently pronounced symbolism to be a territory fit only for "impotent voyeurs *à la* Huysmans and inverts like Oscar Wilde" (69).

Stieglitz probably would have had more difficulty identifying the "feminine" qualities in her work if she had adopted the flat, linear "futurist" modernism that was being featured in *291*. But, while that style intrigued her, she was drawn more to the symbolists' explorations of the mystery of organic form. Several of the works Stieglitz saw in his first encounter with O'Keeffe's art, such as *Specials* numbers 2, 5, and 9, are not unlike Pamela Colman Smith's evocations of music, or Gottardo Piazzoni's *Reflection* (see fig. 27). In their use of outline, contrasting patterns of dark and light, and their emphasis on curving and waving lines, however, they are also related to such symbolist-expressionist images as Albert Bloch's *Summer Night* (fig. 44), reproduced in Eddy's *Cubists and Post-Impressionism*, and even to some of the symbolist-modernist caricatures of Marius de Zayas that were reproduced in the April 1914 issue of *Camera Work* (fig. 45). *Special No. 2* (1915, fig. 46), like Bloch's *Summer Night*, has a particularly Poe-like sense of the mystery of matter, and this makes it look like a mysterious fountain or a shrine to the erotic imagination.

Special No. 9 (fig. 47) is both the most abstract and the most "organic" of this group: a pattern of wavy lines receding toward the upper right establishes a distinct depth of field, making the image seem like a cross between a linocut by Arthur Dow and William Trost Richards's *February* (see fig. 6). It seems like an updated version of the damp and dreary, fog-enshrouded, tree-lined road to the House of Usher, though it could also be seen as a precocious anticipation of the sets for *The Cabinet of*

Dr. Caligari. O'Keeffe, however, laconically insisted that it was merely her impression of a bad headache.

It is possible that O'Keeffe herself recognized that the three-dimensional "materialism" of these works must have played a role in Stieglitz's detection in them of Freudian elements of "the feminine." The more spiritually evolved painters of the time, after all, were expected to concern themselves with flattened, angular, "geometric" compositions that would be worthy of Picasso's "world of the mind."

O'Keeffe, in consequence, may have decided to explore the world of planar abstraction—the flattening of volumes that is such an important part of the strikingly imaginative series of semiabstract watercolors from 1916 and 1917 surviving her autocritique of the following year, when she destroyed most of her previous work. But even the most "abstract" of these works show her fundamental unwillingness to abandon her interest in the organic materiality of her images as mediations between the eye and nature. This is most apparent in the watercolors that are still recognizably landscapes and figure studies, but it is an equally striking feature of such otherwise virtually completely "flat" abstract compositions as *Light Coming on the Plains* (I, II, and III) and the various versions of *Evening Star*, as well as *Sunrise and Little Clouds*, all from 1917. Even *Blue Lines, No.10*, from 1916 (fig. 48), perhaps her most "minimalist" abstract composition, remains an exploration of organic form: the complex variability in width and thickness of the vertical brushstrokes, and the manner in which they have been anchored in the "soil" of the horizontal lines, make this abundantly clear.

In this respect O'Keeffe's work of this period is remarkably similar to that of certain European painters who, during the 1910s, were also trying to shift from the symbolist-tonalist mode of their earlier work into the "spiritual" realm of pure abstraction. A work such as Theo van Doesburg's pastel of 1915, *Cosmic Sun*, for instance, luminous with radiating circles of color over an undulant line of darkness, could well have been part of an O'Keeffe series of experiments such as *Evening Star*. Van Doesburg also prefigures Arthur Dove's organic abstractions of the twenties.

Piet Mondrian, moving from a Hague School organic realism toward the mechanistic abstractions of his later years, was also at first content with the progressive removal of "extraneous" information in his attempts to find the essence of material form. The sense of essential

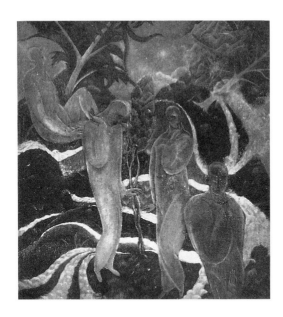

44. Albert Bloch,
Summer Night, 1913.

45. Marius de Zayas,
Dr. A. A. Berg, 1914.

46. Georgia O'Keeffe, *Special No. 2*, 1915. The Alfred Stieglitz Collection, Gift of
The Georgia O'Keeffe Foundation, National Gallery of Art, Washington. © 1998 The
Georgia O'Keeffe Foundation / Artists Rights Society (ARS), New York.

47. Georgia O'Keeffe, *Special No. 9*, 1915. The Menil Collection, Houston. © 1998 The Georgia O'Keeffe Foundation / Artists Rights Society (ARS), New York.

organic form in his familiar *Dune V* of around 1910 is very similar to that of O'Keeffe's watercolors. This is not an accidental resemblance. Though O'Keeffe cannot have been familiar with the work of these Dutch artists when she painted her works on paper, all three were—at this time—focused on abstraction as a way to capture the link between matter and mood. What was to differentiate the subsequent trajectories of Mondrian and van Doesburg from O'Keeffe's was the Dutch artists' typically European obsession with art as an expression of evolutionary masculinity. They progressively banished the "intuitive"—the organic—qualities from their work in search of an expression that would

48. Georgia O'Keeffe, *Blue Lines, No. 10*, 1916. The
Metropolitan Museum of Art, The Alfred Stieglitz Collection,
1979. (69.278.3). © 1998 The Georgia O'Keeffe
Foundation / Artists Rights Society (ARS), New York.

capture the concerns of "the man of the future" (189), as Carel Blot-
kamp emphasizes in his aptly titled essay, "Annunciation of the New
Mysticism: Dutch Symbolism and Early Abstraction."

Abstraction had come to be seen as a means of proving one's "higher
consciousness." In *Is It Art?* (1913), for instance, J. Nilsen Laurvik, a
regular contributor to *Camera Work*, quoted Marius de Zayas, another
regular, as reporting that Picasso considered abstraction important "be-
cause from the idea of the representation of a being a new being is
born." Picasso had, according to de Zayas, also claimed that he was

trying to present "the evolution by which light and form have operated in developing themselves in his brain to produce the idea, and his composition is nothing but the synthetic expression of his emotion." As Laurvik commented astutely, the new art's "whole tendency would appear to be away from art into the realm of metaphysics" (9–11).

Thus what soon came to separate the concerns of O'Keeffe and most of the other American early modernist painters from those of their European counterparts was the Americans' continuing and unwavering respect for the visual-tactile forms of nature—the "lighthouses and fog" that came to Charles Demuth's mind when he was asked to characterize Alfred Stieglitz. O'Keeffe and Stieglitz would find in the matter of matter the marriage of minds that the Europeans, at least on the theoretical level, sought to attain by abandoning not just the "copying" of nature but even its "imitation."

As we have seen, the art world of the 1910s bristled with notions that cast the intellect as the conduit to a new, and therefore ipso facto improved, expression of the spiritual dimension of art. The modernists had reserved seats on the escape-rocket that would take the supermen of the future from the emasculating Kryptonite world of effeminate materialism to the spiritual Metropolis of imperial manhood. By emphasizing mechanistic, nonorganic, "machinelike" shapes, they intended to supersede the traditional modes of representation with forms originating purely in the creative imagination. Their work was to be a tribute to the superior synthesizing capacities of the scientific mind, proof that man was able to transcend the "primitive" limitations of mere nature.

Many of the younger American painters soon recognized the fundamental disjunction between their own interest in the pursuit of organic form and the "mechanistic" intentions of the European modernists. Their continued adherence to the principles of representation was a conscious choice. As Arthur Jerome Eddy had stressed, American painters leaned "toward the painting of things in a big, broad *constructive* manner." They had not yet reached the point where they were "willing to let go of nature entirely and do purely *creative* things." Eddy acknowledged that he believed it would be better for art if things remained that way. "America," he argued, "—like every new country—is so essentially practical, practical in even its most imaginative flights, that it is difficult for its painters to retire within themselves and do things that have only an esoteric or metaphysical relation to actualities; that sort of thing in both art and literature is much easier on the conti-

nent than in either England or America; it is especially easy in the highly charged and hyper-artificial atmosphere of Paris" (195).

Contrasts of this sort, in their most absolutist (and jingoistic) form, easily led to the creation of an artificial set of binary oppositions, in which Europe came to stand for "bad" intellectualism and artifice, and the United States for "good" intuitive spontaneity of expression. As Eddy's remarks make clear, elements of such a jingoistic approach had already become apparent by the middle of the 1910s, in the wake of the turn-of-the-century critics' call for a truly "American" art. But Eddy's remarks also show that the younger American painters knew very well that abstraction had provided the artist with an effective new tool for the expression of the essential qualities of the American environment. Their growing wish to distance themselves from the Europeans was therefore not, as many post–World War II critics have suggested, a spineless return to conventional styles, but a considered and essentially humanist ideological response to the growing antihumanist rhetoric of the European avant-garde. For where the Europeans wanted to use abstraction to elevate themselves and their art above nature, the Americans chose to seek "no ideas but in things."

XIV

Stieglitz and the American Tradition

The *potential* for a creative dialectic between emotion and the intellect had been one of the organizing features of Bergson's philosophy. This "weakness" of his thinking could—as F. T. Marinetti had scornfully emphasized—be traced back at least in part, through the symbolists and Baudelaire, to Edgar Allan Poe. The European modernists' growing antihumanist emphasis on the pseudoscientific superiority of the intellect's mechanistic formal constructs over the inchoate chaos of intuitive being had corrected this weakness and brought Bergson's system in line with the "virile" imperialist worldview of the industrial nations' evolutionary elite.

But Bergson's emphasis on the intuitive sources of the organizing intellect had appealed to many American artists precisely because it emphasized the importance of the emotions and had seemed to propose a humanist *synthesis* of intuition and intellect—of the "female" as well as the "male" qualities of creative expression.

Now European modernism was focusing more and more on Bergson's celebration of the intellect as a mechanism of human transcendence. There were, of course, many Americans who also jumped on this bandwagon. T. S. Eliot, for instance, was to declare in his influential essay "Tradition and the Individual Talent," included in *The Sacred Wood* (1920), that "poetry is not a turning loose of emotion, but an escape from emotion; it is not the expression of personality, but an escape from personality." But the majority of the younger American artists sided with William Carlos Williams, who recognized in Eliot's attitude a profound betrayal of that "contact" with the American background he believed Americans needed to explore to gain their indepen-

dent voice. In his *Autobiography* Williams described the point of view of the "Americanists": "These were the years just before the great catastrophe to our letters—the appearance of T. S. Eliot's *The Waste Land*. There was a heat in us, a core and a drive that was gathering headway upon the theme of a rediscovery of a primary impetus, the elementary principle of all art, in the local conditions. Our work staggered to a halt for a moment under the blast of Eliot's genius which gave the poem back to the academics. We did not know how to answer him" (146).

Williams's oblique equation of Bergson's "élan vital" (the "primary impetus, the elementary principle of all art") with the intuitive truths of the senses—and hence with an art that reflected "local conditions," fit with his acceptance of Freud's notion that art was a "sublimation" of sexual energy. But where the European modernists saw sublimation as an act in which the intellect took control over these chaotic impulses, Williams believed it to be the artist's role to establish "contact"—a creative liaison, a dialectic—between the head and the heart.

Williams had developed his point of view under the influence of Alfred Stieglitz's advocacy of an American art that would adapt the principles of early modernism to the special requirements of the American tradition, so that it would reflect the emotional continuities underlying human experience in the New World. As we have seen, Stieglitz was by no means unique in taking this position. Calls for a truly American art had been legion since the 1880s. His own artistic and intellectual development had been dominated by the tonalists' search for their American roots, and by that "romanticism" which, as Elizabeth McCausland emphasized in *America and Alfred Stieglitz* (1934), "was the inevitable state of a country where the sod is yet to be broken, the forests hewn down, the wilderness conquered" (227).

Here the colloqui of Monos and Una, blending intuition and creative evolution, the emotions and the intellect, still organized human experience: "a life focused on feeling, that is on emotional movement, whereas in an older world thought rules, fixed at dead center." To McCausland Stieglitz "exemplified the American character," that "integrity of the spirit one finds in earlier Americans: Emerson, Whitman, Emily Dickinson. One finds it too in Marin, O'Keeffe, Dove. These painters, one believes, are as American as Stieglitz, as truly one with the romantic ebb and flow of American energies" (227–29).

As Jean Toomer pointed out in the same book of tributes, Stieglitz had, at least in his photographs, remained an intuitive dialectician in a

century of dualistic extremes: "Nothing to him is unrelated, even twigs and pebbles fit in as constituents of the universe." And Toomer astutely identified the core of Stieglitz's transcendental materialism: "Feeling, I believe, is the center of his life. Whatever he does, he does through feeling—and he won't do anything unless feeling is in it." Because "feeling is being," Toomer continued, "Stieglitz can evoke the one and therefore the other; and this is why he can help people find and be what they are, why he can move people both into and out of themselves, why we value him, we who are younger than he but old enough to realize that thought and action are nothing unless they issue from and return to being" (298).

No wonder that Stieglitz's early advocacy of the work of the European avant-garde soon lost its edge of genuine enthusiasm. His sponsorship of the magazine *291* was to be his last gesture of active involvement in the proto-dadaist tendencies of the European modernist movement. From late 1915 onward, as soon as the "mechanistic" tendencies of the Europeans became more apparent to him, his support for them became largely a matter of formal principle, a dutiful gesture of solidarity in recognition of an iconoclastic movement rather than an indication of wholehearted agreement with their objectives.

In a very real sense Stieglitz had now become the theorist of the American movement, intent upon finding abstract visual "equivalents" among the forms of nature for the elusive emotions he saw as the motive forces of human creativity. A tireless talker, unafraid to express his opinions (some found him garrulous, offensive, and obsessive), he helped a whole generation of artists and writers articulate their desire to develop what was "American" in American art. Though he was happy to discourse with anyone about modernism in general, and about American modernism in particular, he was extremely cautious in selecting the artists he considered genuinely "American" in their mode of expression.

These artists, some of whom he had supported with exhibitions at his gallery, 291, from 1909 onward, had, for all practical purposes, been gathered under his cape as a group as early as 1917. All were "organic" abstractionists, driven by a humanist impulse to express their American sense of place in their search for essential form. Like O'Keeffe, each had discovered most of the features of a personal style well before coming under Stieglitz's protection. And though Stieglitz showed the work of many other painters in his galleries, the list of his handpicked

protégés, those both he and the general public soon came to regard as "his" artists, was short: John Marin, Arthur Dove, Charles Demuth, Paul Strand—and O'Keeffe. Marsden Hartley, always uncertain of his identity, floated in and out of focus as a fringe-member of this group. Noticeably absent among this final lineup were any of the many first-generation Americans who constituted one of the most lively and important segments of the New York art scene before the Second World War. Though Stieglitz at first included artists with "immigrant" backgrounds, such as Abraham Walkowitz, Max Weber, Elie Nadelman, and Oscar Bluemner, in his exhibitions at 291, these soon fell by the wayside. During World War I an intense hostility had developed toward immigrants as "socially undesirable." This attitude was to culminate in the highly restrictive Immigration Act of 1924 and was succinctly characterized by an attack in *Collier's Magazine* on artists who had allowed their social conscience to speak in their work—an attack quoted by Max Eastman in 1916, in *Journalism versus Art*: "These are not artists, only low fellows whose immigration hither should have been prevented by law!" (58).

In 1923, in his book *American Artists*, the conservative art critic Royal Cortissoz even countered the modernists' claim to manliness by insisting that modernism was both effeminate and foreign, the obscene invention of a fey horde of immigrants. The United States, Cortissoz raged, "is being invaded by aliens, thousands of whom constitute so many acute perils to the body politic. Modernism is of precisely the same heterogeneous alien origin and is imperiling the republic of art in the same way." Though this invasion began "as our excessive immigration began, in an insidiously plausible manner," things rapidly got out of control, and cultural effeminacy was the lamentable result: "By the time the cubists came along there was an extensive body of flabby-mindedness ready for their reception here . . . promoted by types not yet fitted for their first papers in aesthetic naturalization—the makers of true Ellis Island art" (17–18).

Within this burgeoning climate of racist hostility to "alien" attitudes, Stieglitz, himself the son of German-Jewish immigrants, may well have been swayed—whether consciously or not is impossible to say—by this rapidly growing anti-immigrant sentiment. For in his search for an art with truly "American" roots he concentrated ever more exclusively on the work of what, during these racist times, were commonly known

as "Nordic Americans." He left the still growing ranks of immigrant and first-generation modernist artists in the—fortunately extremely capable—hands of J. B. Neumann, Charles Daniel, and a few others, until, finally, all of the handful of artists he considered worthy of his special attention, except the two photographers, Strand, and, of course, Stieglitz himself, came from well-settled American stock. Stieglitz's "Americanist" art theories thus invested his artists with an elitist dimension of their own that, not surprisingly, was to become, to the art collectors of the twenties, a particularly attractive selling point.

XV

Stieglitz's Dreams of Femininity and Materialism

Stieglitz's inspiration as an artist unquestionably came from his desire to bridge intuition and intellect. American transcendental materialism was in his bones. As an artist he wanted to express, as Jean Toomer put it in *America and Alfred Stieglitz*, "the *treeness* of a tree—what bark is— what a leaf is—the *woodness* of wood" (299)—all those inarticulate experiences of the human body that come to represent to us the tactile and visual parameters of our sense of self (and thus our very being). But even so he was very much a *man* of his own time—and, what is more, a man who, in his ideas about the feminine, had been influenced dramatically by his near decade of life and study in Germany as a teenager and young adult. The double image of woman, both saintly mother and vampire of man's intellectual and creative essence, as revealed by evolutionary science, had taken hold there more rapidly and more thoroughly than almost anywhere else, particularly during the decade of Stieglitz's sojourn.

Sue Davidson Lowe has pointed out that the physiologist Emil DuBois Reymond, who had been one of Stieglitz's teachers at the Berlin Polytechnic Institute, advised him to read Darwin, T. H. Huxley, Oskar Peschel, and Karl Vogt. The latter's *Lectures on Man* (1864) had been enormously influential in establishing the physiological bases for the intellectual inferiority of women. The false science of craniology (which extracted an entire world of gender and race prejudices from the measurement of cranial cavities) had proved conclusively that "the skulls of man and woman are to be separated as if they belonged to two different species" (81). The size and density of the male brain had led him to the conclusion that in evolutionary terms man had left woman in the dust.

Like Schopenhauer (who was also on Stieglitz's reading list at this time), Vogt maintained that woman was little more than a child, destined to be bound forever to the fruit of her loins in a "primitive and natural unity" (57). Among German physicians pseudoscientific and pseudoanthropological research into the inherent "primitivism" of the female was rife, and the sexual physiology of female vampirism was becoming a virtual obsession. Whispered conversation about books such as Krafft-Ebing's *Psychopathia Sexualis* (1886) soon become part of the intellectual's ritual initiation into manhood.

The painter Franz von Stuck, one year Stieglitz's senior, became between 1890 and 1910 one of the undisputed leaders of the visual documentation of the sexual child-woman's disastrous impact on the evolutionary hopes of the upward striving male. Stuck's paintings were widely reproduced in the art magazines of the period, for their lurid subject matter was a surefire circulation booster. Moreover, since a naive older generation still believed that woman was the moral center of Western culture, to admire Stuck's Grand Guignol conception of woman as destroyer was to identify oneself as a card-carrying member of the intellectual avant-garde. Stuck, in consequence, became so successful that large reproductions of his cautionary narratives, printed by the Munich art publishing house of Hanfstaengl, found their way into numerous upper-middle-class German households whose autocratic heads saw his art as a highly moral (as well as uncommonly titillating) reminder of their leadership role in the advance of Aryan culture. Stuck was also a founding member—and had designed the emblem—of the Munich Secession, a group of younger artists determined to break through the effeminate moral stasis of bourgeois German art.

Stieglitz, not surprisingly, given his education, was as avid an admirer of Stuck's cautionary tales as any of his German contemporaries. After his return from Paris in 1902, Edward Steichen frequently visited Stieglitz in his home on Madison Avenue. There, as he noted in his memoir *A Life in Photography*, among the proudest examples of the photographer's own work—*The Net Mender, Winter—Fifth Avenue, The Hand of Man*—he also encountered "two very large reproductions of paintings by Franz Stuck, the German Secessionist painter. One, titled 'Sin,' was of a standing nude. Around her was coiled a huge snake with threatening eyes. The other was the naked torso of a woman emerging from the body of a sphinx. Her front claws were dripping with blood from the limp body of a man she was embracing" (figs. 49 and 50).

49. Franz von Stuck, *Sin* [or *Sensuality*], 1897.

Later the dimorphist "philosophy" underlying these vicious images would become the basis for Hollywood's extensive iconography of feminine evil. Stuck's work, and *Sin* in particular, was also to contribute significantly to Adolf Hitler's understanding of gender relationships—so much so that, as soon as Hitler's rising fortunes permitted such an expenditure, he bought one of Stuck's numerous original replicas of this lurid tale of woman's primal evil.

Stuck's imagery would, unquestionably, still have shocked most middle-of-the-road Americans in 1902 and could therefore not but have been a source of extreme mortification to Stieglitz's wife Emme-

50. Franz von Stuck, *The Sphinx's Kiss*, 1895.

line. Richard Whelan has recently suggested that her husband was "vicariously uttering anguished cries of sexual frustration" (156) to her by hanging these reproductions, but there was clearly nothing vicarious about Stiegitz's choice of decorations. They represented a painfully direct declaration on his part that it did not matter whether a woman considered herself to be an "angel in the house" or a sinner. She was destined, by nature and the processes of evolution, to be a depleter of the male's vital essence, a baleful destroyer of man's hopes for evolutionary transcendence.

At the same time, the theme of woman's inescapable destiny to be the agent of brute nature also allowed Stieglitz to play out the self-serving

erotic duplicity of this false social dichotomy in the form of masochistic fantasies in which Emmeline, having given in to the call of her inner nature, would finally put some energy into her appointed carnal depredations. She, however, a typical daughter of later-nineteenth-century middle-class parents, had grown up in absolute horror of sexual relationships. Instead, she had been trained to be among the conspicuous consumers needed to drive the fin de siècle's burgeoning capitalist economies. Thus she was content to deplete her husband by spending his money. Her upbringing had made it a foregone conclusion that she would see Stieglitz's attempts at artistic sublimation as lewd provocations. As Whelan has pointed out, Stieglitz "must have felt as though he were being strangled and mauled like the sphinx's victim. Every attractive woman he saw was an Eve, a seductress, tempting him to sin" (156). The paintings by von Stuck on his wall were, however, more than "personal" messages—they represented his message to the world that he shared Stuck's opinion of the "psycho-physiological" nature of *all* women.

The eminent photographer's concept of the feminine was therefore very much in line with the "scientific" misogyny of mainstream Western culture. From a historical perspective it is clear that the masochistic prurience of Stieglitz and his contemporaries was a first, though destructive, step toward the liberalization of sexual mores. On the other hand, he and his contemporaries continued to be terrified of the "loss of vitality" they associated with sexual spending. To "sublimate" one's sex drive in the form of art became a way of safeguarding one's manhood while remaining able to display one's "virility." It would therefore be a mistake to interpret Stieglitz's numerous photographs of female nudes as indicative of a particularly vigorous interest in actual sexual relationships on his part. To him, as to many of his contemporaries, capitalizing on a woman's willingness to model nude became a far safer act of masculine self-assertion, of sexual appropriation—one not fraught with the mental and physical dangers of sex itself.

In fact, the case for manly self-control had by 1915 actually been bolstered by the growing popularity of Freud's writings. In its April 1917 issue, *Vanity Fair* ran an article on Freud, calling him "the most discussed of scientific men," and in the December 1915 issue of the same magazine Floyd Dell had reported that as part of polite conversation, psychoanalysis "first saw the light of day a short while ago in the throbbing studios of Washington Square, where it immediately

supplanted Cubism, Imagism and Havelock Ellis. Penetrating slowly northward, it has now reached the suburbs, where it seems implanted for a long vogue among our best talkers."

Dell, with pointed irony, identified the elite's fascination with psychoanalysis as having been given a utilitarian focus through its emphasis on the concept of "'sublimation.' Most of the beauty in the world—music, painting, poetry—has been made out of a surplussage of sex. To sublimate an instinct is, in a moral sense, to heighten, refine and purify it; in a practical sense, it is to make such use of it that, instead of being locked up in jail, you will be praised and paid, loved and honored, and eulogized, in the editorial columns of the newspapers when you die. As a simple business proposition, sublimation has much to recommend it." Thus, Dell pointed out, "the terminology of psycho-analysis seems to have conferred an air of scientific propriety on speculations which—a few years ago—would have been deemed horrific, and made possible new extremes of frankness in regard to ourselves by lending to them an air of heavy and pedantic importance" (53).

Dell's astute observations help us gain an insight into what motivated Stieglitz to reveal his own fears about the feminine in the first issue of *291*. By this time Freud's *The Interpretation of Dreams* had become a clear coffee-table favorite among suburbanites. It was certainly the inspiration for Stieglitz's contribution, which recounted what were presumably three of his own dreams. At the same time his estimation of Stuck's moral fervor had clearly remained high even in these later years, for in the July 1910 issue of *Camera Work* he chose to include an otherwise unremarkable photograph of the artist in a group of portraits by Frank Eugene of some of the leading artistic and intellectual lights of the Aryan advance.

The conception of women that echoed through these dreams was none too supportive of feminist concerns. In each, the dreamer's adversary is identified as "The Woman." In one of the dreams, The Woman wants food. Stieglitz remarks sententiously: "Food—Food—, Child, we are in a world where there is no Food—just Spirit—Will." To placate her he kisses her, and magically food appears: "And as the Woman began to eat ravenously—conscious of nothing but Nature's Cry for Food, I slipped away." Clearly this woman was another version of that crude depleter of the "élan vital"—of the essence of creativity—who at the very moment Stieglitz wrote about her counterpart, was setting the

world abuzz as the voracious "Vampire" of Theda Bara's screen debut, *A Fool There Was*.

In the longest of the dreams, Stieglitz's imagery becomes even more characteristic of what Floyd Dell, in the 1915 "Woman's Citizenship Number" of *The Masses*, had so aptly described as "the witch-doctor view of womankind," which held that "deranged by the fact of her sex" she was, most of the time, "practically insane." Stieglitz's dream woman fits the ruling scientific consensus. "The Woman and I were alone in a room," Stieglitz recounts. "She told me a Love Story. I knew it was her own. I understood why she could not love me. And as the Woman told me the story—she suddenly became mad—she kissed me in her ravings—she tore her clothes and mine—she tore her hair. Her eyes were wild—and nearly blank. I saw them looking into mine. She kissed me passionately and cried: 'Why are you not HE?'" Stieglitz is terrified by The Woman's ghastly passion. "Suddenly she screeched: 'Tell me you are He—tell me—you are He. And if you are not He I will kill you. For I kissed you.' I stood there and calmly said, what I really did not want to say, for I knew the Woman was irresponsible and mad. I said, 'I am not He.' And as I said that the Woman took a knife from the folds of her dress and rushed at me. She struck the heart. The blood spurted straight ahead, as if it had been waiting for an outlet. And as the woman saw the blood and saw me drop dead she became perfectly sane. She stood motionless. With no expression. She turned around. Upon the immaculate white wall she saw written in Blood Red letters: 'He killed himself. He understood the kisses.'—There was a scream. I awoke."

The implication of these "dreams" was clearly that, had the dreamer—Stieglitz—not given in to Woman's lustful whims, to her desire for the male as a source of material satisfaction ("food"), and had he instead maintained his focus on "Spirit—Will," on the realm of masculine transcendence, he would not have lost his "blood" (his creative essence) to her base materialistic desires. It is thus unlikely that O'Keeffe, who, one supposes, read these dreams at just about the same time as she studied the feminist articles in *The Masses*, could have found Stieglitz's conception of "Woman" as expressed in these dreams reassuring. No wonder the fact that Stieglitz had interpreted her work as representative of a supposedly uniquely "feminine" sensibility upset her.

In the complex relationship that was soon to blossom between O'Keeffe and the eminent photographer, his self-conscious Freudian

exploitation of the "sexual bases" of creativity and, in particular, his views on the "essential femininity" of her work must have been rather repellent to her, much as his fascination with the beauty of her body may have intrigued her. Stieglitz's harping on what he saw as the sexual themes in her work would help him make her a star of the art world, but for all the wrong reasons. At the same time his ability to turn his own obsession with her body into art may have helped her appreciate his creative complexity, once it was stripped of the dense, self-serving fog of his Freudian rhetoric.

Thus the sheer art of Stieglitz's photographs—and his search for what was truly American in art—caused his work to transcend the prejudices of gender, even as he continued to exploit these fashionable delusions to justify his failures. "I was able to know more than anyone else—both the worst and the best of him," O'Keeffe pointed out in her introduction to the Metropolitan's 1978 exhibition catalog of Stieglitz's photographs of her. "His power to destroy was as destructive as his power to build—the extremes went together. I have experienced both and survived, but I think I only crossed him when I had to—to survive.

"There was a constant grinding like the ocean. It was as if something hot, dark and destructive was hitched to the highest, brightest star.

"For me he was much more wonderful in his work than as a human being. I believe it was his work that kept me with him—though I loved him as a human being. I could see his strengths and weaknesses. I put up with what seemed to me a good deal of contradictory nonsense because of what seemed clear and bright and wonderful."

XVI

The Boy in the Dark Room:
The Fifty-ninth Street Studio
Once More

The drawings and watercolors O'Keeffe produced in 1916 and 1917, immediately following Stieglitz's first remarks about her work, showed her making a concerted effort *not* to be "a *woman* on paper" in Stieglitz's sense of the term, but an artist in tune with the avant-garde movements of the moment. For a while she tried to move in the direction of the still organically focused, symbolist, fauvist, Nabis- and Blaue Reiter–inflected work reproduced, mostly in color, in Eddy's *Cubists and Post-Impressionism*—work by painters such as Kandinsky, Ségonzac, Derain, Gabrielle Münter, and Albert Bloch (see fig. 44), as well as by such currently neglected artists as Mariana von Werfekin and Emilie Charmy. A superb early study of plant forms by Arthur Dove (fig. 51) must also have caught her eye. Works such as *Morning Sky with Houses, No. 2* (1916) and *Landscape with Crows* (1917—see figs. 32 and 33) suggest that in O'Keeffe's tonalist imagination the linear modernism of *The Masses* artists had merged with symbolist-modernist influences such as these.

The Rodin watercolors Stieglitz reproduced in the April–July 1911 double number of *Camera Work* (fig. 52) clearly informed her *Nude Series* of 1917 (fig. 53), and a surprising series of figural watercolors of 1918 show her doing work closely related to the elegant multicolor "white line" woodblock prints Provincetown artists such as B.J.O. Nordfeldt and Blanche Lazzell were producing just around this time—experiments in a collagelike flattening of surfaces, designed to simplify form, not in an attempt to induce us to *move away* from nature, but rather to lead us *toward* it by emphasizing the links between emotion

51. Arthur Dove, *Based on Leaf Forms and Spaces*, ca. 1913.

and the tactile-visual language of organic form. The technique of O'Keeffe's *Three Women* (1918, fig. 54), for example, closely resembles that of Nordfeldt's print *Pride of Possession* (fig. 55) of 1916.

Her work of this period thus shows that, even though she was far removed from the New York scene in Canyon, Texas, she kept herself informed about what was going on elsewhere. Anita Pollitzer was her primary contact, and Stieglitz was now corresponding with her on a regular basis as well. When asked to lecture on modernism at the Faculty Circle in Canyon, she found herself "laboring on Aesthetics — [Willard Huntington] Wright—[Clive] Bell—DeZayas—Eddy— All I could find—everywhere—have been slaving on it since in November——even read a lot of Caffin—lots of stupid stuff . . ." (159).

The watercolors she produced during this period have, in recent years, come to be among her most celebrated works. This is at least

52. Auguste Rodin, *Nude*, drawing from *Camera Work*, 1911.

53. Georgia O'Keeffe, *Nude Series, No. 3*, 1917. © 1998 The Georgia O'Keeffe Foundation / Artists Rights Society (ARS), New York.

54. Georgia O'Keeffe,
Three Women, 1918.
Watercolor on paper,
8⅞ × 6 inches. Gift of
Gerald and Kathleen Peters.
The Georgia O'Keeffe
Museum.

partly due to their spontaneity and their often remarkably original ex-
ploration of the extreme simplification of organic form. The forms in
these watercolors never violated the material integrity of the nature she
sought to express, but they were nevertheless quite as daring in their
departure from convention as anything being produced by the Euro-
pean modernists at this time. On her way to the "white line" effects of
the figural watercolors of 1918, she became very comfortable with a
flattened representation of form that emphasized line and texture over
three-dimensionality; she had encountered examples of this approach
in *The Masses* and in the works by John Marin, Picasso, Braque, and
Abraham Walkowitz that had been reproduced in *291* during 1915. On
the other hand, the proto-dadaist "machine-portraits" of Picabia and
the "visual" poems of Katherine Rhoades that were also reproduced in
the magazine clearly left her cold. In fact, her obvious indifference to
the intellectual games of the New York dada movement of the latter half

55. B.J.O. Nordfeldt, *Pride of Possession*, ca. 1916.
Collection Frederick R. Weisman Art Museum at the
University of Minnesota, Minneapolis, Minnesota.
Bequest of Emily Abbott Nordfeldt.

of the decade is indicative of her determination to continue to explore
the truths of nature rather than the "nonsense" of an art that could find
its material justification only in the rhetorical flourishes of theory.

Even in the *Specials*, which are easily the most "intellectual" experi-
ments of her career, she shunned intellectual games. Instead she re-
mained determined to express, in a two-dimensional visual calligraphy
derived from the material world, the most inexpressible of her emo-
tions: those perceptions of equivalence and interdependence she
knew existed between her sense of self and the textures and shapes of
the natural world. In such fascinating sequences of variations on a
single theme as *Blue* numbers 1 through 4, we see her trying to distill
the information of her senses. She moves from the organic, even still
recognizably "landscape based" three-dimensional, tree-form-derived

volumes of number 1 to the pure calligraphy of number 4. From that point it is but a small step to the complex simplicity of *Blue Lines*, or to the *Evening Star* and *Light Coming on the Plains* series of 1917.

At this point O'Keeffe had gone about as far with experiments in the simplification of form as was possible without abandoning the organic basis of her inspiration altogether. By 1917 she had discovered and explored the principles of what would later come to be known as minimalism and pure color abstraction. She had studied—and explored—that world of the "virile intellect" so precious to the champions of "pure abstraction." But what she saw in her own work, in the blotted membrane of watercolor paint and the grainy soil of pigment against textured paper, was not the spiritual future of mankind's "evolutionary intellect" in the process of transcending the limitations of nature—but the infinite beauty of the natural world itself, triumphing over theory and brought to the very essence of its visual and structural equivalence with the emotional sources of material being. Suggestions of three-dimensionality reasserted themselves tenaciously in these seemingly "entirely abstract" watercolors. The early glow of dawn, for instance, could not be captured more effectively on paper than it is in the implied three-dimensional weight of the moisture-laden morning sky of *Light Coming on the Plains III* (1917, fig. 56). No realistic painting could be as succinct in capturing the emotional mystery of this natural phenomenon. It represents the logical culmination of the American tonalist sensibility.

O'Keeffe, in these watercolors, avoided conventional perspective by omitting the use of distinct outlines. But, ironically, the absence of formal "containment" made the outline of the paint against the surface of the paper on which she painted all the more precise in its self-definition as edge. The fluid paint, in drying, molded itself into volume and material weight. The most striking difference between Rodin's nude studies and O'Keeffe's explorations of the subject in 1917 is, in fact, that where Rodin's are sketchy line drawings, rapidly overlaid with flesh-toned watercolor paint, that remain, to a large extent, two-dimensional studies of line, O'Keeffe's watercolors are not based on line drawings at all. They are built from the texture and shading of paint alone. Yet the outlines created by the drying watercolor pigment are more extraordinary in their approximation of the material weight and volumes of the human body than any of the outlines in the Rodin watercolors reproduced in *Camera Work*.

56. Georgia O'Keeffe, *Light Coming on the Plains III*, 1917.
Watercolor on paper, 1966.31, Amon Carter Museum,
Fort Worth, Texas. © 1998 The Georgia O'Keeffe Foundation /
Artists Rights Society (ARS), New York.

It is clear that O'Keeffe, by now, was perfectly aware of the impor-
tance of abstract texture, of paint as paint, as a means of expression for
the artist. She had abandoned outline in order to discover the essential
function of color as a factor in the representation of the material world.
But even color had shown itself to be a source of three-dimensionality
and material volume. Vanderpoel's remarks about the importance of
the "third dimension" in art, as an expression of the artist's sense of the
world, had proved to be far more significant to her than the modernists'
would-be spiritualist rhetoric about the "fourth dimension" of mind

represented by intellectual abstraction. Like light coming on the plains, the weight of the human body could not be transcended by the mind of man—of that she had become certain.

Toward the close of 1917, O'Keeffe therefore seems to have found herself at an unexpected impasse in her development as a painter. Her American background had made her revel in the three-dimensional complexity of the textures and volumes of the material world, and even her abandonment of distinct outline had succeeded only in moving her right back into the direction of the symbolist feeling of her earlier charcoal drawings. In addition, oil paint was proving to be a maddeningly recalcitrant medium. The oils of 1918, works such as those grouped as *Series I*, still have an extremely tentative feeling. O'Keeffe was evidently trying to recapture the complex, luminous textures of her watercolors in oil paint. But oil paint does not create outline the way watercolor or ink does as it dries.

As a result shape in these paintings remains awkwardly defined, and without distinctive organic volume—the curved patterns of works such as *Series I, No. 1*, or *Series I, No. 4*, seem awkward attempts at capturing the calligraphic simplicity and energy of the *Blue* sequence of watercolors of 1916. If she wanted to develop into a "painter" rather than remaining a watercolorist, she needed a new direction; she needed to integrate what she had learned from the wealth of stylistic influences she had examined into a style that would make her art capable of expressing the intense feeling of satisfaction the shapes of the wordless material continued to give her. In addition she was sick of the pettiness and the wartime jingoism of the people in Canyon, Texas. Thus when Stieglitz and Paul Strand showed themselves determined to bring her to New York, she was happy to pack up her things and go.

If it is understandable that O'Keeffe, given her laconic, commonsense outlook on the world, did not care for poetry, her skepticism about the practical value of most intellectual systems made her even less tolerant of abstract theorizing. She saw it as a verbal arena in which intellectuals could prove their manhood to each other without ever having to test the soundness of their mental erections in the realm of common sense. This was, she noted in her recollections of 1976, "the time when the men didn't think much of what I was doing. They were all discussing Cézanne with long involved remarks about the 'plastic quality' of his form and color. I was an outsider. My color and form were not acceptable. It had nothing to do with Cézanne or anyone else. I didn't understand

what they were talking about—why one color was better than another. I never did understand what they meant by 'plastic.' Years later when I finally got to Cézanne's Mont Saint-Victoire in the south of France, I remember sitting there thinking, 'How could they attach all those analytic remarks to anything he did with that mountain?' All those words piled on top of that poor little mountain seemed too much."

In 1978 she also stressed that Stieglitz, talking, became the aggressively "masculine" Stieglitz of the dream sequences from *291*: "He molded his hearer. They were often speechless." His need for verbal conquest was pervasive—and that, to her, reduced his stature as a human being. But even if she did not care for Stieglitz's rhetorical grandstanding, she recognized that his eye transcended the errors of his education. What he saw with his camera corresponded to the music of her own experience. And what his camera saw in the lines and volumes of her body made her feel clear and bright and wonderful.

To someone not as self-possessed and confident of her own abilities as O'Keeffe, Stieglitz's feverish, erotic-artistic obsession with her body during their stay at the Fifty-ninth Street studio might well have been offensive: a theft of privacy, of personal control, of agency. Stieglitz, like many autocratic men, was drawn to strong, independent women, not for their personality—though this remained part of the challenge—but because he regarded their "conquest" as proof of the superiority of his will. A good Freudian, he saw his art as an expression of his masculine potency, and he maintained that whenever he photographed he made love. But O'Keeffe recognized that, stripped of its masculinist posturing, Stieglitz's obsession with the erotic landscape of her body was no different from her own creative fascination with the earth, the leaves of a tree, or the curves in a riverbank. She remarked laconically that Stieglitz, in his art, was not really paying tribute to others, but that, instead, he was "always photographing himself." Secure in her own creative identity, she understood—and accepted—his photographic appropriation of her body as a form of artistic self-expression. Thus by separating his art from his invidiously gendered equation of creativity with issues of sexual dominance and submission, she succeeded in deflecting his attempts to take control over her identity.

O'Keeffe, clearly, was comfortable with her body and regarded it as a friend. Stieglitz's photographs of her were therefore also expressive of her own joy in the world of sense experience. As she "sat around painting with nothing on" in the subdued light of the Fifty-ninth Street

57. John Vanderpoel,
Torso, ca. 1905.

58 (opposite). Alfred
Stieglitz, *Georgia O'Keeffe*,
1919. The Metropolitan
Museum of Art, Gift of
Mrs. Alma Wertheim, 1928.
(28.130.2)

studio, she came to see it as a place of the body—her body—as both
source and vehicle of her creativity. When Stieglitz began to photo-
graph her in the nude, something new entered into her understanding
of her own objectives that took her out of the "intellectual" direction her
art had taken between 1915 and 1918. She recognized the objectives of
her own concerns in Stieglitz's photographs, which treated the shapes
of the material world as "equivalents" to the artist's state of mind.

Paul Strand's photography had already taken her eye into a new
world of material abstraction forged from unexpected camera angles
and reconceptualized fragments of ordinary things. Now, as O'Keeffe
found herself "photographed with a kind of heat and excitement and in
a way wondered what it was all about" (*Portrait*, n.p.), she began to
understand what she had already sensed: that it was not the abstraction
of the object but the motive for the process involved in abstracting an

object that counted most for her. When she saw how in Stieglitz's pho-
tographs her body had taken on an identity beyond herself—and had
become the creation, the self-expression of another person—without
ever ceasing to be, at the same time, recognizably the vehicle of her own
physical identity, she must have realized that what Stieglitz was doing
in his photographs was to express exactly those principles of represen-
tation in art she had learned from Vanderpoel fifteen years earlier. The
rhetoric of modernism had merely concealed the logical parallels be-
tween organic abstraction and the emotional continuities of the earlier
styles of American art she admired.

There was unquestionably a striking similarity between Stieglitz's
and Vanderpoel's intense determination to express the quintessential
values of creative experience through the linear modulations of a
woman's body (figs. 57 and 58). Stieglitz's focus on O'Keeffe's torso was

in virtually every detail analogous to Vanderpoel's pursuit of the evocative significance of line as a distillation of "essential form." Do not dwell excessively on the delineation of particular features, Vanderpoel had warned his students; concentrate on evoking the expressive power of "the salient lines that emphasize the movement and the great planes that envelop the substance" of the body whose essence you are trying to capture. "Only the experienced know the danger and fascination of being lured into the expression of insignificant detail" (136). In his drawings Vanderpoel often succeeded brilliantly in demonstrating the validity of his own advice.

Stieglitz, in photographing O'Keeffe, acted according to the same principles. He shared Vanderpoel's awareness of the evocative qualities of light on the body. The latter might have been lecturing as a stand-in for Stieglitz when he stressed that to evoke the essential beauty of the human body, the artist must at all times remember that "the surface of the body is enveloped in effects of light and shade, iridescent color and delicate tone" (11). For both artists essential line serves to delineate volume, and for both matter—three-dimensional volume—is the key to the effectiveness of the image as an expression of fundamental human emotions.

O'Keeffe was still struggling with precisely these issues of line and volume when Stieglitz began to photograph her. She had been unable, and, she now must have realized, unwilling, to suppress their use in favor of a more "intellectual" exploration of pure color, or even the textures of "paint as paint" she had explored in the transitional oil paintings of 1918. Her recognition of the fundamental continuities between the art of the past and modernism established a solid basis for her own concerns: in Stieglitz's photographs of her body the shadows of tonalism and the volumes of Vanderpoel had merged with—and defused—the destructive, antihumanist ambitions of modernist theory to which she had remained unwilling to succumb.

The shock of recognition had been reciprocal. In creative terms Stieglitz, too, had been in a slump before he began to photograph O'Keeffe. He, too, had been at an impasse in his attempts to adapt the rhetoric of modernism to the requirements of photography. He had focused perhaps too much on a series of portraits of artists, which, though they were superb in their evocation of character, did not satisfy his desire to express his inner experience through visual "equivalents." It is possible that the brilliant innovations of the much younger Paul

Strand had inhibited his own work. Now, through his photographic explorations of the body of O'Keeffe, Stieglitz had begun to rediscover the world. Her art and her physical presence helped him find a new visual language that could tie his modernist ego to the conventions of photography among which he had grown up.

Stieglitz, by then a fifty-two-year-old man with the inquisitive impertinence of a boy, had, in that dark room of creativity, the Fifty-ninth Street studio, thus revealed to O'Keeffe the repressive significance of the vestiges of self-doubt that had continued to constrain her as a woman struggling to be an artist in a culture of dimorphist prejudice. Seeing herself become a subject of art in Stieglitz's photographs, recognizing herself as a landscape of infinitely subtle gradation and linear variation in the sharply modulated lines and shadows of her loins, her arms, and her breasts, she at once began to rethink the function of volume and line in her own work, and to uncover in nature that topography of the emotions she had recognized in the body of the man's desire. If for Stieglitz her body had become the landscape of his personal longing, if he was able to express himself through her body, and turn her body into the matter of his life, then the matter she loved could just as easily become body to her sense of self.

Her art now rapidly reached that brilliant, mature coherence between content and form, that urgent awareness of the essential equivalence between her sense of self and the lines and volumes of the material world, that invariably led to her best paintings. Among these the *Fifty-ninth Street Studio* was certainly both one of the first and one of the finest. The artificiality and the hard coloring of her paintings of 1918, abstractions not solidly rooted in organic forms, represent an element in her work that would, from time to time, continue to crop up, but only when her confidence in her own vision faltered—an element that critics were to see, almost gleefully, as a confirmation of her "femininity" as an artist, of her presumed link to the "primordial sources" of "feminine eroticism."

One might apply similar elements of presumption to her painting of the *Fifty-ninth Street Studio* and point to its suggestion of a "vulval portal" into the realm of feminine creativity, but such an interpretation would lose its intended purpose very rapidly, because the painting retains its integrity as an emotive entity long after the divisive ideological intentions of such an interpretation have lost their power to speak to us. For issues of gender-identification are relevant to the emotive signifi-

cance of the *Fifty-ninth Street Studio* only as elements of dimorphist ideology. As an image it represents a thoroughly coherent integration of the various elements of O'Keeffe's previous explorations of the visual world as a vehicle for the expression of fundamental *human* emotions.

On a formal level the painting combines a determinedly three-dimensional representation of space with a sophisticated "abstract" arrangement of color planes, whose formal organization suggests a counterclockwise pattern of movement toward the center of the image. The viewer's eye is drawn inward beyond these planes, past the three-dimensional "darkness" of a central plane. The darkness of this plane suggests the presence of an uncertain space, whose potentially threatening quality is overcome by the warming glow of a carefully balanced pattern of rectangles; these, at the very center of the painting, offer the observer a point of passage into other spaces beyond the restrictive boundaries of the canvas.

By using what she had learned from Stieglitz's photographs about the expressive effect of the combination of light and sharply accentuated outline, O'Keeffe was able to integrate the planar organization of the image with its three-dimensional environment. The *Fifty-ninth Street Studio* announces in O'Keeffe's work a new and successful resolution of her preoccupation with the issue of edges—with the use of outline as a means to contain volume. She now began to emphasize their organic unfolding in a manner that took much from the sharply defined demarcation of outlines in terms of shadows and light to be found in the photographs of Stieglitz and Strand, while continuing to be based on the experiments of her own *Nude* series of 1917. There is nothing "artificial" about O'Keeffe's outlines in the *Fifty-ninth Street Studio*, but at the same time, the organic quality of these lines transcends the minor structural "irregularities" one might find in the actual outlines of a room. These freely flowing, sensuously curving lines now come to echo the naturally unfolding yet "essentialized" body-lines in Stieglitz's photographs of her—and in Vanderpoel's drawings of his models.

In addition, as if to help accentuate the organic lines of the *Fifty-ninth Street Studio*, O'Keeffe placed a new emphasis on the translucent "grain" of the pigment of thinned oil paint, which allowed her to obtain effects analogous to those she had been able to explore in her watercolors. She was now able to avoid the heavy, "flattening" torpor of opaque, weighted impasto—the awkward textural quality—of the paintings of 1918. This new approach allowed her to obtain a translucency of color

tones very similar to that one also encounters in the snows and mists of the tonalists. O'Keeffe's immediate inspiration for this tonality, however, was most likely Stieglitz's meticulous attention to the sepia values of his photographic prints and of the photogravures in *Camera Work*. The effects of light and shade Stieglitz had used to evoke the sensuous, three-dimensional, organic integrity of her body, deliberately accentuated by the texture of his papers, in turn cannot but have called to O'Keeffe's mind Vanderpoel's attention to the manner in which a particular density of "grain" in shading could bring special effects of light and volume to a charcoal drawing.

In the *Fifty-ninth Street Studio*, then, O'Keeffe was able to integrate her American love for organic form and volume with the modernists' emphasis on a stylized, flattened, abstracted, and hence "intellectualized" picture plane. She was well aware that mechanistic configurations of perception had come to be privileged as "masculine." She also knew that every other form of the organization of perception, ranging from religious mysticism to organic materialism, had come to be branded as expressive of the "feminine" consciousness. Thus O'Keeffe, by conjoining prejudicially identified, and supposedly contradictory, elements of style in painting, brilliantly succeeded in subverting and transcending the reigning clichés of gender in art.

She had discovered a visual language that transcended the artificially constructed boundaries of gender, and that was at the same time capable of expressing the infinite variety of analogues between the shapes of the material world and the subtle shadings of our emotions. From this point on she rarely moved away from the techniques of visual notation she had developed in the *Fifty-ninth Street Studio*. Her subjects might vary, but, whether she painted abstractions or "realistic" subjects, the stability and consistency of her technique in the vast majority of her subsequent work demonstrates that her style had, in this painting, reached its maturity.

XVII

The Revenge of the
Rhetoricians
of Gender

There are indications that O'Keeffe initially hoped that the stylistic discoveries of the *Fifty-ninth Street Studio* might have placed her work beyond the cultural "battle of the sexes" that was preoccupying so many of the male intellectuals of her time. Her art, after all, had attained a remarkable equilibrium: very modern in its use of abstraction, yet firmly anchored in nature, it seemed to have little to do with issues of gender as such. It forcefully expressed her sensuous commitment to the pleasures of mere being, yet that expression was tempered by calm reflection and deliberation. It was entirely of the present but remained distinctly indebted to the historical continuities of the American sensibility.

Unfortunately reason and insight nearly always take a backseat to the seductive rhetoric of social ideology. Her new work, probably precisely because it was so strong and original, almost instantly became a prime target for the gender dimorphists. Most intellectuals had accepted the biologists' argument that women should simply resign themselves to the role nature had designed for them and become walking sex lures (hence Helena Rubinstein's claim that "to evolve from woman to superwoman, the great requirement is beauty") and domestic experts in all that related to their reproductive function.

Man over nature, reason over instinct, spiritual transcendence over materialism: These opposing forces should cease to commingle in the higher civilization. The (masculine) intellect must bring order to the primal (and hence "feminine") impulses: "Nature," said Eddy in *The New Competition*, "is merciless, she knows no pity. 'Survival of the fittest' is her goal. The way is strewn with corpses of the weak, with the

debris of the rejected. Nature has no use for the lame, the halt, and the blind; her prizes are to the strong, and to only those of the strong who have no heart, who unfeelingly trample on the necks of others. The slightest hesitation is fatal; the man who lags behind to lend a helping hand never catches up; the man who lifts the weak, carries the old, sits by the side of the sick, is a fool. Nature's competition is a battle in which no quarter is given" (16). In such a world of crass materialism clearly only Theda Bara, the vampire of masculine essence, could hope to triumph. She must be controlled, defanged, and kept in the nursery. Eddy longed to see the chaotic and wasteful world of primal femininity superseded by "*the earnest, intelligent, friendly striving* of man with man to attain results *beneficial to both*" (18).

Eddy did not actually cast his well-intentioned, though confusing, argument in favor of "the new competition" in explicit gender terms, but as the language of the above passage makes clear, ideas concerning nature as a ruthless "she" simmered in his imagination quite as much as they did in the direct arguments of the biologists and the ever burgeoning ranks of "sexologists." To be a modernist, a progressive intellectual, Eddy knew, was to seek to rise above nature, for it was "her" biological destiny to wish to keep him mired in primordial passions. Woman was out to kill Man's intellect by engulfing him with her sexuality. It had come to be accepted as a commonplace of evolutionary science that ontogeny recapitulated phylogeny. This meant that each individual male, in his personal development from newborn child to full-grown adult, had to retrace the entire trajectory of his species from preconscious bestiality to the rarefied realm of intellectual transcendence.

This biological destiny of the human species made it necessary for the properly evolved male to accept that he must pass through, and hence for some time even partake of, the primitive pleasures characteristic of woman's enthrallment to vulgar eroticism. The upward striving male, however, should take care not to become mired in this realm of feminine sensuality. Having successfully completed his ritual of passage on the road to masculine transcendence, the intellectual would henceforth be able to analyze, identify, dissect, and classify "the feminine character" dispassionately, with complete authority—and superiority.

As the "symbolic content" of Stieglitz's "dreams" in the first issue of *291* already served to indicate, the photographer was a true believer in this ideology of the necessary evolutionary divergence of the sexes. In *Alfred Stieglitz: An American Seer*, Dorothy Norman, who was as

uncritical in her acceptance of Stieglitz's ideas as O'Keeffe was skeptical, quoted a 1919 letter to Stanton Macdonald Wright on the theme of "Woman in Art," in which he neatly and categorically summarized his agreement with the prevailing wisdom. "The Woman" of his 1915 fantasies once again made a capitalized appearance: "One of the chief generating forces crystallizing into art is undoubtedly elemental feeling—Woman's & Man's are differentiated through the difference in their sex make-up. They are *One* together—potentially One always. The Woman receives the World through her Womb. That is her deepest feeling. Mind comes second" (137). In other words, man and woman were complementary; they could be "*One* together," but the masculine and feminine spheres were fundamentally different, and separated by their sexual differences, and therefore could not really blend in the same person.

Stieglitz's viewpoint was thus exactly that of the turn-of-the-century theorists of dimorphic gender evolution. To try to teach a woman to produce an art like that produced by men was stupid, for in such cases "she attempted to become what her teacher was to her. She was attempting the impossible not really realizing that she never could do what he did." Man, in turn, seeing that she could not do what he did, misunderstood her failure as proof of woman's complete inability to produce art of any sort. "His theory may have been right in the past—may still be partially correct—I have never agreed to it. The Social Order is changing. Woman is still Woman—but not so entirely *His* Woman."

Instead "Woman" was beginning to discover the art that was unique to her own, separate sphere. If a man's art was logically the child of his intellect, a woman's art was the child of her childbearing function—"her Womb." In the past, Stieglitz continued, "a few women may have attempted to express themselves in painting. Remember when I say themselves I mean in a universal, impersonal sense. But somehow all the attempts I had seen until O'Keeffe, were weak because the elemental force & vision back of them were never overpowering enough to throw off the Male Shackles. Woman was afraid. She had *her* secret. Man's Sphinx!!" Recalling the moral message of Stuck's painting about woman's "elemental force & vision" had clearly sent a sudden exclamatory shiver up Stieglitz's spine at this point.

He acknowledged the presence of what might seem to be "masculine" qualities in O'Keeffe's work—her sense of color, her creative imagina-

tion—and pointed out that the year before "one simple black & white one was unanimously ranked as *Art* by those we concede know." (In other words the boys had decided it could have been made by a boy.) "In short if these Woman produced things which are distinctively feminine can live side by side with male produced Art—hold their own—we will find that the underlying aesthetic laws governing the one govern the other—the original generating feeling merely being different. Of course Mind plays a great role in the development of Art. Woman is beginning—the interesting thing is *she has actually begun.*"

What is particularly interesting about this letter is Stieglitz's underlying uncertainty about his theory of "Woman's separate sphere" in art as in life. His recognition that O'Keeffe's *art* in fact *was* art—"even" from the men's point of view—clashed with his insistence that "Woman produced things" must always represent an entirely different "generating feeling" (that of the dangerous, enigmatic Sphinx of men's nightmares). By qualifying his argument at each turn he tried to reconcile his admiration for O'Keeffe's work with his insistence that it must nonetheless represent "the Woman unafraid—the child!" (137–38).

Woman = Womb = Child = Woman's Art. No wonder that O'Keeffe, though she admired Stieglitz's passionate intensity in his search for beauty, and his ability to see "equivalents" to human emotion in the material world—his basic humanity, in other words—also made it a point to tune him out whenever he started in on his theoretical disquisitions. However, unlike O'Keeffe, a whole generation of younger American male artists and critics hung on to the photographer's every word. And Stieglitz, for his part, was determined to turn the "woman on paper" of 1916 into Western culture's first true manufacturer of artistic fruits of the womb. What she thought about that venture was of little importance to him. In *Alfred Stieglitz Talking* Herbert Seligmann described the dynamic of distance that developed between them: "For hours Stieglitz talked . . . , with sometimes as many as fifteen or eighteen people standing in a semi-circle listening so hard that, as O'Keeffe said later, she could whisper with another woman in the small room and not distract anyone" (55).

From the moment the relationship between the two artists had turned intimate, Stieglitz began to magnify the significance of his "conquest" by exploiting his dimorphist agenda. Now that sex, in the wake of Freud, Havelock Ellis, and the evolutionary biologists, had relatively abruptly come to be accepted as a theme of widespread public

discussion, the issue was on everyone's mind. The "sexual" basis of male creativity was not particularly titillating as a theme: after all, it manifested itself only in its "sublimated" form—in that "alluvial Nile-flood" Pound was talking about—in complex free verse, "abstract" painting, music expressive of "spiritual" depth, the "ambiguities" of philosophy, or the "objective truths" of science. But female sexuality was another matter altogether. In her "primitive" need to gather as much of the male's cranial sediment as possible, "woman" had little use for sublimation. The requirements of her womb dominated her entire life. By recognizing this, and by discussing and describing the processes involved, as well as the resulting physiological threat to men's chances for superman status, the intellectuals of the twenties could "sublimate" as much as they needed to even while their research into "female sexuality" allowed them to explore their erotic fantasies about women to their hearts' content.

This is exactly what Stieglitz did when he undercut O'Keeffe's (obviously already very slim) chances to be recognized as a painter rather than as a "woman artist," by parading her art as the expression of "the Woman" whenever he could. Unfortunately this, at least during the early twenties, was virtually all the time. Thus he could present his photographs of her not as expressive of his *own* erotic sensibility, as O'Keeffe knew them to be, but as an artist's (a male authority's) definitive, objective analysis of "female sexuality." In addition the photographs established his "manhood" in no uncertain terms, since the body of O'Keeffe—a body *he* "possessed," was demonstrably worthy of every man's most jealous fantasies.

Barbara Buhler Lynes has effectively delineated the deliberate nature of Stieglitz's public act of appropriation in her book *O'Keeffe, Stieglitz and the Critics, 1916–1929*. She points out that when Mitchell Kennerley arranged the first exhibition of Stieglitz's photographs since 1913 at the Anderson Galleries in February 1921, "almost one-third of the prints Stieglitz exhibited were of O'Keeffe, and anyone who had been unaware of her before the show would certainly never forget her after seeing it. As [Henry] McBride later recalled, the photographs depicted 'every conceivable aspect of O'Keeffe.'" Stieglitz, Lynes continues, "was not only aware that the nudes in his O'Keeffe portrait would create a stir, he also could not resist initiating even more controversy. He tantalized visitors to the exhibition by implying in the catalogue that the works on view were among his more modest achievements: 'some important prints of

this period are not being shown, as I feel that the general public is not quite ready to receive them'" (41–43).

Thus Stieglitz achieved what most of the supermen of evolutionary gender dimorphism could only dream about: he was able to assert his absolute authority over the body of O'Keeffe and his superior knowledge of "Woman's" sexuality at one stroke. The effects of this double assertion were immediate. The critics and the art public were henceforth incapable of separating O'Keeffe's art from Stieglitz's perception of it as the materialization of the womb of "Woman." In his review of the show for the *Dial*, Paul Rosenfeld, as Lynes notes, let the world know that the master's message had come through loud and clear: "In Stieglitz's exhibition, Rosenfeld declared, 'Sphinxes look out over the world again,' and 'these arrested movements are nothing but every woman speaking to every man'" (45). O'Keeffe had finally become Stieglitz's (and Stuck's) "Sphinx."

From the inception of O'Keeffe's fame as a public figure, Stieglitz therefore made sure that her work would be perceived as the body of female sexuality incarnated in "woman's art." He thus had cast himself as Svengali, transforming "the Woman's inherent sexual nature" into a new, sublimated "female creative impulse." O'Keeffe, the public came (and, for the most part, still continues) to believe, was the womb incarnate. She did not paint at "the arm's length that is usual between the artist and the picture; these things of hers seem to be painted with her very body" (132), the painter Alexander Brook insisted, in the February 1923 issue of the *Arts*, in his review of the show of O'Keeffe's work that Stieglitz organized at the Anderson Galleries two years after he had introduced the world to her nude torso. The reality of O'Keeffe's personality, meanwhile, effectively expressed in a portrait by Marion Beckett, and reproduced on the page opposite Brook's review, was very different from the fiction of O'Keeffe Stieglitz had created. The world therefore hastened to forget Beckett's image of a strong, austere, sensible, deeply intelligent "frontier" woman with no more surface sexuality than the female figure in Grant Wood's *American Gothic* of whom her portrait, indeed, might well have been an earlier rendition. But the "arm's length" we perceive in Wood's version, that ironic distance of the male artist—his usurpation of his subject—is absent from Beckett's portrait of O'Keeffe. Instead she acknowledges her subject's quietly skeptical perspective on the fuss her work was causing among "the men" (fig. 59).

59. Marion H. Beckett, *Portrait of Georgia O'Keeffe*, ca. 1920.

Brook's review of O'Keeffe's art also contained a passage that developed a theme Stieglitz's public presentation of O'Keeffe began to emphasize only after she had officially become his wife: O'Keeffe's art, Brook, said is "clean. It is the first adjective that occurs to the beholder. Had Georgia O'Keefe [*sic*] taken up the customary duties of woman, had she married and kept house, there would have been no dust under the bed, no dishes in the sink and the main entrance would always be well swept" (132). This imagery of O'Keeffe's art as thoroughly "domestic," even though "she painted with her very body," became the subject matter of Stieglitz's photographs of O'Keeffe, clothed, as an untouchable goddess of vestal cleanliness, the Sphinx tamed by civilization.

It is clear that neither of these representations of O'Keeffe had any relationship to O'Keeffe's perception of herself at this time, or to her approach to art. But because they fit so neatly into the late twentieth century's continued acceptance of the turn of the century's theories of essential sexual dimorphism, they have become the basis for her media-life as an icon of "the soul of woman." In the long run she gave up trying to fight this public perception and developed her own version of the "O'Keeffe myth" in her public persona. Thus she became "the Woman," the Sphinx of primal intuition, the "intuitive Goddess-woman" of Jungian cultists.

Ironically Stieglitz and the critics who helped him create the myth of O'Keeffe were far more "feminine" and emotional about the meaning of her art than she ever was. Their overwrought language and the logical instability of their interpretations showed *them* to be the "womb-driven" and "hysterical" ones. But their romantic volatility also gave their thinking a distinctly antimechanistic indeterminacy—a kind of "transsexual" emotional ambiguity that kept them from falling into the fascist mind-set of writers such as T. S. Eliot and Ezra Pound. Their erotically charged, "subjective," destabilization of the domestic-totalitarian dualism of the theory of sexual dimorphism frequently translated into an art that continued to be expressive of the principles of Poe's transcendental materialism. No wonder O'Keeffe liked Stieglitz's photographs better than his theorizing.

The critics, goaded by Stieglitz's self-serving manipulation of her career, were clearly haunted by thoughts of her body every time they viewed O'Keeffe's mature paintings. These could not—given O'Keeffe's obvious command over her material, and her cohesive visual calligraphy—be dismissed as the typical "woman artist's womb-skewed" attempts at art: amusing but "insignificant." However, to see them as "transcending" the realm of the feminine would be to question the reigning dualistic categories of gender. As a result the critics followed Stieglitz's lead and treated her work as if she had cleverly managed to quilt her "essential feminine being" into art.

The assault started with Marsden Hartley, who, in his *Adventures in the Arts* of 1921, referred to her paintings as "expositions of psychism in color and movement" and insisted, in what must surely be the most blindly erroneous assessment of a fellow artist's work ever written, that her work showed that "she despises existence" (118). Paul Rosenfeld, perhaps the most steadfast of Stieglitz's acolytes, followed his 1921

paean to O'Keeffe as the very sphinx of womanhood with an article in the October 1922 issue of *Vanity Fair* that reads like the lucubrations of a psychoanalyst on speed. Rosenfeld was a fine critic as long as he was dealing with the art of males, although he usually managed to bury his insights in a morass of murky verbiage. He recognized the dialectical qualities of O'Keeffe's art. She had, he said, "the power of feeling simultaneously the profoundest oppositions. Here is not the single-tracked mind, with the capacity for feeling only a single principle at a time. She seems never conscious of a single principle without simultaneously being aware of the opposites with a definiteness, a clearness, a condensation that is marvellous" (56).

But soon the cauldron of the id spilled out over Rosenfeld's gray matter and the battle of the sexes was on: "Rigid, hard-edged forms traverse her canvases like swords through cringing flesh. Great rectangular menhirs plow through veil-like textures; lie in the midst of diaphanous color like stones in quivering membranes"(112). A narrowly gender-specific "feminine" language of sexual violation and impregnation apparently governed O'Keeffe's way of seeing the world. A "mysterious brooding principle" governed her being. She stalked through the chaos of primordial nature like a praying mantis in heat. Her work was a documentary record of this "life in the dim regions where human and animal and plant are one, undistinguishable, and where the state of existence is blind pressure and dumb unfolding. There are spots in this work wherein the artist seems to bring before one the outline of a whole universe, an entire course of life, mysterious cycles of birth and reproduction and death, expressed through the terms of a woman's body" (112). Alfred Stieglitz Talking, indeed!

Rosenfeld's article set the tone for most of the subsequent male critical reaction to O'Keeffe's work, particularly during the twenties and thirties. These critiques, in turn, continue to be the principal sources for our contemporary conception of O'Keeffe's motives as an artist. There was virtually always an edge of voyeuristic excitement in the critics' comments about her presumed unveiling of the secret nooks and crannies of the "woman soul"—often accompanied by a carefully worded derogation of her technical skills. This allowed them to convey their intellectual distance from her crass displays of female sexual incontinence. Robert Hughes's critique of her work in his *American Visions* demonstrates that we still find it necessary to reassure ourselves that her art's visual strength was not the logical result of the considered

development of a strongly individual style by a superbly self-possessed artist who happened to be a woman, but rather the almost accidental by-product of barely controlled primal intuitions "instinctively" expressed in visual terms by a woman who came to consider herself an artist.

Even when critics became lyrical in their description of the "human significance of her pictures" as Lewis Mumford did, in the *New Republic* of March 2, 1927, their metaphors always made it immediately apparent that in their eyes, such "humanity" was a feminine characteristic, not a masculine one. "The point is," Mumford remarked, "that all these paintings come from a central stem; and it is because the stem is so well grounded in the earth and the plant itself so lusty, that it keeps on producing new shoots . . ."(41). Plant, roots, central stem, earth, lust, new shoots: fertilization, germination, reproduction—these are the marks of the universal female, a creature whose impulses are "instinctual," not rational. Such interpretations conveniently continue to reassure men that to be humane is entirely the responsibility of the "other" sex.

It would make no sense to deny that O'Keeffe's works not infrequently express the material world from a woman's perspective. It would, indeed, be as tendentious to make such a denial as to insist upon her work's "radical femininity." O'Keeffe, it is clear, was eminently comfortable with her physical identity as a woman. Her body was to her a coherent and pleasurable medium for her experience of being in the world. She saw its characteristics echoed in the world around her and celebrated the joyous analogues between the shapes of the natural world and her self. "I find that I have painted my life— things happening in my life—without knowing," she emphasized. Her celebration of the world of sense experience could not have been as complete, or as accurate, if she had tried to avoid expressing the specifics of her experience as a woman.

A work such as her infamously famous *Music—Pink and Blue II* of 1919 (fig. 60) has almost universally come to be seen as a direct, and almost too graphic, vaginal image. One's mental rigor would have to be superhumanly austere to prevent one's making such an association. But that is precisely why the image makes many of us uneasy. It could be said, to borrow from Rosenfeld's hothouse of metaphors, that the image undermines the stability of our precariously erected towers of conceptualization by enveloping them with the warm embrace of existential indeterminacy. When we see the image, we see a portal to the

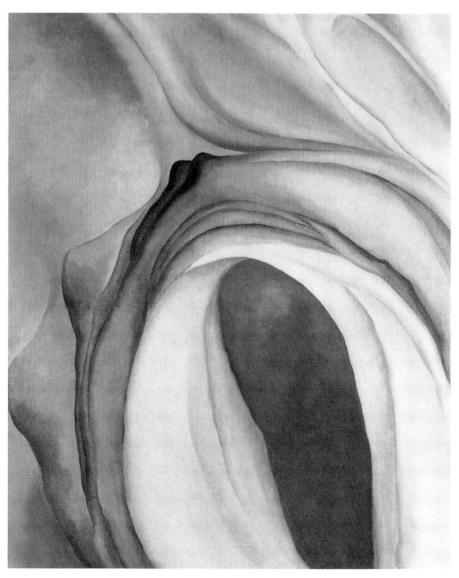

60. Georgia O'Keeffe, *Music—Pink and Blue II*, 1919. Whitney Museum of American Art, New York. © 1998 The Georgia O'Keeffe Foundation / Artists Rights Society (ARS), New York.

unknown. Fear of "loss of control," fear of sexuality as a "subversive," destabilizing force—as a "drain upon our cultural vitality"—these are the elements of social conditioning that interfere with our ability to see this image for what it is: an affirmation of life experience, of joy; a celebration of being as being—but precisely because of this, in its refusal to accept our carefully constructed fictions of progress as valid motives for self-denial, also certain to undermine the systems of domination and submission that maintain our economic and intellectual productivity.

The feminine as a subversion of masculine hegemony; a challenge to see ourselves differently; a negation of the false certainties of foolish fictions—those are the motives behind this work of art. O'Keeffe was not interested in *reinforcing* the structures of dimorphic gender ideology, as Stieglitz and the critics would have us believe, but in *undercutting* their authority. To see the celebration of the senses as a *humane*—a humanist—experience first and foremost, whether expressed from a woman's perspective or a man's, and therefore as equally accessible and joyous, in its humanity, to men as to women, is still an emotionally destabilizing concept for most people. If, in the modulations of a shell, a mountain range, or a flower, O'Keeffe is able to make us celebrate the body of being, it may be that her medium for the expression of that experience was most often the female body, but the essence of what we feel—that intense joy of the senses that is at the core of all good art and that confounds all theorizing—is *human* and without gender.

The work of Arthur Dove, O'Keeffe's closest "soul mate" in the field of art, is just as "physical" an examination of the links between human sense experience and material nature as O'Keeffe's. Organic shapes of a potentially "phallic" or, for that matter, "vulval" nature can also be found in many of his paintings: columns soar, mountains undulate, and luminous circular or oval celestial bodies oscillate throughout his oeuvre. Yet we rarely encounter any critical analyses of Dove's "primal phallic experience" of the world, let alone discussion of his "archetypal need" to express the world as an extension of his womb—although, had Dove happened to be a woman, there would, by now, probably be an entire library of interpretations of that sort.

The fact is that Dove and O'Keeffe were driven by the same intense desire to express the sheer sensuous joy of material being. Their common source for such an endeavor was their American background, and their experience of the American land. Even so, the contention that

O'Keeffe saw the world with her womb has continued to pursue the artist and has today, unfortunately, been augmented by the numerous mystical, "woman-soul" related interpretations of her work by "feminine-ists" unaware of their own compliance with the self-serving masculinist theories of fundamental sexual dimorphism developed within the antifeminine framework of social Darwinism.

As we have seen, O'Keeffe herself had little tolerance for such "mystical" interpretations of her work. As early as 1922, after the appearance of Paul Rosenfeld's palpitating prose in *Vanity Fair*, she wrote to Mitchell Kennerley that she found what Hartley and Rosenfeld had written about her very hard to take: "The things they write sound so strange and far removed from what I feel of myself They make me seem like some strange unearthly sort of a creature floating in the air—breathing in clouds for nourishment——when the truth is that I like beef steak—— and like it rare at that" (170–71).

XVIII

No Ideas but in Things: The First Postmodernist Era in American Art

Toward the end of the First World War, just around the time that O'Keeffe had settled in the Fifty-ninth Street studio, a heady confidence in the inherent superiority of "the American way" came to dominate the country's mood. Arthur Jerome Eddy, even before America's entry into the war, had identified the underlying economic causes of this change succinctly in *The New Competition*: "The bitterest—and true—cause of the present war is the rivalry of Germany and Great Britain for *trade supremacy*. This country has caught the virulent fever and is ambitious to reach out for the markets of the globe. We, too, seek war, *for war will surely follow*" (42).

The nationalistic fervor expressed itself in the art world in the form of a new interest in "American" forms of modernism. This enhanced the stature of the artists associated with Stieglitz, but it also led to a remarkable increase of public interest in the work of a wide range of artists who had been influenced by modernist concepts, but who had used these influences to develop personal styles of "organic modernism" that were often closer to the work of Cézanne than to cubism's "intellectual reconfiguration" of Cézanne's stylistic innovations. They sought to use abstraction, the simplification of outline, as a way of getting *closer to* the core of material reality. The European avant-garde, with its emphasis on theorizing, had, more and more, come to use abstraction to *move away* from material reality. The American artists' return to an organic basis for their art was therefore by no means simply a "regressive" attempt on

the part of American artists to return to their "provincial" ways, as most critics have maintained since World War II. Instead it represented a conscious effort on their part to adapt the innovations of modernism to the humanist materialism of the nineteenth-century American cultural environment. It was therefore the logical outcome of several decades of attempts by artists and critics to define the special virtues of "the American way."

But at the same time the American artists' sensitivity to the textures and the moods of nature made their organic humanism incompatible with the mechanistic sentiments of the evolutionary elite. Ralcy Husted Bell, writing in 1914, emphasized the "emotional intensity" of the tonalist painters in terms that would not have been inappropriate to a description of O'Keeffe's work. The tonalist, Bell said, "expresses breadth, teasing transparency, mysterious distances, the illusion of luminosity—in a word, the drama of air, light, and colour" (15). Throughout the twenties and thirties most American critics were to remain sensitive to what was regarded as the special link between the artist and the American land. That art should have a humanist focus continued to be taken for granted. Even those among the Americans who had initially been influenced by the futurists' and dadaists' self-consciously antihumanist glorification of machine forms as a higher principle of mechanistic order, of totalitarian control over the senses, tended to transform that focus into the precisionists' positive celebration of machines and factories as quasi-organic extensions of the American industrial imagination's creative genius. This focus would turn darker only with the coming of the Great Depression.

In fact the period between the world wars, following upon the exhilarating years of experimentation of the previous decade, saw the unfolding of a remarkably variegated and cosmopolitan artistic environment in this country. Artists were free to explore a wide variety of styles, ranging from pure abstraction to exact realism—*and* were able to find pockets of interest among patrons and gallery owners for the display (if not necessarily the actual sale) of their work. Within this context intergroup quarrels were, of course, legion, and every group had a tendency to call all the other groups retrograde, but no group had as complete a stranglehold on the public's attention as the abstract painters were to obtain over the cultural media of the fifties.

The American painters of the twenties were as convinced that they had discovered a viable, and truly "indigenous," form of modernist ex-

pression as those who were later to declare abstract expressionism to be "the triumph of American art" (itself a phrase already used by Margaret Steele Anderson in 1914 to describe the work of the landscape painters). Most of the younger painters of the 1920s had been involved in the experiments of the 1910s, or had absorbed the lessons of the modernist revolution. Almost all were in accord with the Stieglitz group's hostility to mechanistic forms of visual expression. In search of a timely visual language, they began to explore styles that might offer an appropriate urban analogue to the predominantly rural inspiration of the earlier American landscape painters.

Among most people with an interest in culture, the notion that modernism might be a dangerous, disruptive force in the visual arts had, by the early twenties, been superseded by a belief that art *should* concern itself with the exploration of "essential form." Tolerance of "nonrealistic" forms of drawing became a standard feature of the rhetoric of art instruction. The most sophisticated among the art public had become bored with cubism, futurism, and the host of other isms that had intrigued them during the 1910s, Then, as now, the general public, through all this, continued to prefer images that could be understood without arduous reflection. Had there been radio talk shows during the early twenties, the subject would probably have elicited just about the same range of complaints about the deficiencies of "modern art" one would be certain to hear in such a context today.

Time magazine, a journalistic upstart, and already, in its very first issue of March 3, 1923, eager to spot trends, ran a headline: "Cubism on the Wane"; it quoted Clive Bell as remarking that the movement "had served its purpose of freeing art from conventional restraints, and is in danger of becoming itself a mere convention." In the May 1923 issue of the *Arts*, in an article on Charles Sheeler, Forbes Watson, too, insisted that experimentation for its own sake was dead. "The bandwagon of 'modernism,'" he remarked, "after a period of immense usefulness, is pretty well deserted and the word 'modern,' after fifteen years—or is it fifteen centuries—of perpetual strain, is an invalid requiring long rest and complete seclusion."

Had the critics of the time been slightly more alert in their use of complex designations of supersedure of the sort so popular today, they would have found plenty of reasons to designate the 1920s as a first "postmodernist" era. In his article on Sheeler, as a matter of fact, Watson was very vocal in his advocacy of the new eclecticism. Among

contemporary artists, he said, those who had "fallen asleep" on the bandwagon of modernism were bound for oblivion quite as inevitably as those who were still trying to satisfy the hidebound requirements of the academies. The only artists who still counted were those, like Sheeler, who had taken "their way along a path of their own choice." To these, he said, "real things have happened. They are the only important younger artists, the rock-bound having brought forward none of any importance whatsoever" (335).

Indeed, even the grand master of cubism himself was advocating a "postmodern" eclecticism in which content and form might coexist in harmonious integration. In the same issue of the *Arts* in which Watson had declared that modernism was "passé," an interview with Picasso, written as a personal statement, found this master of mechanistic art backtracking to a more classical position: "When I paint my object is to show what I have found and not what I am looking for," he said humbly, in an apparent reversal of his attitude of the previous decade. Even he rejected the notion of experimentation, of "research," for its own sake. "Intentions," he remarked, "are not sufficient" to make good art. "What one does is what counts and not what one had the intention of doing."

Explaining the logic behind his own retreat from abstraction to a stylized, monumental neoclassicism, Picasso insisted that he was not a rebel without a cause, not a dadaist merely out to tweak bourgeois noses: "Whenever I had something to say, I have said it in the manner in which I felt it ought to be said. Different motives inevitably require different methods of expression. This does not imply either evolution or progress, but an adaptation of the idea one wants to express and the means to express that idea" (323).

Picasso had good reason to cast himself as a voice for moderation. As Henry McBride reported in the December 1926 issue of the *Dial*, his work was becoming quite the rage among the "vulgar" rich: "The sort of success that the usual artist yearns for was Picasso's, last summer in Paris. Anybody who was anybody felt it necessary to see the exposition of his work and to have his opinion about it. Very rich collectors with a newly awakened interest in modernity looked askance at the prices that were asked for the pictures and said that Rosenberg the merchant who handles Picasso's stuff was really becoming impossible."

McBride drew a telling analogy between the official ascendancy of cubism to the level of investment portfolio art and its rapidly diminish-

ing appeal to the American painters of the twenties: "It is a sort of axiom among the young that everything that is established, everything that brings high prices, and is hawked about by the merchants, is and must be rotten." The abandonment of cubism and other largely mechanistic forms of abstraction by most of the American painters of the twenties was therefore due, not to a "lack of nerve" on their part, but to a mixture of ideological and generational factors. The younger painters now became involved in an attempt to define a visual language that would fit effectively within the "postmodern" conditions of the American experience of their time.

Even so, many still—rather oddly—regard any American painter's decision *not* to copy European abstraction during this period as indicative of that painter's lack of "originality." Typically our critics will, in a single breath, point to the "slavishly imitative" nature of much of the American art of the twenties and bemoan its abject provincialism because it did *not* seek to imitate European models directly. Work produced by American painters that was responsive to the particulars of the local environment has almost invariably been regarded as reflective of the Americans' "inferior" artistic imagination. The arts of this country have always remained colonized by Europe. Most American critics still tend to regard any self-consciously "American" style or movement in art that has not been certified as "legitimately" modernist as a form of cultural effeminacy—and hence as mindless hokum.

But during the twenties and thirties it seemed for a short while as if this country's critical indenture to European cultural values had finally come to an end. There can be no question that this was due, at least in part, to the formidable presence of Stieglitz, talking. The photographer insisted that art should represent a moment of experience suspended in time, an "equivalent" to the inner world of the artist. That inner world could not be a realm of authentic experience if it had not been built from the textures and forms of the local environment, which constituted the grammar of the artist's emotions. Our senses shape our understanding, Stieglitz argued, and therefore the matter that informs our senses must also be the primary material for the artist's attempts at self-expression.

What Stieglitz said about the function of art rang true to O'Keeffe and to most of her contemporaries. Their reexamination of organic representation was part of their considered rejection of a movement that had outlived its immediate usefulness. Many of the younger artists were

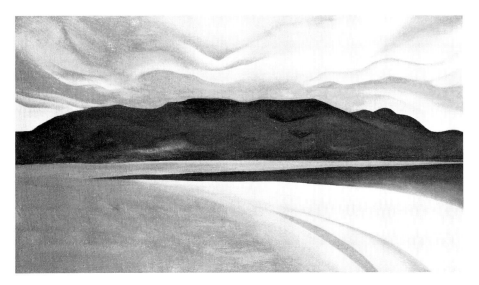

61. Georgia O'Keeffe, *Lake George*, 1926. Curtis Galleries, Minneapolis, Minnesota
© 1998 The Georgia O'Keeffe Foundation / Artists Rights Society (ARS), New York.

eager to examine the apparent contradictions between the organic pre-
occupations of earlier American art and the expressive requirements of
the new, industrialized, urban world of the twenties. O'Keeffe, having
delineated herself in the shapes and the edges of the *Fifty-ninth Street
Studio*, and having experienced the appropriation of her body as ex-
pressive matter by the creative eye of another in Stieglitz's photographs,
had already developed the visual grammar of her own art. She now
began to explore, ever more securely, that calligraphy of the emotions
she saw everywhere around her, in the forms, colors, and visual tex-
tures of her American environment. As part of that process she contin-
ued to revisit in her art the tonalist sensibility of the American artists
whose work had been a formative influence on her own conceptualiza-
tion of the function of art. Such works as her *Lake George* (fig. 61) of
1926, for instance, directly pay tribute to the tonalists' homage to the
material world as a source of inner balance. So do paintings like her
Black Cross, New Mexico (fig. 62) and *Gray Cross with Blue*, both of 1929.
In the first the last light of evening casts a yellow and red atmospheric
glow under the edges of monumental darkness formed by the shape of
the cross, bringing a new existential poignancy to the tonalists' tributes

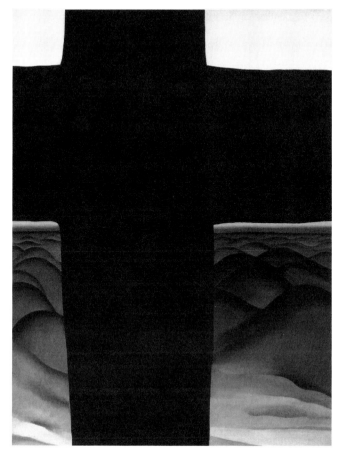

62. Georgia O'Keeffe, American, 1887–1986, *Black Cross,
New Mexico*, oil on canvas, 1929, 99 × 77.2 cm, Art Institute
Purchase Fund, 1943.95. © 1998 The Georgia O'Keeffe
Foundation / Artists Rights Society (ARS), New York.

to a dying religion of humane reflection, while in the second a luminous
backlight warms this formal religious symbol, not to emphasize its for-
mal hieratic function, but to bring out the tactile and material existence
of the cross itself. These paintings are extraordinary testimonials to the
persistence of the tonalist sensibility in O'Keeffe's art.

XIX

Barns and Apples

O'Keeffe's major paintings of the twenties are often explorations of the expressive ramifications of the interaction of emotion and organization so remarkable in works like the *Fifty-ninth Street Studio* and *Music—Pink and Blue II*. As the central figure of Stieglitz's inner circle during this period, she became intimately familiar with the equally independent and equally "American" work of Arthur Dove, John Marin, and Marsden Hartley. Dove and Marin, were, like O'Keeffe, able to combine an interest in abstraction with their love of material being, to create an often brilliant "postmodern" synthesis of matter and mind, of "intuition" and careful composition—of Monos and Una. Stieglitz and Hartley, however, constantly attempted to shore up the nongendered ambiguities of their best work with aggressive masculine verbiage.

Both wanted to be all-dominant, all-male, and misinterpreted their possessive reconceptualization of the eros of place as a manifestation of the masculine intellect's yearning for "spiritual transcendence." No wonder Hartley was, as William Carlos Williams characterized him in his *Autobiography*, perpetually tormented by self-doubt, and "one of the most frustrated men I knew" (171). But where Hartley attempted to absorb the masculinity he yearned for in the pursuit of other men, Stieglitz sought to assert his masculinity by demonstrating his ability to control the "primal instincts" of women. Forever wily, he was also extraordinarily astute in assessing the psychological needs and insecurities of those who visited his galleries.

His "seduction," late in 1927, of Dorothy Norman (herself quite adept at manipulating others), is a case in point. In her memoir, *Encounters*, Norman's account of the event is demure. Shortly after the birth of her first child, she had visited The Intimate Gallery:

> Stieglitz is alone, looking far into space. He asks if I am married, if the marriage is emotionally satisfying. I am so full of questions of my own,

his questions startle me. "Yes, I'm in love with my husband and we have a new baby." "Is your sexual relationship good?" Talking about such matters is of vital importance, in spite of my inability to be totally honest.

Stieglitz inquires, "Do you have enough milk to nurse your child?" Gently, impersonally, he barely brushes my coat with the tip of a finger over one of my breasts, and as swiftly removes it. "No." Our eyes do not meet again. I am neither affronted nor self-conscious. (56)

Overwhelmed by the photographer's ability to ask her pertinent questions, she cannot resist returning to Stieglitz's gallery over and over again after that. She is hooked. Soul, it would seem, has met soul, in an exchange of serious conversation.

But she had in fact responded to a direct gesture of appropriation on Stieglitz's part. Just as he had manipulated O'Keeffe's public image as the painter of the womb of woman to assert his authority over her, he now played upon Norman's own mystical—and dimorphist—Jungian conception of the feminine. In private conversation Norman's account of the incident left no doubt that she regarded Stieglitz's gesture as an archetypal rite of appropriation through which masculine authority— "the hero"—had asserted its right over the sexual identity of "the ur-mother." She privately remembered the effect on her of Stieglitz's gesture as analogous to the life-giving charge that passed between the outstretched fingers of God and Adam in Michelangelo's fresco for the Sistine Chapel. Stieglitz had touched her nipple, and the gesture had electrified her being—making her, in her estimation, forever his.*

Norman was a tireless worker for progressive social causes, an important presence in the civil rights struggles of the thirties; but her independence as a person was undermined by her search for heroes and her need to see herself as acting out the "mysteries of the universal woman soul." She was thus a true believer in the rhetoric of sexual dimorphism. Norman's record of her first meeting—and clash—with O'Keeffe is indicative of their radically different personalities. As Norman gives O'Keeffe an account of all the causes she is working for, the latter brusquely asks "why I don't work for the Woman's Party and drop all other 'nonsense.' My answer: 'Other causes interest me more.' Clearly the subject is dear to her heart." Norman recalls that, miffed by O'Keeffe's abruptness, she tried to point out to her that she was "learning more about being a woman, beyond and including 'women's rights.'

* In conversation with the author, May 1966.

I can act only when I'm ready." She was "mystified" by O'Keeffe's ada-
mant refusal "to be called Mrs. Stieglitz" (62).

Choosing between O'Keeffe's rebellious independence and Norman's
idolatry was not difficult for Stieglitz. Aging and finding himself in-
creasingly marginalized in the New York art world owing to the new
socioeconomic environment of the Depression, he soon found it a lot
easier to listen to the lilting siren song of Norman's mystical femininity,
with its leitmotiv of unbounded admiration and eager submission, than
to countenance O'Keeffe's laconic pragmatism. Stieglitz's shift of alle-
giance from O'Keeffe's humanist materialism to Norman's Jungian mys-
ticism prefigured the fundamental shift that would take place in Ameri-
can culture immediately following World War II, from a focus on art
grounded in material reality to one dominated by rituals of mystical
conceptualization.

O'Keeffe's art of the twenties, like that of Marin, Dove, and most
other younger Americans, was centered on tributes to sense experience.
This aspect of her work is most brilliantly expressed in the superb series
of small still lifes of fruit and vegetables she painted between 1920 and
1924. At first glance many of these canvases of grapes, plums, apples,
or figs may appear to be rather typical realistic representations of famil-
iar objects in our lives. But there is an internal luminescence in these
works that is very different from traditional "photographic" realism.
Conventional works of that sort most often use sharply delineated line
as a means of containment—perhaps even confinement. That is, the
objects depicted are displayed as specimens, as trophies. They tend to
appear bereft of any sense of movement—and their stillness is inten-
tional, because they are meant to be arrangements, displays. Often they
are metaphors of ownership.

O'Keeffe's little still lifes of the early twenties, however, are "character
studies": they seek to capture the inner life of form as form. But for
O'Keeffe that was a life created, not by any mystical power beyond our
perception, but by the restless movement of the human eye in search of
tactile equivalences to our emotions. There is, in these seemingly sim-
ple images, in their subtle patterns of line, layered volume, and gritty
pigmentation, an admiring, and impassioned, homage to the integrity
of what is "other" in our world.

That quality communicates itself even in such a tiny work as *Figs*
(1922). Here are two objects with shapes so unprepossessing that we
would, in general, conceive of them as shapeless. Indeed, when these

fruits are ripe, they become so soft that they seem barely capable of maintaining their own structural coherence. These are objects so far removed from our society's hierarchies of power and value that we are unlikely to see them as having any "essence" at all. And yet O'Keeffe succeeds in calling our attention to their integrity as objects of essential otherness.

The artist's space of visualization is a piece of cardboard less than eight by six inches in size. She has placed the—very accurately rendered—figs on a plane of basic white, restructured, with the help of gray-blue lines of shading, to become a platform centered within a troughlike, distinctly three-dimensional, abstract composition. The figs themselves are given internal luminescence through an array of interdependent color shadings that edges from light green and yellow through ocher and burnt umber into echoes of mauve and blue-gray to the barest hint of a deep purple sheen along the edges formed by the fruit's mottled skin.

The extraordinary precision with which O'Keeffe was able to maintain the organic integrity of the objects she painted is what makes them loom so much larger in our memory than the actual size of the images themselves might seem to warrant. That is why, when after a period of time, we return to certain of O'Keeffe's works, we are likely to be startled by their minute size—particularly in comparison to their place in the inventory of our imagination.

O'Keeffe's still lifes of fruit thus usually succeed marvelously in capturing the "otherness" of the objects she depicts. But it was not always her primary goal to convey that particular aspect of organic form. In such images as *Alligator Pear, No. 11* of 1924, she was concerned not with the object itself but with the distillation of line and color into visual melody. It is an important aspect of O'Keeffe's nonhierarchical sense of the various expressive options available to her that she was as likely to use abstraction as the more conventional forms of representation to achieve her intentions.

Both *Figs,* and *Alligator Pear, No. 11* show that O'Keeffe had been able to benefit from the mechanistic tendencies of European modernism without relinquishing her native predilection for the accurate rendition of organic form. In some of her work of the late 1910s and early 1920s, however, that integration was not so fully achieved. Works such as *Blue and Green Music* or *Orange and Red Streak*, both of 1919, move far more closely to a mechanistic (one is tempted to say "mechanical") stylization

of form. In *Blue and Green Music*, in particular, organic line has been supplanted almost entirely by a "normalized" and denatured, a "mechanical," delineation of form. Ruler-guided straight lines and closely calculated, "intellectualized" curves produce an image that, to late-twentieth-century eyes, could almost have been computer-generated. Similarly, the curve in *Orange and Red Streak* seems too controlled, too deliberate, to have had its origin in an organic phenomenon.

Paintings such as these are unquestionably visually arresting, but there is something very artificial about them. It cannot be said that they represent a passing phase of overly intellectualized experimentation in O'Keeffe's oeuvre, for she returned to works of an analogous nature from time to time throughout her career. *Lake George Window* of 1929 and much of the *Jack in the Pulpit* series of 1930 are among the later manifestations of this aspect of O'Keeffe's art. The appeal of these paintings is often as cerebral as that of the visual explorations of the minimalists of the sixties. At other times they reveal, in their rigorous emphasis on the stylization of line, a decorative impulse akin to that of the commercial artists working for the fashionable magazines of the twenties and thirties. In these works the element of technical control came to dominate her organic sensibility to the detriment of the humanist side of the artist's vision.

Another extreme mode of representation in O'Keeffe's work, one that might be described as excessively stylized, pseudo-organic soft-focus abstraction, is exemplified by *Spring*, of 1922. Work such as this is no less carefully composed or abstracted than *Blue and Green Music*. But whereas the latter painting is characterized by an excessive mechanization of form not unlike the self-consciously masculine art of the futurists or the British vorticists, *Spring* sentimentalizes organic form by blurring the edges of material experience. In their seemingly tentative quality of line, works such as this (which tend to be favorites of the feminine-ists among the artists' admirers) approach, in a, for O'Keeffe, uncharacteristic fashion, the emphatically "gendered" art of such French painters as Marie Laurencin and Hélène Perdriat. The work of these latter painters, invariably identified by the critics as "truly feminine," was extremely fashionable during the twenties, both in Europe and in the United States.

Generally, however, O'Keeffe's work of the twenties was driven by her obviously not gender-specific desire, shared with many of the other American artists of the period, to uncover equivalences between the emotions and the forms of nature. A work such as her *Calla Lily in a Tall*

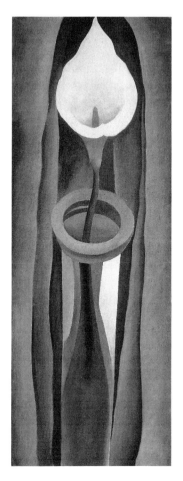

63. Georgia O'Keeffe, *Calla Lily in a Tall Glass, No. 1*, 1923, oil on board, 32 × 11½ inches, Private Collection, Courtesy, Gerald Peters Gallery, Sante Fe. © 1998 The Georgia O'Keeffe Foundation / Artists Rights Society (ARS), New York.

Glass, No. 1 of 1923, a magnificently modulated single flower in a vase (fig. 63), is remarkably idiomatic for its time. Its textures, its sharply delineated edges, and its cubist-inspired partial flattening of the picture plane are elements of style the painting shares with the still lifes of many of O'Keeffe's American contemporaries. Painters such as Maurice Sterne, Henry Lee McFee, Charles Sheeler, Konrad Cramer, B.J.O. Nordfeldt, and Andrew Dasburg were painting still lifes in similar styles. But where the work of these other painters tended to be cluttered, a piling up of outlines, colors, and textures on a crowded picture plane, O'Keeffe's *Calla Lily* exhibited a cool simplicity of theme that served to counterbalance the passionate intensity of its linear visualization of organic forms. Brilliantly composed, a work of visual music, full

of sonorous harmonies of line and color, it also blends—and hence confounds—symbols the Freud-minded critics of her time could have read as gender-specific.

Virtually the same remarks apply to *Corn, Dark I* of 1924, with its dramatic emphasis on the vertical surge of the leaves surrounding a leaf-bud at the center of a corn plant seen from above. In a similar fashion the daring dark volumes, topped and intersected by sensuous lines and by what seems once again a memory of the glow of fading light so often found on the horizon of a tonalist sunset, of her marvelous *Dark Abstraction*, also of 1924 (fig. 64), alert us to the complementary impulses of fear and celebration so often found in the ambiguities of evening, while the stylized linear realism of her *Lake George* of 1926 corresponds to the blend of mechanistic and organic impulses of her cityscapes of a few years later.

In these paintings the simplification of line and the delineation of essential volume never take anything away from the intense organic authenticity of the forms O'Keeffe has abstracted. These images, or such seemingly "nonrepresentational" works as *From the Lake, No. 3*, also from 1924, actually enhance our sense of jointure with the natural world. To grasp their full significance, we must be willing to synthesize the intellectual and the emotional factors that usually are made to play separate roles in perception. These paintings integrate the forms of nature with our reflective capacity. They do not place us beyond nature; they place us at that point of convergence between the intellect and the affections that forms the core of humanism.

Though the American art public of the twenties was by no means unaware of O'Keeffe's technical achievements, most critics were unwilling to abandon the convenient equation of intellect with masculinity and of emotion with all things feminine. Sexual dimorphism was to remain the undercurrent of every discussion of O'Keeffe's work. In the April 1924 issue of the *Arts*, which featured side-by-side full-page reproductions of two versions of O'Keeffe's *Calla Lily*, Virgil Barker made the following comparison between her work and that of Charles Sheeler: "Miss O'Keeffe's pictures are the clean-cut result of an intensely passionate apprehension of things; Mr. Sheeler's, the clean-cut result of an apprehension that is intensely intellectual."

Recognizing that he had just reiterated everyone's favorite platitude about the fundamental differences between men and women, Barker hastened to add: "Of course, there can be no splitting-up of any mentality into intellect and emotion and will after the fashion of an outworn

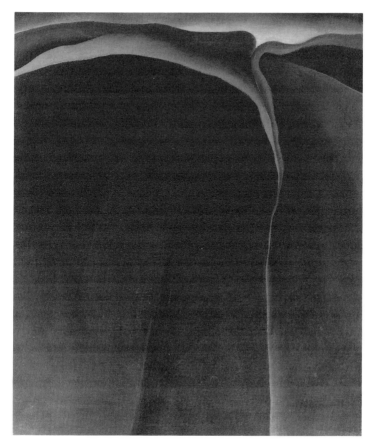

64. Georgia O'Keeffe, *Dark Abstraction*, 1924. The Saint Louis Art Museum. Gift of Charles E. & Mary Merrill. © 1998 The Georgia O'Keeffe Foundation / Artists Rights Society (ARS), New York.

psychology; in art, at least, emotion cannot be made concrete without intellect, nor can intellect do anything without emotion. But as long as such differentiations are understood in no exclusive sense, they may serve. And only in such a sense is it suggested that Miss O'Keeffe's pictures embody intelligent passionateness while Mr. Sheeler's embody passionate intelligence."

Barker's remarks are particularly interesting because they give us insight into what, by the middle of the 1920s, thoughtful, enlightened, progressive male intellectuals were willing to concede about the possible *similarities* between men's and women's creative abilities. Yet with all of Barker's suave concessions to potential sex-equality in the arts, he

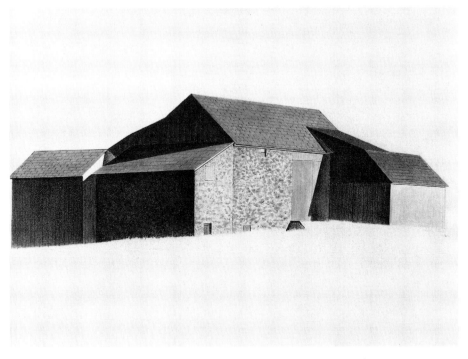

65. Charles Sheeler, *Bucks County Barn*, 1923. Whitney Museum of American Art, New York.

clearly felt rather daunted by the "unmanly" emotional immediacy and intensity of O'Keeffe's work: "All Miss O'Keeffe's paintings are intimate," he said, "some of them almost unbearably so; fruit and leaves and sky and hills nestle to one another. In contrast Mr. Sheeler's paintings are far-withdrawn; barns and flowers and jugs stand cool and quiet and remote" (222).

On its surface, Barker's delineation of the distinctions between the work of O'Keeffe and Sheeler is undoubtedly correct. What is problematic about his remarks is their implication that the "almost unbearable intimacy" of O'Keeffe's paintings was a factor of what he obviously saw as her nesting instinct, while Sheeler's "cool and quiet and remote" barns, flowers, and jugs represented the male's "analytic" capacity. It does not seem to have occurred to Barker that O'Keeffe's rejection of the "cool and quiet and remote" approach might have been the result of a conscious choice, an intellectual decision on her part, rather than a hormone-driven necessity.

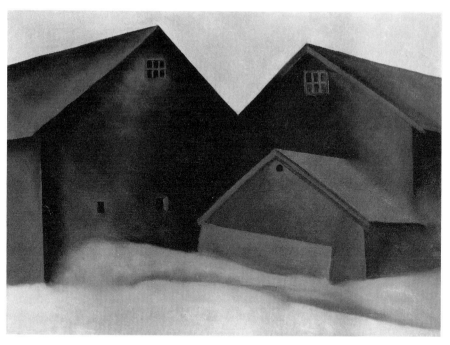

66. Georgia O'Keeffe, *Ends of Barns*, 1922. Gift of William H. and Saundra B. Lane, Juliana Cheney Edwards Collections, Emily L. Ainsley Fund and Grant Walker Fund. Courtesy, Museum of Fine Arts, Boston.

Ironically, directly following his interpretation of O'Keeffe's "almost unbearable" display of feminine emotionalism, Barker waxed almost unbearably emotional himself, in his praise for Stieglitz's photographic *Equivalents*, works that had been inspired at least in part by O'Keeffe's methods of abstract representation. Stieglitz's "sky-songs," Barker enthused, were "a call to adventure, an enlargement of experience, a spiritual release. A perceiving soul has trapped sublimity in a machine and on sheets of paper a hand's breadth wide has fixed immensity." Clearly, what applied to the goose did not apply to the gander.

During the late teens and early twenties Sheeler made a remarkable series of studies of the rhythmic lines of barns. When we compare these works, well characterized by a *Bucks County Barn* of 1923 (fig. 65), to O'Keeffe's *Ends of Barns* of 1922 (fig. 66), the similarities and differences in these two artists' conceptions prove to be, indeed, quite remarkable. Both painters use the planes, edges, and angles of existing barns to construct superbly affective images whose visual import far

transcends mere documentation. At first glance it would certainly seem, as Barker insisted, that in Sheeler's work emotion is placed in the service of the intellect. The razor-sharp outlines, and the finely balanced contrasts between black and white, which extend and enhance the abstract patterning of the image, the deliberately "clean" lines omitting virtually any representation of the land that, in a conventional image, would have foregrounded the barn—all these elements appear to be indicative of the benign government of the intellect over the passions.

However, what we witness—and respond to—in this image, is actually only to a very limited extent a celebration of the intellect. What truly catches our attention is Sheeler's obsession with control. The carefully arranged three-dimensional "cubism" of the painting elevates the harmonious "order" of being above the terror of nothingness. The play of light and dark, of "essence" against "absence" in this painting represents a determined reliance on human control over matter. However, since our impulse to privilege order and control is, to a very large extent, prerational, "emotional"—this also represents an impossible attempt on our part to defend ourselves against chance. In this respect the work takes a stand *against* the constructive interaction of the intellect and the emotions, for such an interaction can lead only to uncertainty and tentative understanding. The greatest appeal of Sheeler's painting, then, is that it offers us an artificial escape into order: the image implicitly yields to the rule of emotion by privileging control.

O'Keeffe's *Ends of Barns*, though constructed with the same technical concern for the interplay of edges, angles, and planes as is apparent in Sheeler's work, has an entirely different visual effect. O'Keeffe's barns do not exist in isolation; they do not triumph over the void in an effort of will. Instead they continue well beyond the picture plane. They are, we realize, an integral part of the always slightly skewed movement of our affections as they seek coherence in a world of ever shifting options. The slightly drunken, squatty wobble of the shed in the foreground has a lot to do with that effect, as has the yellow wave of organic matter, be it soil or grain or grass, that seems to lift the barns into a blustery commotion. When we look at these barns, we see warmth and color and pleasure, but we also see conflict and uncertainty. In this painting the organic and the constructed, the emotions and the intellect, the heart and the eye, coexist and interact in a dialectical exploration of the logic of humane astonishment.

What separates Sheeler's barns from those of O'Keeffe, then, is that where Sheeler celebrates order, O'Keeffe celebrates being. This difference in their perspectives came to be regarded, within the heady atmosphere of early-twentieth-century American industrial and economical self-confidence, as indicative of their evolutionary status. Sheeler, the man in control—O'Keeffe, the woman open to hesitation. Barker's insistence upon reading O'Keeffe's work as almost unbearably intimate, as "emotional"— that is, in gender-ideological terms, a "woman's" mode of representation—made it possible for him to avoid having to deal with the dialectical implications of her work.

The critics' habit of turning O'Keeffe's conscious decisions, her laconic sociopolitical apperceptions, into matters of "biological predestination" has, of course, persisted to this day. O'Keeffe, for her part, was well aware that the irrationalism of order held such sway over the society around her that her own point of view would have little chance to be heard. She decided that all she could do in response was to let her paintings be what they had to be—no matter what the critics thought they ought to represent. In the catalog statement that accompanied her first major solo exhibition of oil paintings at the Anderson Galleries in 1923, she said as much: "I grew up pretty much as everybody else grows up and one day seven years ago found myself saying to myself—I can't live where I want to—I can't go where I want to—I can't do what I want to—I can't even say what I want to—. School and things that painters have taught me even keep me from painting as I want to. I decided I was a very stupid fool not to at least paint as I wanted to and say what I wanted to when I painted as that seemed to be the only thing I could do that didn't concern anybody but myself—that was nobody's business but my own."

XX

Flowers and
the Politics of
Gender

One of the most remarkable developments in O'Keeffe's art of the twenties came not long after she wrote this statement, when she ventured into painting the extreme close-ups of flowers that were to add considerably to her fame as well as to her notoriety as a "gender-specific" artist. Although she was to deny, throughout her career, that the flower close-ups were meant to have any sexual overtones, she was far too self-conscious an artist not to recognize that these works would provoke precisely such associations in the average viewer. That she persisted in exploring this field of representation cannot have been a matter of obstinacy or simple naïveté on her part. As always, she had a purpose.

O'Keeffe, as a painter, and as a person, concentrated on the affirmation of life. The twenties, worldwide, was a period of ambition, greed, exploitation, and aggressive, increasingly antihumanist attitudes: a fertile breeding ground for fascism. It was a world dominated by ideas of order whose impracticability created a cultural environment filled with exalted, often contradictory, and usually unattainable expectations. These fostered in most people vague feelings of frustration and personal failure. Within this atmosphere misogyny, like racism and anti-semitism, became a popular opiate, generously disseminated by the media of the period to receptive audiences everywhere. This misogyny took many forms, but one of its most visible manifestations was the widespread adoption, in the popular culture of the twenties, of the imagery of woman as a ravenous, destroying "flower of evil," which had found its origin in the "high art" of Baudelaire and the symbolists. This imagery soon began to outpace the pervasive sentimental nine-

teenth-century theme that cast "Woman" as a passive, receptive, virtuous flower.

The popularity of European—and in particular French—literature among American intellectuals had led, among other things, to the formation of Boni and Liveright's "Modern Library of the World's Best Books." These were very inexpensive, pocket-size translations of numerous books with dangerous reputations. Baudelaire, of course, was included, as well as a wide range of texts by other authors, including Nietzsche, Schopenhauer, Strindberg, D'Annunzio, Gourmont, Swinburne, Flaubert, Anatole France, Schnitzler, Hermann Sudermann, Oscar Wilde, and Maurice Maeterlinck. The influence of these works on younger Americans eager to gain true sophistication was dramatic. As these young intellectuals began to play a role in this country's cultural life during the twenties and thirties, they helped establish an unholy popular alliance between their fear of female sexuality and the biologists' "scientific" denigration of women as nature's vampires. This imagery spread like wildfire through "high" and popular culture alike; it resulted, by the midtwenties, in a widespread fascination with an often truly vicious imagery of woman as "man-eating flower."

Indeed, as early as 1918, in his ironically titled *In Defense of Women*, H. L. Mencken—whose credentials as a misogynist no one could dare question—had begun to get worried that all this cultural emphasis on women as "mythical anthropophagi" might give his fellow males the mistaken impression that there was more logic to women's destructive power than they were in his opinion capable of exerting, given their small brains and minuscule intelligence. Thus the core of his argument was, much like that of F. T. Marinetti, that—as the latter had expressed it succinctly—the time had come to "murder the moonshine" and to get rid of the "enfeebling influence of Gabriele D'Annunzio, lesser brother of the great French Symbolists, nostalgic like them and like them hovering over the naked female body" (68).

After all, the modernist temper held, as F. Scott Fitzgerald's Maury expressed it concisely in *The Beautiful and Damned* (1922), that "Man was beginning a grotesque and bewildered fight with nature—nature, that by the divine and magnificent accident had brought us to where we could fly in her face" (255). But for most of the artists and intellectuals of the twenties the image of woman as nature now also, despite Marinetti's rantings, came to mean woman as a predatory flower who must

be overcome in the name of "enlightenment." Gloria, the femme fatale who succeeds in turning the intellectual Anthony Partch into a doddering, mindless wreck after she snares him into marriage, first appears to him "dressed in pink, starched and fresh as a flower" (128).

In Wallace Irwin's popular best-seller of 1924, *The Golden Bed*, turned into a movie the following year by Cecil B. DeMille, the destroying woman even has the name Flora Lee. Admah, the hero who survives her seduction to marry her virtuous sister Margaret, is first attracted to her "oval, impertinent, arrogant little face" when he sees a picture of her "holding a bouquet of roses against a lacy gown which she had worn as a bridesmaid at somebody's wedding" (146). Flora Lee orchestrates the seductions of "her precious fragrant body" (312) from the bed that gives the book its title, inherited from her decadent mother, and placed in an "Oval Chamber" of sin. The bed is decorated with "golden flowers, asphodels perhaps, twined all around the headboard. Upon the apices of its four short posts perched gilded swans, their wings spread, their heads drawn back belligerently on serpentine necks" (33).

Popular culture is perhaps most easily distinguished from its more elevated counterparts by its pristine simplicity of statement and uncluttered exploitation of whatever happen to be the dominant phobias of its time. It therefore serves as a particularly useful tool in illuminating the twenties' pervasive obsession with the concept of the "flower of evil." A story in the September 1927 issue of the science fiction adventure pulp magazine *Amazing Stories* (whose readership consisted overwhelmingly of adolescent boys and young adult males) indicates that the theme of woman as a man-eating flower had by this time moved deeply into the popular imagination. It had clearly taken on an aura of quasi-scientific authenticity. The story was titled "The Malignant Flower," and its author was a pseudonymous everyman who identified himself only as "Anthos."

In this narrative a British gentleman by the name of Sir George Anderson goes in search of a "little valley of the Himalayas" containing "a ravine hedged in by three high perpendicular walls." He finds it completely overgrown with "wary, dreamlike, gigantic flowers, with heat-trembling calyxes." Sir George instantly intuits the link between these creations of nature and the eternal feminine: "These flowers, . . . were they not all satanically beautiful beings, which resembled reasoning creatures, benumbing the senses with a whirl, while they simulated the human organs—ear, eyes, lips, and tongue? Sir George gave free reign

[*sic*] to his imagination. These ruthless beings which emitted this perfume out of their great languishing calyxes, at once seeming to have unsatisfied long and dreaming, were they not half-flower, half-animal?"

Of course they are, as Sir George finds out the moment he steps in among them to investigate. A colossal flower at the center of the mass goes into action: "The pair of blooms of this great flower which hiterto had hung down, stiffened themselves visibly,—the piercing sweet perfume streamed out of them overpoweringly, and the three-fold thorny lips with their colored pattern trembled in the atmosphere back and forth." A "labyrinthian net of blood red veins" covers the flower's "frightful spotted viperlike body." Soon Sir George meets his end: "The flower slowly opened, and something bright and fleshcolored shot out of it. What darted so suddenly? Was it the sucking arms of an octopus? Was it the soft arms of a woman?" Pretty soon our intrepid explorer finds himself beyond caring, as he disappears "slowly into the calyx of the atrocious, malignant flower, whose petals once more drew themselves together with a start. In this way Sir George celebrated a symbolic marriage with nature, a festival more overcoming, but also more horrible than that for which he had prepared himself" (526–30).

Symbolism can hardly get more explicit without being banned in Boston, but the magazine insisted on accompanying the story with documentary photographs proving the existence of gigantic flowers, and an editorial blurb maintained that "the story of man-eating plants has persisted for many years and there is no good reason why such a plant should not, or could not, exist." The story, furthermore, was embellished with a drawing of a man battling a gigantic flower with an ax, and the cover of the magazine featured a striking image of a helpless explorer being pulled relentlessly into the vulval calyx of a colossal flower (fig. 67).

Without an understanding of the period's obsession with flowers as symbols of the destructive allure of feminine eroticism, the undercurrent of prurient excitement so characteristic of the critics' discussions of O'Keeffe's close-up paintings of flowers might seem to be simply a by-product of the period's obsession with Freudian psychoanalysis. But the "flower of evil" imagery went clearly much further than that. It had become a cultural platitude, and O'Keeffe could therefore hardly have been unaware of the pervasive exploitation of flower symbolism for the misogynistic derogation of female sexuality in the society around her. She was far too well-informed. As a feminist, she must have been

67. Frank Paul, Cover, *Amazing Stories*, September 1927.

eminently aware of the malicious implications of the period's woman-as-flower symbolism. To paint flowers *as* flowers and nothing else, close-up, for their own sake, would thus, in itself, become for her an act of defiance, a radical gesture of dissociation from the antihumanist values of the prevailing social order.

O'Keeffe's claim—that, in painting her close-ups of flowers, all she intended to do *was* to paint close-ups of flowers—may therefore not necessarily reveal the whole of her purpose, but it certainly remains its core. By focusing strictly on the beauty of the flower as part of the natural world, by delineating the visual music of its lines, and by trying to capture the emotive complexity of its unfolding petals, O'Keeffe tried to reclaim the flower from the hothouse of obsessive cultural symbolism to which it had been confined. At the same time she probably also decided, as she painted certain of these images, particularly her justly celebrated *Black Iris III* of 1926, to emphasize the subtle beauties of a natural configuration that was able to drive her male contemporaries into such absurd fits of dark anxiety.

O'Keeffe probably never really expected that her explorations of flowers as flowers would succeed in keeping her contemporaries from reading analogues to female sexuality into these studies. Patterns of cultural indoctrination cannot be changed overnight. A symbol, once established, can only very slowly be modified in its meaning. What O'Keeffe's flowers were designed to do, much like her *Music—Pink and Blue II* (see fig. 60), aside from presenting us with flowers as flowers, was to make the public recognize the inherent absurdity of any comparisons between women and flowers—malignant or otherwise. Flowers were an integral part of the beauty of being. The celebrations of our eyes are—or at least should be—genderless. Her contemporaries, however, waylaid by spurious symbolic equations of nature, the feminine, and evil, thought they had discovered evidences of destruction even in such simple objects as flowers. O'Keeffe wanted to make them look closely at those flowers, so that they would come to realize that all they symbolized was beauty and the music of life.

O'Keeffe understood better than most of her contemporaries that we concretize our pleasures as well as our fears in terms of the human body. We anthropomorphize inanimate matter to express our states of mind. Almost all of her works, whether they are largely abstract or "precisionist" and exact in capturing the forms of nature, celebrate the

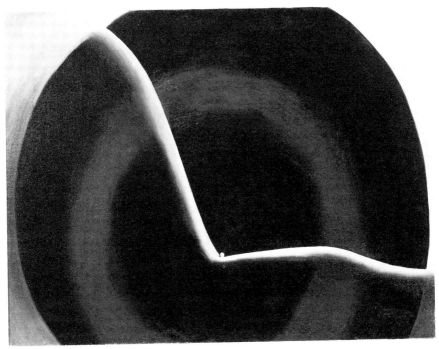

68. Georgia O'Keeffe, *Black Abstraction*, 1927. The Metropolitan Museum of
Art, The Alfred Stieglitz Collection, 1949. (69.278.2) © 1998 The Georgia O'Keeffe
Foundation / Artists Rights Society (ARS), New York.

world of matter in its chameleonic capacity to assume the visual config-
urations of our selfhood. Many later-twentieth-century artists have in-
terpreted modernism's tendency to fragment imagery as an assault on
matter itself. Abstraction and fragmentation thus came to express their
fear of the exterior world. They became a means with which to eradicate
"otherness." But, as we have seen, during the twenties and thirties the
European tendency to abstract from nature to the disembodied struc-
tures of theory had been rejected by most of the younger American
artists. Such an imperious disregard for the matter of experience was
clearly also entirely alien to the humanist intentions of O'Keeffe's art.
Her purpose was to celebrate the pleasures of the senses, rather than to
delve into our fears.

 That intention is perhaps most brilliantly expressed in such extraor-
dinary visual inventions as her *Black Abstraction* of 1927 (fig. 68). In this
painting many of the symbolic forms most commonly exploited in our

society to enforce fear and loathing have been made to serve a celebratory imagery of affirmation. Though at first glance we may be inclined to register this image as a rare excursion by O'Keeffe into the realm of surrealist psychologizing, we soon realize that it transcends the artificial theories of the emotions constructed by early-twentieth-century psychoanalysis. Black, usually perceived as absence, as a void, becomes, in this image, the color of presence, of substance, against which all other forms must be measured to gain their material essence. The white in this image, for instance, may represent light, but here it gains substance only as an echo of black. Similarly, we usually perceive circles within circles as "targets," as isolate coherences that, if for that reason alone, invite assault. But in this image circles are the forms of "absence." Darts thrown at them would simply disappear into nothingness. Anchoring the image is a three-dimensional curve of limb and thigh: tactile and sensuous—the essence of materiality, its luxurious presence a graphic denial of the value of any attempt to privilege conjecture over reality. At the center of it all, in peaceful equilibrium, resides a tiny speck of indeterminate matter—the self? In this painting O'Keeffe's tonalist sensibility seamlessly blends with the principles of abstraction *to* reality that initially drew O'Keeffe and most of her American contemporaries to modernism. Monos and Una here find themselves united in the philosophical jointure between a thigh and infinity.

Descriptions of this sort can only begin to suggest the manner in which O'Keeffe's paintings communicate. Like *Black Abstraction*, which, even as it remains mysterious is nevertheless not at all ominous, most of her best work resists interpretation, even when its meaning as an affirmation of our being in the world is crystal clear to us. Surrealism sets out to exploit our existential fears, but O'Keeffe assures us that our fears of the body of life are errors of ignorance—that life is our only protection against nothingness.

XXI

O'Keeffe and New York City

If the critics of the twenties did keep on about the "feminine sensibility" of O'Keeffe's work, they were also coming to recognize that hers was a genuinely "American" eye. She was gaining increasing recognition as a major painter, and the sort of arrogant "in-group" censure that, since the late 1940s, has been capable of toppling an artist's reputation in a single season, was not yet in operation during her New York years. Arguably because of this receptive and, in terms of its cultural variety, remarkably open-minded environment, those years were to be among the most inventive and creative of her long career.

The New York of the twenties was teeming with activity. Its skyscrapers were looming over the industrious throngs as guardians of the country's economic health, symphonic movements in the music of prosperity. The world of American capitalism seemed good—even to its artists. In the November 1927 issue of *Creative Art*, Ernestine Evans discussed "the benefits the young artist may expect to reap in this unprecedented era of American prosperity." Art had been brought in "like loot, by the little soldiers we have so many of, the surplus dollars." Just "walk, any day, down Madison Avenue and observe how from the ends of the earth, have been sucked in the treasures of the ages."

Evans was worried that, in this climate of ease and instant recognition, young artists might forget that what they needed was not "the promise of great and ultimate rewards for their painting, not even security in their formative years, but merely, not too much insecurity." The climate for art, indeed, had been so good, of late, Evans continued, that artists were beginning to forget that things had not always been this way: "There was a time, not so very long ago, when few indeed were the galleries that would show the work of young modern artists at all." But in recent years, "one by one those who were youngsters at the close of the war have found small publics and a dealer. There is even competition between dealers for certain of the younger painters." It was time for

the American artists to band together and learn to protect themselves from the vagaries of the marketplace: the time was ripe for "a trade union of artists" (xxix). Evans, however, rightfully doubted that in the current climate of unbounded prosperity artists would give such matters a second thought. Her article contained an edge of doubt about the stability of the economy. October 24, 1929, "Black Thursday," was still almost two years away.

Under Stieglitz's smart management, O'Keeffe became independently wealthy during these years. As she looked out on the East River, she saw an urbanized world alive with industrial energy and with the smoke of a pollution that, from the safe distance of the thirtieth floor of the Shelton Hotel on Manhattan island, almost came to seem like the haze in the fields of Wisconsin or on the shores of Lake George—like a membrane of new life that could make the light of the setting sun into a halo for the material world. In her studies of the skyscraper canyons of New York, O'Keeffe became—like so many other American painters of the twenties—caught up in the festive celebration of a city that seemed capable of transcending the grime of urban reality: an ever self-renewing "City of Ambition," the city Stieglitz had already captured as it had begun to assert itself in the early years of the century.

But for O'Keeffe the constructive realities of New York City in the twenties were as emotionally complex as the shapes of her *Black Abstraction*—a work painted contemporaneously with her great images of the city. Tonalist modalities blended with the precisionist edges of the modern mind. The future of America seemed written in the sunspots surrounding the Shelton on a bustling afternoon. Like Sheeler, Demuth, Marin, Niles Spencer, Stefan Hirsch, Stieglitz, and many others, she was intrigued by the city's almost organic passion for growth, and by its will to create, to develop, to build. In paintings such as *Radiator Building—Night, New York* of 1927 and *New York Night* of the following year, she caught those positive energies: light glowing with the reds and yellows of determination, cars streaming down the darkened canyons of Manhattan, their headlights turning streets into a milky rush of industrious movement.

In slightly earlier paintings of New York, her approach had still been more contemplative. Such works as the three *East River from the Shelton* paintings of 1926, are, indeed, tonalist through and through. It is as if in these paintings of rooftops covered with snow against the cold leaden gray of the river and the sluggish industrial fog of the factories beyond,

69. Georgia O'Keeffe, *City Night*, 1926. The Minneapolis Institute of Arts. © 1998 The Georgia O'Keeffe Foundation / Artists Rights Society (ARS), New York.

O'Keeffe herself was expressing a melancholy sense of her loss of contact with earlier American values. The mood in these works is like that motivating the tonalists in their atmospheric explorations of countrysides suffused with foggy hues and moonlight. *New York with Moon*, of 1925, her first cityscape, and *The Shelton with Sunspots*, of 1926, seem cast in a similar mold. But in *City Night* (fig. 69), also of 1926, one of her most brilliant creations, she let herself be captured by the insistent energy of the city's buildings. Though the subject matter of this painting is instantly recognizable, it is, in its ambiguity of effect, comparable to her *Black Abstraction* of the following year: towering dark forms lean toward the viewer and dwarf the white building at the center, forming a trough in which the hazy moon of a streetlight massively echoes a tiny star above.

Sheeler, Stefan Hirsch, Niles Spencer, Louis Lozowick, Preston Dickinson, and others had already painted the angles and planes of the city and its aggressive energies. Their use of line and volume had come from the same American sources as O'Keeffe's: the sharp outlines of buildings against light, a focus on essential form over detail—necessary to capture the vast surfaces of American life. Many of these painters continued to be fascinated with patterns of order and control, as is obvious in the still clearly cubist inspiration of works such as Spencer's *Buildings* (fig. 70). Others, such as the young Chicago painter Belle Baranceanu, pursued the organic potential of such human constructions. Visiting the West Coast, she discovered the unlikely musical potential of a Los Angeles brick factory (fig. 71) and recorded its elegant presence among the green hills of a Pacific springtime, in a symphony of deep pink, grays, ochers, and flattened volumes. All these painters expressed, in their obsession with the formal beauties of industry, a nationwide confidence in the unlimited potential of a world of creative materialism that seemed eminently capable of coexisting peacefully with the forms of nature.

Within the atmosphere of materialist optimism that prevailed among the younger American artists, the artificial strictures of gender ideology were beginning to lose some of their force. While the political climate moved toward absolutism, the artists in America countered with a greater emphasis on an eclectic range of forms of expression. As a result the twenties also gave a generation of younger American women artists the chance to develop and obtain public exposure. For, although during the twenties O'Keeffe was certainly the best-known artist who

70. Niles Spencer, *Buildings*, ca. 1923.

happened to be a woman, there were many others who did brilliant work that was to be buried—along with that of their male colleagues—in the antirepresentational pogroms which swept the art world of the late forties. Throughout the country painters such as Marguerite Zorach, Anne Goldthwaite, Blanche Lazzell, Belle Baranceanu, Katherine Schmidt, Helen Forbes, Agnes Weinrich, Helen Torr, Elsie Driggs, Lucille Blanch, Dorothy Varian, Henrietta Shore, Molly Luce, Florine Stettheimer, Agnes Pelton, and many others had developed distinctively personal styles in the wide-open "postmodern" modernist cultural environment of the twenties.

Even so, O'Keeffe's *East River from the Thirtieth Floor of the Shelton Hotel* of 1928 (fig. 72) may well lay claim to being the quintessential American painting of the period. Perhaps no other painting has been quite as successful in capturing the mood of harmony and integration that seemed to exist between the monoliths of business and industry and the waters and mists of nature. The work was painted at the height

71. Belle Baranceanu, *The Brick Factory—Elysian Park, Los Angeles*, 1927.
Private collection.

of America's mood of ambition and optimism about its invincible ca-
pacity for continuous industrial growth. If any painting ever expressed
to perfection the creative optimism of the American sensibility, it is
most certainly this one. It presents us with a perfect integration of or-
ganic and mechanistic impulses—a perfect blending of perception and
thought, of the rhythms of movement, the textures of touch, the colors
of sound, and the synthetic dreams of the eye.

In this painting the city becomes truly a living organism, a breathing
giant—and yet not a monster. A subtle pattern of orange, ochers, and
an infinite variety of grays defines the buildings in the foreground.
These delineate themselves with precision against the water of the river,
which has the milky-blue, caressing texture of a hazy midwestern
spring sky. The massive stretch of industry beyond the river integrates

72. Georgia O'Keeffe, *East River from the Thirtieth Story of the Shelton Hotel*, 1928. New Britain Museum of American Art, Connecticut, Stephen B. Lawrence Fund. © 1998 The Georgia O'Keeffe Foundation /Artists Rights Society (ARS), New York.

the parallel themes of the foreground and the middle distance into a world of blended, organic colors. These interlace the mechanistic horizontals and verticals of the rooftops and smokestacks on the horizon, to suggest the existence of a world of harmonious creativity—a far cry from the reality of rank pollution, human pain, and financial chicanery that actually underlay this pastoral panorama of heavy industry. It is an ideal world expressed as if it were a frank reality: it is the American imagination caught in a single image.

XXII

An American Place?

The more real a fantasy seems, the less likely it is to last. Reality has a way of undermining the syntheses of the imagination. O'Keeffe had an eye for beauty, but she was also very matter-of-fact. With the stock market crash of 1929 and the United States' subsequent prolonged descent into a desperate depression that would last for more than a decade, New York City rapidly lost its capacity to hold her attention. Stieglitz, as he grew older, was yielding to what she regarded as the weakest elements in his character. His infatuation with the adoration of a twenty-two-year-old was opening up old doubts about the logic of her own relationship with him—and casting a bitter pall over her affection. Her health suffered, and her personal equilibrium was tested severely.

O'Keeffe had never been tolerant of adversity. Her talent and the circumstances of history had made it possible for her to give adversity a wide berth. She had discovered the landscape of New Mexico just before the Crash. In the long run New York had proved to be nothing compared with the lure of the flowers and natural waters of Lake George. Now the sensuous body of the West was beckoning her. Though she continued to live at least part-time in the city until Stieglitz died in 1946, the continuing success of her art permitted her to ignore the agonies of the Depression and to move into a world of natural beauty beyond time.

She had helped to define the harmony of the American eye—but neither was she willing to countenance, nor was she temperamentally attuned to, the social conflicts of the thirties that came to occupy the attention of many of her fellow artists. And yet, in these other American artists' populist fervor—in their angry, principled choice to stand in solidarity with the poor and the exploited, and in their spirit of cooperation and community—the humanist values in American art that O'Keeffe had helped to preserve, nourish, and develop were coming to fruition. Working for the most part in poverty themselves, these artists,

under the financially marginal, yet stabilizing, protection of the Works Progress Administration, developed a sense of social purpose difficult to grasp for someone like O'Keeffe, linked as she was into the nineteenth century's sense of the collective individuality of self and soil. She did not see herself as part of a community of workers in the arts. Though for a while the reign of dimorphist gender theories began to diminish in the arts (at least in part because there was so little money to be made that it would have served little purpose to bicker over what little there was), O'Keeffe became ever more the recluse.

But if the thirties for a while promised to bring in a new era of gender-integration in the arts, the outbreak of the Second World War rapidly brought a reinstitutionalization of the worst features of dimorphist gender theory. The country focused on the needs of boys who must be made to feel like Men, so that they would be willing to fight, and many workers feared that the women might want to hold onto the jobs they had begun to occupy with skill and flair in the defense industries as the men were sent abroad. The intellectuals felt guilty for being able to avoid the immediate dangers of battle. The fictions of manhood that had served to justify World War I, and that had made the world ready for the genocidal racial arrogance of Hitler's Germany, now also reasserted themselves with a vengeance in a new "strict" modernism, an antihumanist, mechanistic cultural rhetoric established by a paternalistic critical oligarchy in the arts.

Elitist theories of art allowed the intellectuals to prove to themselves, and—they hoped—to others, that they were, in fact, as manly as anyone. The critics adopted the authoritarian mentality of the dictators. Ultraconservative and ultramodernist critics were united on one front: the American public needed to be told what was acceptable—and, even more important, what *not*—in the realm of "high" art. A popular textbook by Frederic Taubes (one of the ultraconservatives), first published in 1942, had the provocative, and deadly serious, title *You Don't Know What You Like*. Its message: Aesthetics is a highly specialized science. Don't try to enjoy art without guidance. We, the experts, will tell you what to buy.

It was a well-timed argument, for with the country's entry into the war the coffers of the industrialists were brimming again, and by 1944 art sales were going through the roof.* The more money was being

* A succinct and informative account by Frederick Sweet of this development can be

poured into the art market, the more social concern came to be seen as an indicator of "bad" judgment. The critics hastily dusted off the argument that women were technically and emotionally unsuited to participate in the field of high art. Culture once again became the stomping ground of "virile" minds. The "triumph of the intellect" was rediscovered in the works of Picasso and the new "spiritual transcendence" of Mondrian's squares (a form of painting Poe, no doubt, would have regarded as the ultimate apotheosis of the "rectangular obscenities" of the industrial world).

In the United States artists and intellectuals have never been more than marginal figures. The typical American today regards them with suspicion, as if they were mere confidence tricksters trying to skim money from decent people by seducing them into bad investments. Indeed, in this country embezzlers and con men are often treated with greater admiration than artists or academics, because you at least have to work hard to put together a fraudulent scheme in the business world. Most Americans have, since the mid-forties, come to see being part of "high" art as a license to con the public without having to do any "real" work. Much of that attitude stems from the "shut up and like what we tell you to" stance of the New Critics of the immediate postwar years, which, itself, took a lot from Stieglitz's arrogance toward the general public.

But at least Stieglitz understood the average American's respect for a con man who worked hard at his job. His storms of talk and his well-publicized trick of *not* selling certain works to certain patrons "because they did not 'deserve' art of such transcendent quality" constituted the perfect elitist-modernist con. His public admired him for his audacity and, with typical American insecurity about all things related to "culture," decided that, if he was that sure of himself, he must be right. Stieglitz's aggressive assertion of his right to tell others what to like had been a logical application of the early modernist theories of the European avant-garde. These, in turn, had originated in a thinly disguised attempt on the part of the artist-sons of the early-twentieth-century bourgeoisie to transcend the commercial middle-class status of their parents by becoming part of the new world order's intellectual and artistic class of supermen in training. The cultural arm of the evolu-

found under the rubric "Art Sales" in *Ten Eventful Years*, vol. 1 (1947); see bibliography for further details.

tionary elite had been able to demonstrate—at least to its own satisfaction—that its capacity to upset the vulgar proved that it should be considered the new "intellectual aristocracy" of the world, the cream of the racial crop, the vanguard of evolutionary manhood.

The rise of modernist values in art is therefore intimately tied to the racist and sexist evolutionary rhetoric that became the norm in both Europe and the United States during the first half of this century. Students of early modernism, however, have for the most part gingerly sidestepped the issue of "politics" in their celebration of the art of the new. But a willingness to acknowledge and come to terms with this connection need not be seen as an attempt to disparage the historical—and aesthetic—significance of modernism as a force of liberation from the often stultifying clichés that had come to dominate certain aspects of the European academic art hierarchies of the late nineteenth century in particular. The historical function of modernism is extraordinarily complex. As a movement it was able to accommodate both progressive and reactionary ideological motives, both humane and inhumane sentiment, both "organic" and "mechanistic" philosophies. There was, however, also nothing inherently "socially progressive" in the stylistic explorations of the early modernists. To continue to privilege their work as inherently superior to the art of nineteenth-century humanism would be tantamount to endorsing the early-twentieth-century fictions of the "genetic" superiority of certain groups—fictions on which the modernist principle of "high art" is based.

But this is exactly what happened when, in the wake of the United States' emergence as a central world power after World War II, its intellectual community came to see a narrow revival of the elitist "spiritual-intellectual" primacy of abstraction as proof of its ascendancy to a level of cultural manhood comparable to its role in world affairs. A new generation of critics, having watched Stieglitz con his clientele into compliance with his point of view, had come to understand that it was a lot easier to make the American people believe that critics should tell the public what to like than to have to justify the intellectual superiority of postwar abstraction over representational art within the context of cultural history.

The main postwar assumption was that true intellectuals could not but recognize the "spiritual" qualities of "nonobjective" abstraction as "inherently better" than any art form dependent on recognizable imagery. This made it particularly easy to maintain the patent misconcep-

tion that modernist art was also, because it was an irritant to conservative advocates of content-driven art, the mark of distinction of intellectuals with a socially "progressive" attitude. Thus the notion developed that artists and critics who embraced postwar abstraction were by that very token also part of "radical" politics—an argument that was given added force by the convenient tendency of political conservatives to denounce abstraction as a communist plot. The result of this development was that even today many young artists and critics assume that to advocate what most people find "ugly" or outrageous is a shortcut to membership in the "cultural elite" and will also automatically turn you into a card-carrying cultural "progressive."

What had begun as a Stieglitz-like, would-be masculine domination of the other on the part of the intellectuals soon took on a new practical usefulness during the McCarthy era, when the critics' meretricious objectification of art as art provided artists and critics alike an excellent excuse for a retreat from social commitment. The new virile elitism of the intellectuals helped to maintain an aura of progressive cultural involvement even while it explicitly encouraged a view of art as completely self-referential. Though the critics presented this would-be "objective" view of the function of culture as a clear sign of progress, their theories were thus little more than a reprise of the mechanistic idealism of the early European modernist avant-garde, made to fit the United States' new role as the authoritative, undisputed "leader of the free world."

But these new theories also required a wholesale reworking of the history of American art. Just as the critics of the turn of the century had called for the rejection of the sentimental—and hence "effeminate"—humanism of mid-nineteenth-century American values, so in the era after World War II, the critics rejected as inferior any work by earlier American artists that did not in some way prefigure the "serious" qualities of the new abstraction. In the process the strongly humanist, celebratory, and—in the thirties, socially conscious—work of the large and important contingent of "postmodernist" artists who flourished in the United States between 1920 and 1940 came to be dismissed (and has, to a large extent continued to be so) as provincial and insignificant.

Though O'Keeffe managed to survive this cultural pogrom, she did feel its impact in the years following Stieglitz's death in 1946. Her own humanist emphasis on the expressive immediacy of organic form rapidly became subjected to a great deal of censure during the postwar

institutionalization of "correct" modernist attitudes in American culture. The assault on O'Keeffe's work, as on that of virtually every other American artist whose roots were in the humanist tradition, was conducted largely under the aegis of Clement Greenberg, an extremely skilled purveyor of arrogant, simplified axioms about the transcendent value of "pure art." His opinions, delivered with a carefully honed European-style air of absolute assurance, patterned after Stieglitz's habitual mode of operation, were tailor-made to impress a half-informed and easily-conned American middle class, mightily impressed with its newfound status in the arena of world affairs, and hence ready to be told what it should like in the field of art.

Indeed, Greenberg had understood very early in his career who buttered the artist's (and hence also the critic's) bread. The socially conscious painters were, he pointed out, stupid to let principles blur their economic eyesight. In his 1939 essay "Avant-Garde and Kitsch" (arguably still the single most influential essay in American art history), he pointed this out in no uncertain terms: "The masses have always remained more or less indifferent to culture in the process of development. But today such culture is being abandoned by those to whom it actually belongs—our ruling class. For it is to the latter that the avant garde belongs. No culture can develop without a social basis, without a source of stable income. And in the case of the avant-garde this was provided by an elite among the ruling class of that society from which it assumed itself to be cut off, but to which it has always remained attached by an umbilical cord of gold" (1:10–11). It was thus time, Greenberg implied, that artists stop annoying that very elite to whom they were connected so intimately and so potentially lucratively. Disturbing images of social suffering, or ones representative of "vulgar" beauty ("kitsch"), accessible to all, were—because of their accessibility—clearly not very valuable as tokens of cultural superiority, at least in cash-related terms. Instead of driving the ruling class away, why not attract them with an art that, being abstract, was purely self-referential, and hence devoid of any messages that might disturb those who paid the bills?

Greenberg's opinions were invariably absolutist and categorical. "The non-representational or 'abstract,' if it is to have aesthetic validity," he declared in this same essay, "cannot be arbitrary and accidental, but must stem from obedience to some worthy constraint or original" (1:9).

His take on the function of art thus helped to transpose the totalitarian mood of the European early modernist intellectuals directly into the postwar era. His writings always projected an invasive, self-consciously "masculine" prescriptive certainty about what was right and wrong, and hence good or bad, in art. "The dogmatism and intransigence of the 'non-objective' or 'abstract' purists of painting today cannot be dismissed as symptoms merely of a cultist attitude towards art," he insisted in 1940, in the opening lines of his essay "Toward a Newer Laocoon." Instead "purism is the terminus of a salutary reaction against the mistakes of painting and sculpture in the past several centuries" (1:23). These mistakes were due to a naive "confusion" over the function of art. "The avant-garde arts have in the last fifty years achieved a purity and a radical de-limitation of their fields of activity for which there is no previous example in the history of culture" (1:32). Abstraction was the nexus of all contemporary truths: "The imperative comes from history, from the age in conjunction with a particular moment reached in a particular tradition of art. This conjunction holds the artist in a vise from which at the present moment he can escape only by surrendering his ambition and returning to a stale past" (1:37).

Greenberg's confidence that he had spotted an "inexorable" trend became something of a self-fulfilling prophecy. After all, his disdain for those who tried to dismiss abstraction as "too decorative or too arid and 'inhuman'" (1:37) was based, at least in part, on his understanding that such an inhuman art was just what the bursar ordered to bring the "elite" back to market. Moreover, it was easy to learn from Stieglitz's example, for, as Greenberg noted in 1942, the man had been able to market such figures as "the ineffable O'Keeffe and the saccarine Dove" very effectively, and he had come to be seen as "the tutelary genius of the acclimatization of modernism in America," even though "too many of the swans in his pack are only geese" (2:107–8).

Americans tend to be inordinately impressed with anyone who seems to be unencumbered by doubt. Greenberg's arrogance convinced the numerous well-heeled wartime industrialists eager to invest in art that he was the right man to tell them what to like. His absolute belief in the "spiritual superiority" of the intellect, joined with a strong distrust of emotion, a fetish for discipline, and an obsession with the need to suppress all evidences of "degenerative" weakness among artists (such as any residual interest in "pictorial" representation)—any form

of expression that might impair the proper unfolding of the brave new universe of "pure painting"—was to set the tone for most postwar art criticism.

Greenberg had, in essence, translated the gendered values of early-twentieth-century science into a set of aesthetic principles. For him abstraction represented a muscular, "virile," counterforce to the weak-kneed emotionalism of socially concerned painters and the sentimentalism of those concerned with imitating the forms of nature ("the saccarine Dove"). To be valuable, Greenberg insisted, apparently under the impression that he had discovered a radically new principle in aesthetics, art had to be an intellectual construct *against* nature. It must be a visual expression of the mind's capacity to synthesize thought. It should not attempt to serve as an intermediary between the eye and the emotions. "The purely plastic or abstract qualities of the work of art are the only ones that count. Emphasize the medium and its difficulties, and at once the purely plastic, the proper, values of visual art come to the fore" (1:34), he said as early as 1940, clearly in search of an aesthetic analogue to the speculative verities of pure science.

His review of O'Keeffe's retrospective show at the Museum of Modern Art in the June 15, 1946, issue of the *Nation* therefore concentrated on condemning the emotional naïveté of an art that seemed unwilling to recognize its golden umbilical attachment to the purses of the American ruling class and instead saw itself as "a new kind of hermetic literature with mystical overtones and a message—pantheism and pan-love and the repudiation of technics and rationalism, which were identified with the philistine economic world against which the early American avant-garde was so much in revolt." Notwithstanding Greenberg's deliberately pejorative, and historically inaccurate, appropriation of the proto-Jungian focus Dorothy Norman had imposed on the public perception of the artistic intentions of Stieglitz's "stable," this comment shows that he was well aware of the humanist context of O'Keeffe's art, and that he did not like that context one bit: her "pseudo-modern art is almost entirely historical and symptomatic. The errors it exhibits are significant because of the time and place and context in which they were made. Otherwise her art has very little inherent value."

Though Greenberg did not state straightforwardly that he considered the artist's errors directly linked to what he perceived as her "female" sensibility, his language made the nature of his prejudice crystal clear: The "deftness and precision of her brush, and the neatness with which

she places a picture inside its frame," he remarked condescendingly, "exert a certain inevitable charm which may explain her popularity." Americans, the implication was, were sentimentally attracted to the visual analogue implicit between O'Keeffe's style of painting and the actions of a housewife puttering about industriously among her domestic utensils: he referred scornfully to the "lapidarian patience she has expended in trimming, breathing upon, and polishing these bits of opaque cellophane. . . ."

Greenberg concluded his remarks with one of those grandstanding declarations of all-inclusive dismissal for which he was to become famous (the second volume of his collected essays is proudly called *Arrogant Purpose*), and which have continued to echo through the field of American art criticism to this very day: "That an institution as influential as the Museum of Modern Art should dignify this arty manifestation with a large-scale exhibition is a bad sign. I know that many experts—some of them on the museum's own staff—identify the opposed extremes of hygiene and scatology with modern art, but the particular experts at the museum should have had at least enough sophistication to keep them apart" (2:85–87). If we waft away the foul-smelling fogs of fancy verbiage under which Greenberg sought to conceal the sophomoric vulgarity of the last remark, all we are left with is his (complex, unemotional, considered) conclusion that O'Keeffe's paintings were no more than "neatly packaged pieces of shit."

Such exhibitions of giggly, boyish, self-admiring cleverness, couched in a Latinate terminology deliberately designed to exclude the uninitiated, and most often directed against the humanist focus of earlier-twentieth-century American art, became, largely under Greenberg's aegis, the norm among the intellectuals of the fifties, as abstract expressionism came to be celebrated as "the triumph of American painting." After all, as Greenberg had pointed out, "culture means *cultivation*." He was cheered by the public's eagerness to be told what to like in art. "Whether it succeeds or not, the very fact of this experiment in mass cultivation makes us in several respects the most historically advanced country on earth" (2:162–63).

Greenberg's brutally disparaging, deliberately antifeminine attack upon O'Keeffe's art represents, on more than one level, an important new departure from the, in comparison, still far less aggressive, "separate but—perhaps—equal" attitude of Stieglitz and the critics of the twenties. Two more decades of dimorphist development had clearly

made it acceptable for Greenberg to drop the mask of condescending appreciation that had still allowed a critic such as Virgil Barker to see the work of Sheeler and O'Keeffe as separated primarily by differences of "aptitude" based on gender. What for Alexander Brook and Virgil Barker had still been the "clean-cut" art of a well-meaning, instinctive housekeeper had become for Greenberg the meretricious tinkering of a female "hygienist." His attitude represented a giant step forward in the denigration of women as artists, but it was in no sense more rationally grounded.

Greenberg's article saw O'Keeffe's "errors" as having been cut from the same sheet of cellophane responsible for the early American modernists' almost universal failure to understand the true meaning of cubism as a "break with nature." For Greenberg, the early American modernists' concern with organic values in art, their attempt to find visual equivalences to human emotion, was a wrongheaded, sissy "repudiation of technics and rationalism" by a group of provincials. Greenberg, for his part, longed for an American art that would be as tough and uncompromising in its victory over sentimentality as American technology had been on the battlefield.

The blatant misogyny of the first generation of abstract expressionists is too well-documented to need further exposure here, but in their desire to be the first generation of true "Americans" in art, the postwar artists and critics were also eager to brand most previous efforts by American painters as merely abject imitations of European styles, mired in weakness. This rewriting of the history of earlier-twentieth-century American painting is to a large extent still part of our standard lore, and the pejorative terminology attached to many of our current critics' descriptions of pre–World War II American painting, particularly to their treatment of such contemplative styles as tonalism, still bases itself on analogies between that art's supposedly nonrational, emotional, literal, and detail-oriented qualities and its failure to be "valuable." The equation of humanist concerns and organic styles of representation with a lack of "manly courage" that forms the basis of Greenberg's sophomoric critique of O'Keeffe was soon to become a standard subtext in most post–World War II discussions of value in art.

His attack on the postmodernist American art of the interwar period implied that whatever promise there might have been for a truly "potent" form of modernist expression in the United States during the years following the Armory Show had rapidly been submerged in a welter of

weak-kneed and simpleminded attempts at "a heightening or idiosyn-cratic twisting of ideas imported from Europe." In a telling, though probably unconscious, reprise of Charles Caffin's point of view of 1907, Greenberg insisted that what he considered to be the failure of nerve of the earlier-twentieth-century American artists was due to their attempts to satisfy the vulgar materialism and the anecdotal preoccupations of a banal horde of bourgeois women—who had made certain that art was commented on in the American press only "by permanent college girls, male and female" (2:162).

The notion that American art went into a tailspin during the twenties and thirties can be maintained only if we continue to accept the sexist and elitist premises of Greenberg's theories, with their melodramatic imagery of an American art at last liberated from the shackles of its "sissy" humanist concerns, and now finally able to pursue the truly manly preoccupations of mechanistic abstraction. It is a disturbing in-dication of the reactionary focus of the postwar mood in the United States that Greenberg's point of view was so rapidly adopted and dis-seminated by others. It soon became the critical party line on much of the American art of the twenties and thirties and has, as such, remained largely unchallenged to this day.

In 1954, in the spring issue of *Reality*, Isabel Bishop, one of the great social-expressionist painters of the thirties, pointed to what had been lost in the dogmatism of the moment: "The health of education depends on freedom to question *all* assumptions," she said, dismayed that such a truism would have come to seem "reactionary" in the postwar climate of opinion. She scoffed at the claim that the manly stance of postwar abstraction represented a truly "American" approach to art. The words "boldness" and "freedom," she pointed out, were on every critic's lips, but "unless the boldness and freedom result in a work of discernible likeness to that of Kandinsky or followers, Klee or followers, Miró, Mondrian, Picasso, with a permitted dash of Kokoschka, it isn't Bold, it isn't Free, it isn't Art." Unfortunately, voices such as Bishop's were lost in the country's headlong rush to celebrate its newfound intellectual muscle.

Much of the second half of the twentieth century was to be an age of overblown *talking* about art. It was to be the great age of gestures and conceptualization—the triumph of theory over the eros of place. Greenberg and his followers continued to stand guard for decades, al-ways ready to destroy any evidence of humanist values with a single

phrase of scornful dismissal. O'Keeffe's reputation suffered along with those of most of the other artists who had gained national prominence in the years between the wars. But the "popular" interest in her work, the democratic, Whitmanesque strain in American culture Greenberg had seen as the nadir of vulgar ignorance about aesthetic truths, kept it from descending into obscurity and ultimately came to be responsible for its prominence today—and, thus, ironically, also for its current status as a first-rate investment opportunity for art market speculators.

XXIII

Forms beyond Time

The institutionalization of a boys' club mentality in the American art world after World War II, with its emphasis on elitism and its return to the harsh extremes of gender-ideology she had encountered during the 1910s, undoubtedly played a role in O'Keeffe's decision to move permanently to New Mexico in 1949, and to forego her practice of living in New York for at least part of each year. If she became more reclusive, it was because she had learned all too well that it was virtually impossible for her to make people see the world the way she saw it, unless they were already inclined to see things as she did. It was becoming ever more useless to talk about such things. But though O'Keeffe had never been able to develop an interest in politics, and though she showed as little interest in "socially conscious" art as any postwar critic could have wished, her attitude was not based on the elitist principles of the postwar intellectuals. She liked people, but she hated pretense—and more and more of the people she encountered in New York were, like Clement Greenberg, able to believe in the transcendent importance of their own pretentiousness.

She preferred the company of the American land. Therefore, as I have tried to show, we cannot hope to grasp the historical significance of her art until we learn to recognize the continuities between her sense of things and the moods of the transcendentalists, the tonalists, and, in particular, the emotional materialism of Edgar Allan Poe—though there is no indication that, at any time during her life, she ever gave him or his writings a moment's thought. In 1925 William Carlos Williams brilliantly eulogized Poe as a "genius intimately shaped by his locality and time" in the conclusion to his book *In the American Grain*. What Williams saw of America in Poe is equally applicable to O'Keeffe. First and foremost was their hatred of pretense: "It was the truest instinct in America demanding to be satisfied, and an end to makeshifts, self-deceptions and grotesque excuses."

In Poe's writings, Williams recognized, "one is forced on the conception of the New World as a woman"—a woman submerged in his sense of self. The woman in the man was the creative source of his material being: "What he says, being thoroughly local in origin, has some chance of being universal in application." Since his conception of the world was

> made to fit a place it will have that actual quality of *things* anti-meta-physical—
>
> About Poe there is—
> No supernatural mystery—
> No extraordinary exccentricity of fate—
> He is American, understandable by a simple excercise of reason; a light in the morass—which *must* appear eerie, even to himself, by force of terrific contrast. (222)

The widespread misunderstanding of Poe's philosophy was seen by Williams as a deliberate unwillingness of generations of readers to recognize the universals underlying Poe's "local" imagination. O'Keeffe, too, has suffered from the deliberate unwillingness of her many critics to consider the *humanism* of her art: "Invent that which is new, even if it be made of pine from your own back yard, and there is none to know what you have done. It is because there is no *name*" (226), as Williams said about Poe's work. We still can find no name for the nongendered material being that Poe's dreams could only adumbrate, but that O'Keeffe resolutely came to inhabit by the strength of her determined self-reliance. Even the rhetoricians of gender and the acrobats of verbiage who today dominate a "high" culture otherwise abandoned by virtually all except "investors" and those dependent on these investors for their livelihood have grudgingly had to acknowledge her power to make art speak to—and for—the sheer pleasure of material being.

During her long and celebratory journey through life, Georgia O'Keeffe shunned talk and quietly went her own way. In the process she created some of the most memorable and, in their implications, most truly "socially concerned" images of the twentieth century. For she understood that art *is* being. Art is both *what*, and *who* we are. An art that *professes* to have no moral content (for no art can *be* without moral content) is an art expressive of the social morality of those who hide in the abyss of their own being.

O'Keeffe's joyous topography of the human mind, expressed in the sensuous petals of flowers and the ever shifting bodyshapes of an

androgynous earth, has added immeasurably to the sheer pleasure of being of those of us willing to see. She was an artist. All good artists experiment, and many of their experiments fail. All good artists have lapses of creative vision, of inspiration, even of skill: All good artists paint many more indifferent and bad paintings than masterpieces— even if art market hype tries to convince us of the opposite. But, of course, what we consider "good" or "bad," "beautiful" or "ugly" in art is determined, not by universal standards of judgment, but by where we stand in the politics of culture. In the long run it is only what stays in our minds after we have paid our tithe to the gatekeepers of fashion that counts.

Once we have seen the work of O'Keeffe, it lingers in our imagination. Her best work stands far beyond our ideologies of gender, and it is not her concern, but our good fortune, if we can join her where she stood. Only rarely is it given an artist to speak so clearly about what concerns us all that she can hope to reach more than a few of us at a time. O'Keeffe has succeeded in reaching millions, because her art speaks to us of basic human values, and because it celebrates the sensuous pleasures of the material world. Her art affirms the indelible link between ourselves and the world that surrounds us. Above all, her art is a love affair with sheer being. Her art makes us feel lucky, simply for being alive.

BIBLIOGRAPHY OF
WORKS CITED

Note: Charles C. Eldredge's *Georgia O'Keeffe, American and Modern* contains a superb chronology of her life. The literature on O'Keeffe and the Stieglitz circle has grown to daunting proportions in recent years. Detailed bibliographies abound. The most useful one is undoubtedly the chronological record of critical notices in Cowart, Hamilton, and Greenough's *Georgia O'Keeffe: Art and Letters* (1987). Barbara Buhler Lynes's *O'Keeffe, Stieglitz and the Critics 1916–1929* (1989) has an extensive general bibliography covering this period. Sarah Whitaker Peters's *Becoming O'Keeffe* (1991) includes a good group of listings for the various members of the Stieglitz circle. Sue Davidson Lowe's *Stieglitz: A Memoir/Biography* (1983) covers the photographer's cultural environment very thoroughly, and Francis M. Naumann's *New York Dada 1915–23* (New York: Harry Abrams, 1994) lists writings on the avant-garde movement. Gerdts, Sweet, and Preato's *Tonalism: An American Experience* (1982) contains an extensive listing of books and magazine articles on the subject.

Abbott, Charles C. "The Beauty of the Lilies." *Monthly Illustrator* 3, no. 10 (February 1895): 209–13.

America and Alfred Stieglitz. See Frank, Waldo.

Anderson, Margaret Steele. *The Study of Modern Painting.* New York: The Century Co., 1914.

"Anthos." "The Malignant Flower." *Amazing Stories* 2, no. 6 (September 1927): 526–30.

Barker, Virgil. "Notes on the Exhibitions." *The Arts* 5, no. 4 (April 1924): 222.

Bell, Ralcy Husted. *Art Talks with Henry Ward Ranger, N.A.* New York: G. P. Putnam's, 1914.

Benjamin, S.G.W. *Contemporary Art in Europe.* New York: Harper & Bros., 1877.

Bergson, Henri. *Creative Evolution.* Translated by Arthur Mitchell. New York: H. Holt & Co., 1911.

———. *An Introduction to Metaphysics.* Translated by T. E. Hulme. London: Macmillan, 1913.

———. *Matter and Memory* (1911). Translated by Margaret Paul and W. Scott Palmer. New York: Zone Books, 1988.

Bishop, Isabel. "Fads and Academies." *Reality: A Journal of Artists' Opinions* (New York), no. 2 (Spring 1954): 1.

Blotkamp, Carel. "Annunciation of the New Mysticism: Dutch Symbolism and Early Abstraction." In Maurice Tuchman, Judi Freeman et al., *The Spiritual in Art: Abstract Painting 1890–1985*. Los Angeles County Museum of Art; New York: Abbeville Press, 1986.

Boime, Albert. "The Chocolate Venus, 'Tainted' Pork, the Wine Blight, and the Tariff: Franco-American Stew at the Fair." In Annette Blaugrund, *Paris 1889: American Artists at the Universal Exposition*, 67–91. Pennsylvania Academy of the Fine Arts; New York: Harry N. Abrams, 1989.

Bragdon, Claude. *Delphic Woman: Twelve Essays Reprinted from* The New Image *and* Old Lamps for New. New York: A. A. Knopf, 1936.

Bridgman, George B. Foreword to Vanderpoel, *The Human Figure*, q.v.

Brook, Alexander. "Georgia O'Keefe [sic]." *The Arts.* 3, no. 2 (February 1923): 130–33. Reprinted in Lynes, *O'Keeffe, Stieglitz and the Critics*, 194, q.v.

Brownell, W. C. "French Art III; Realistic Painting." *Scribner's Magazine* 12 (1892): 604–27.

Brownson, Orestes. "Two Articles from the Princeton Review." In *The Transcendentalists*, edited by Perry Miller, 240–46. Cambridge: Harvard University Press, 1950.

Burns, Sarah. *Inventing the Modern Artist: Art and Culture in Gilded Age America*. New Haven, Conn.: Yale University Press, 1996.

Caffin, Charles H. *American Masters of Painting*. New York: Doubleday, Page & Co., 1902.

———. *The Story of American Painting*. New York: Frederick A. Stokes Co., 1907.

Castro, Jan Garden. *The Art and Life of Georgia O'Keeffe*. New York: Crown Publishers, 1985.

Child, Theodore. *Art and Criticism: Monographs and Studies*. New York: Harper & Bros., 1892.

Clarke, Ellis T. "Alien Element in American Art." *Brush and Pencil* 7, no. 1 (October 1900): 35–47.

Corn, Wanda M. *The Color of Mood: American Tonalism, 1880–1910*. M. H. DeYoung Museum; San Francisco: Palace of the Legion of Honor, 1972.

Cortissoz, Royal. *American Artists*. New York: Charles Scribner's Sons, 1923.

Cowart, Hamilton, and Greenough, *Georgia O'Keeffe, Art and Letters*. See O'Keeffe, Georgia, *Georgia O'Keeffe, Art and Letters*.

"Cubism on the Wane." *Time Magazine* 1, no. 1 (March 23, 1923).

Dell, Floyd. "Adventures in Anti-Land." *The Masses* 7, no. 1 (October–November 1915): 5–6.

———. "Speaking of Psycho-Analysis: The New Boon for Dinner Table Conversationalists." *Vanity Fair*, December 1915, 53.

———. *Women as World Builders: Studies in Modern Feminism*. Chicago: Forbes & Co., 1913. Reprint, Westport, Conn.: Hyperion Press, 1976.

Dijkstra, Bram. *Evil Sisters: The Threat of Female Sexuality and the Cult of Manhood*. New York: A. A. Knopf, 1996.

———. *The Hieroglyphics of a New Speech: Cubism, Stieglitz and the Early Poetry of William Carlos Williams*. Princeton, N.J.: Princeton University Press, 1969.

————. *Idols of Perversity: Fantasies of Feminine Evil in Fin-de-siècle Culture*. New York: Oxford University Press, 1986.

Douglas, Ann. *The Feminization of American Culture*. New York: A. A. Knopf, 1977.

Dow, Arthur Wesley. *Composition*. Boston: Joseph Bowles, 1899.

Eastman, Max. *Journalism versus Art*. New York: A. A. Knopf, 1916.

Eddy, Arthur Jerome. *Cubists and Post-Impressionism*. Chicago: A. C. McClurg & Co., 1914. And rev. ed., 1919.

————. *The New Competition* (1912). 4th ed. Chicago: A. C. McClurg & Co., 1916.

Eisler, Benita. *O'Keeffe and Stieglitz: An American Romance*. New York: Doubleday, 1991.

Eldredge, Charles C. *American Imagination and Symbolist Painting*. Grey Art Gallery; New York: New York University, 1979.

————. *Georgia O'Keeffe, American and Modern*. New Haven, Conn.: Yale University Press, 1993.

Eliot, T. S. "Tradition and the Individual Talent." In *The Sacred Wood: Essays on Poetry and Criticism*. London: Methuen, 1920.

Evans, Ernestine. "The Young Painters and 'Prosperity.'" *Creative Art* 1, no. 2 (November 1927): xxviii–xxxii.

Fink, Lois Marie. *American Art at the Nineteenth-Century Paris Salons*. Washington, D.C.: National Museum of American Art; New York: Cambridge University Press, 1990.

Fitzgerald, F. Scott. *The Beautiful and Damned*. New York: Charles Scribner's Sons, 1922.

Frank, Waldo, Lewis Mumford, Dorothy Norman, et al. *America and Alfred Stieglitz*. New York: The Literary Guild, 1934.

Gerdts, William H., Diana Dimodica Sweet, and Robert Preato. *Tonalism: An American Experience*. New York: Grand Central Art Galleries, 1982.

Greenberg, Clement. *Collected Essays and Criticism*. Vol. 1, *Perceptions and Judgments, 1939–1944*. Vol. 2, *Arrogant Purpose, 1945–1949*. Edited by John O'Brian. Chicago: University of Chicago Press,, 1986.

Harrison, Birge. *Landscape Painting*. New York: Charles Scribner's Sons, 1909.

Hartley, Marsden. *Adventures in the Arts: Informal Chapters on Painters, Vaudeville and Poets*. New York: Boni and Liveright, 1921.

Hartmann, Sadakichi. *A History of American Art*. 2 vols. New York: L. C. Page & Co., 1901. New rev. 1-vol. ed., New York: Tudor Publishing Co., 1934.

Hogrefe, Jeffrey. *O'Keeffe: The Life of an American Legend*. New York: Bantam Books, 1992.

Hughes, Robert. *American Visions; The Epic History of Art in America*. New York: A. A. Knopf, 1997.

Huneker, James Gibbons. "What Is the Matter with Our National Academy?" *Harper's Weekly* 56 (April 6, 1912): 8. Reprinted in *Americans in the Arts, 1890–1920: Critiques by J. G. Huneker*, edited by Arnold T. Schwab, 590. New York: AMS Press, 1985.

Irwin, Wallace. *The Golden Bed*. New York: G. P. Putnam's,, 1924.

Isham, Samuel. *The History of American Painting*. New York: The Macmillan Co., 1905.

Jones, Harvey L. *Twilight and Reverie: California Tonalist Painting 1890–1930*. Oakland, Calif.: The Oakland Museum, 1995.

Kandinsky, Wassily. *Concerning the Spiritual in Art* (1912).New York: Dover Books, n.d.

Koehler, S. R. *American Art*. New York: Cassell & Co., 1886.

Krafft-Ebing, Richard von. *Psychopathia Sexualis*. Translated by Franklin S. Klaf. New York: Bell Publishing Co., 1965.

Laurvik, J. Nilsen. *Is It Art?* New York: The International Press, 1913.

Lears, T. J. Jackson. *No Place of Grace: Antimodernism and the Transformation of American Culture 1880–1920*. New York: Pantheon Books, 1982.

Lisle, Laurie. *Portrait of an Artist: A Biography of Georgia O'Keeffe*. Completely revised and updated. New York: Washington Square Press, 1987.

Lowe, Sue Davidson. *Stieglitz: A Memoir/Biography*. New York: Farrar, Straus & Giroux, 1983.

Lynes, Barbara Buhler. *O'Keeffe, Stieglitz and the Critics, 1916–1929*. Ann Arbor, Mich.: U.M.I. Research Press, 1989.

Marinetti, F. T. *Selected Writings*. Edited by R. W. Flint. New York: Farrar, Straus & Giroux, 1972.

The Masses. January 1911–November 1917. Reprint, introduced by Alex Baskin. 4 vols. Millwood, N.Y.: Kraus Reprint, 1980.

McBride, Henry. "Modern Art." *Dial*, December 1926. Reprinted in *The Dial: Arts and Letters in the 1920s. An Anthology of Writings from the Dial Magazine, 1920–1929*, edited by Gaye L. Brown, 123–24. Worcester, Mass.: Worcester Art Museum, 1981.

McChesny, Clara T. "A Talk with Matisse, Leader of Post-Impressionists." *New York Times*, Sunday, March 9, 1913. Reprinted in *The Armory Show—International Exhibition of Modern Art 1913*, vol. 3, *Contemporary and Retrospective Documents*. New York: Arno Press, 1972.

Mechlin, Leila. "Trend of American Art; with Some Notable Examples of Recent Painting." in *Cosmopolitan Magazine* 41, no. 2 (June 1906): 177–84.

Mencken, H. L. *In Defense of Women*. New York: A. A. Knopf, 1918.

Mumford, Lewis. "O'Keefe [*sic*] and Matisse." *New Republic* 50 (March 2, 1927): 41–42. Reprinted in Lynes, *O'Keeffe, Stieglitz and the Critics*, 264–66, q.v.

Neuhaus, Eugen. *The Galleries of the Exposition: A Critical Review of the Paintings, Statuary and the Graphic Arts in the Palace of Fine Arts at the Panama-Pacific International Exposition*. San Franciso: Paul Elder and Co., 1915.

"New York Letter." *Brush and Pencil* 6, no. 2 (May 1900): 80–83.

Nordfeldt, B.J.O. *The Woodblock Prints of B.J.O. Nordfeldt: A Catalogue Raisonné*, Edited by Fiona Donovan and Susan Brown. Minneapolis: University Art Museum, University of Minnesota, 1991.

Norman, Dorothy. *Alfred Stieglitz: An American Seer*. New York: Random House, 1973.
———. *Encounters: A Memoir*. San Diego: Harcourt Brace Jovanovich, 1987.

Novak, Barbara. "Georgia O'Keeffe and American Intellectual and Visual Traditions." In Peter H. Hassrick, *The Georgia O'Keeffe Museum*. New York: Harry Abrams, 1997.

O'Keeffe, Georgia. Note: All otherwise uncredited quotations from O'Keeffe (except correspondence) are taken from the artist's autobiographical notes accompanying the plates of *Georgia O'Keeffe*. New York: The Viking Press, 1976 (unpaginated). All quotations from O'Keeffe's correspondence are from the volume listed directly below, except as noted in the text.

O'Keeffe, Georgia. *Georgia O'Keeffe, Art and Letters* Edited by Jack Cowart and Juan

Hamilton. Letters selected and annotated by Sarah Greenough. Washington, D.C.: National Gallery of Art, 1987.

O'Keeffe, Georgia. Catalogue Statement, *Alfred Stieglitz Presents One Hundred Pictures, Oils, Water-Colors, Pastels, Drawings by Georgia O'Keeffe, American.* The Anderson Galleries, New York, January 29–February 10, 1923. Reprinted in *Georgia O'Keeffe: An Exhibition of the Work of the Artist from 1915 to 1966,* edited by Mitchell A. Wilder. Fort Worth, Tex.: Amon Carter Museum, 1966.

O'Keeffe, Georgia. (1978) Introduction to *Georgia O'Keeffe: A Portrait by Alfred Stieglitz.* New York: The Metropolitan Museum of Art, 1978) (unpaginated).

Peters, Sarah Whitaker. *Becoming O'Keeffe: The Early Years.* New York: Abbeville Press, 1991.

Picasso, Pablo. "Picasso Speaks: A Statement by the Artist." *The Arts* 3, no. 5 (May 1923): 314–29.

Poe, Edgar Allan. *The Complete Tales and Poems.* Introduced by Hervey Allen. The Modern Library. New York: Random House, 1938.

Pollard, Percival. *Their Day in Court.* New York: The Neale Publishing Co., 1909.

Poore, Henry Rankin. *The New Tendency in Art: Post Impressionism, Cubism, Futurism.* Garden City, N.Y.: Doubleday, Page & Co., 1913.

Pound, Ezra. "Translator's Postscript." In Remy de Gourmont, *The Natural Philosophy of Love* (1922), 169–80. New York: Rarity Press, 1931.

Robinson, Roxana. *Georgia O'Keeffe: A Life.* New York: Harper & Row, 1989.

Rosenfeld, Paul. "The Paintings of Georgia O'Keeffe." *Vanity Fair,* October 1922, 56, 112, 114. Reprinted in Lynes, *O'Keeffe, Stieglitz and the Critics, 1916–1929,* 175–82, q.v. Also reprinted, with significant alterations by the author, in Paul Rosenfeld, *Port of New York* (1924), edited by Sherman Paul. Urbana, Ill., 1961.

Rummell, John, and E. M. Berlin. *Aims and Ideals of Representative American Painters.* Buffalo, N.Y., 1901.

Seligmann, Herbert J. *Alfred Stieglitz Talking: Notes on Some of His Conversations, 1925–1931.* New Haven, Conn.: Yale University Library, 1966.

Sheldon, George William. *American Painters.* New York: D. Appleton & Co., 1879.

————. *Ideals of Life in France; or How the Great Painters Portray Woman in French Art.* New York: D. Appleton & Co., 1890.

————. *Recent Ideals of American Art.* New York: D. Appleton & Co., 1888–90.

Sloan, John. *John Sloan's New York Scene—From the Diaries, Notes and Correspondence, 1906–1913.* Edited by Bruce St. John. New York: Harper & Row, 1965.

Smith, Paul Jordan. *The Soul of Woman: An Interpretation of the Philosophy of Feminism.* San Francisco: Paul Elder and Co., 1916.

Steichen, Edward. *A Life in Photography.* Garden City, N.Y.: Doubleday & Co., 1963.

Sweet, Frederick A. "Art Sales." In *Ten Eventful Years, 1937–1946,* edited by Walter Yust, 1:194–95. Chicago: Encyclopedia Britannica, Inc., University of Chicago Press, 1947.

Taubes, Frederic. *You Don't Know What You Like: Finding the Good and the Bad in Art.* New York: Dodd, Mead & Co., 1942.

Tufts, Eleanor. *American Women Artists 1830–1930.* With essays by Gail Levin, Alessandra Comini, and Wanda M. Corn. Washington, D.C.: National Museum of Women in the Arts, 1987.

291. New York, March 1915–February 1916. Twelve issues, edited by Marius de Zayas and Agnes Ernst Meyer.

Vanderpoel, John H. *The Human Figure*. 1st rev. ed. Pelham, N.Y.: Bridgman Publishers, 1935.

Vogt, Carl. *Lectures on Man: His Place in Creation, and in the History of the Earth*. Edited by James Hunt. London: Longman, Green, 1864.

Wagner, Anne Middleton. *Three Artists (Three Women): Modernism and the Art of Hesse, Krasner, and O'Keeffe*. Berkeley and Los Angeles: University of California Press, 1996.

Watson, Forbes. "Charles Sheeler." *The Arts* 3, no. 5 (May 1923): 335–44.

Whelan, Richard. *Alfred Stieglitz: A Biography*. Boston: Little, Brown & Co., 1995.

Whitman, Walt. "Song of the Answerer" (120–24) and "A Woman Waits for Me" (76–78). In *Complete Poetry and Selected Prose*, edited by James E. Miller Jr. Boston: Houghton Mifflin, 1959.

Williams, William Carlos. *Autobiography*. New York: Random House, 1951.

———. *In the American Grain* (1925). New York: New Directions, 1956.

Wright, Melville E. "Philadelphia Art Exhibition." *Brush and Pencil* 7, no. 5 (February 1901): 257–76.

Wright, Willard Huntington. *Modern Painting: Its Tendency and Meaning*. New York: John Lane Co., 1915.

Young, Art. *On My Way: Being the Book of Art Young in Text and Picture*. New York: Horace Liveright, 1928.

LIST OF ILLUSTRATIONS

INDEX

Italicized page numbers refer to illustrations

ABOUT THE AUTHOR

Bram Dijkstra is Professor of American and Comparative
Literature at the University of California, San Diego. He is the
author of numerous books, including *America and Georgia
O'Keeffe, Evil Sisters: The Threat of Female Sexuality and the Cult
of Manhood, Defoe and Economics: The Fortune of Roxana in the
History of Interpretation*, and *Idols of Perversity: Fantasies of
Feminine Evil in Fin-de-Siècle Culture*.